Songs on Stone

JAMES McNEILL WHISTLER

AND THE ART OF LITHOGRAPHY

THE ART INSTITUTE OF CHICAGO *Museum Studies*

THE ART INSTITUTE OF CHICAGO *Museum Studies*

VOLUME 24, NO. 1

This issue is published in conjunction with the exhibition "Songs on Stone: James McNeill Whistler and the Art of Lithography," presented at The Art Institute of Chicago from June 6 to August 30, 1998, and at the National Gallery of Canada, Ottawa, from October 2, 1998, to January 3, 1999.

©1998 by The Art Institute of Chicago

ISSN 0069–3235

ISBN 0–86559–153–9

Published by The Art Institute of Chicago, 111 South Michigan Avenue, Chicago, Illinois 60603-6110. Regular subscription rates: $20 for members of the Art Institute, $25 for other individuals, and $32 for institutions. Subscribers outside the U.S.A. should add $10 per year.

For individuals, single copies of this issue are $20.00 each (other issues are $15.00 each). For institutions, all single copies of this issue are $24.00 each (other issues are $19.00 each). For orders of single copies outside the U.S.A., please add $5.00 per copy. Back issues are available from The Art Institute of Chicago Museum Shop or from the Publications Department of the Art Institute at the address above.

Executive Director of Publications: Susan F. Rossen; Guest Editor: Britt Salvesen; Editor of *Museum Studies*: Michael Sittenfeld; Designer: Ann M. Wassmann; Production: Sarah E. Guernsey; Subscription and Circulation Manager: Bryan D. Miller; Circulation Assistant: Stacey Hendricks.

Unless otherwise noted, all works in the Art Institute's collection were photographed by the Department of Imaging, Alan Newman, Executive Director, with the exception of Whistler's lithographs, which were captured digitally by Martin Senn, Philomont, Virginia.

Volume 24, no. 1, was typeset in Stempel Garamond by Z...Art & Graphics, Chicago; color separations were made by Professional Graphics, Inc., Rockford, Illinois; and 4,300 copies were printed by Meridian Printing, East Greenwich, Rhode Island.

Front cover: James McNeill Whistler (1834-1903), *Nocturne* (detail), 1878 (cat. no. 23). Back cover: James McNeill Whistler, 1879 (see p. 4).

This issue of *Museum Studies* has been supported, in part, by generous grants from The Arie and Ida Crown Memorial and the National Endowment for the Arts.

Ongoing support for *Museum Studies* has been provided by a grant for scholarly catalogues and publications from The Andrew W. Mellon Foundation.

Table of Contents

THE ART INSTITUTE OF CHICAGO

Museum Studies, Volume 24, No. 1
Songs on Stone: James McNeill Whistler and the Art of Lithography

BY MARTHA TEDESCHI AND BRITT SALVESEN

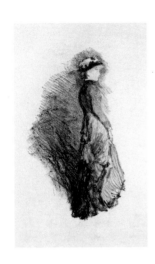

Acknowledgments

James McNeill
Whistler, 1879.
Glasgow University
Library, Department
of Special Collections.

This special issue of *Museum Studies* accompanies the exhibition "Songs on Stone: James McNeill Whistler and the Art of Lithography," presented at The Art Institute of Chicago (June 6–August 30, 1998) and at the National Gallery of Canada, Ottawa (October 1, 1998–January 3, 1999). The exhibition in turn celebrates the publication—after more than a decade of research and preparation—of *The Lithographs of James McNeill Whistler,* a definitive catalogue raisonné, technical study, and compilation of primary documents presented in two volumes. In the process of assisting our team of scholars on the catalogue raisonné project, many individuals and institutions also played a role in the development of this exhibition and its catalogue. These colleagues are acknowledged for their specific contributions in the first volume of the catalogue raisonné. Here I would simply like to reiterate our gratitude to every scholar who shared expertise, every print room that facilitated our cataloguing visits, every archivist who answered our inquiries, and every colleague who supported our efforts. *The Lithographs of James McNeill Whistler* represents a major overhaul of the standard approach to Whistler's work in the medium of lithography. It is largely thanks to the scholars who worked with me on the catalogue raisonné, and to those who facilitated our research, that it is now possible to offer a retrospective exhibition of Whistler's lithographs that can effectively demonstrate the importance of these evocative yet long-neglected images within the artist's life and work.

Although most of the lithographs included in this exhibition are drawn from the various

collections housed at The Art Institute of Chicago, the contextualization of this material would have been impossible without the generosity and goodwill of the many lending institutions. Of utmost importance, as in the case of any Whistler exhibition, were the loans from the Hunterian Art Gallery at the University of Glasgow. We are enormously indebted to our colleagues at this institution for approving and facilitating our unusually large loan request. I offer our heartfelt thanks to Mungo Campbell, Anne Dulau, Martin Hopkinson, Malcolm McLeod, and Pamela Robertson for supporting this exhibition from its earliest stages. We are also grateful—as ever—for the assistance and enthusiastic support of the scholars at the University of Glasgow's Centre for Whistler Studies, Margaret MacDonald, Patricia de Montfort, and Nigel Thorp.

We also owe a debt of gratitude to the many staff members of the other lending institutions, who have generously assisted the development of this exhibition by supporting our loan requests, providing information and photographs in a timely fashion, preparing works of art to our specifications, and always giving graciously of their time. In alphabetical order by institution, we extend our particular thanks to the following: at the Addison Gallery of American Art, Phillips Academy, Susan Faxon, Denise J. H. Johnson, Allison Kemmerer, and Jock Reynolds; at the Albright-Knox Gallery, Cheryl A. Burtvan and Douglas G. Schultz; at the Amon Carter Museum, Jane Myers, Richard Stewart, and Melissa G. Thompson; at the British Museum, Robert Anderson, Antony V. Griffiths, and Janice Reading; at the Cecil Higgins Museum, Caroline Bacon and Amanda Beresford; at the Cleveland Museum of Art, Robert P. Bergman, Diane De Grazia, Carter Foster, Jane Glaubinger, and Mary Suzor; at the Cummer Museum of Art and Gardens, Kahren Arbitman, Chantel Y. Cummings, and Sally Metzler; at the Denver Art Museum, Loretta Dimmick and Lewis I. Sharp; at the Fine Arts Museums of San Francisco, Robert Flynn Johnson, Sonya Knudsen, Steven A. Nash, and Harry S. Parker III; at the Fitzwilliam Museum, Cambridge University, Clay Hartley, Duncan Robinson, David Scrase, and Thryza Smith; at the Herbert F. Johnson Museum of Art, Cornell University, Matthew Armstrong, Carol DeNatale, Nancy E. Green, and Franklin W. Robinson; at the Hood Museum of Art, Dartmouth College, Suzanne Gandell, Kellen G. Haak, Barbara MacAdam, and Timothy Rub; at the Isabella Stewart Gardner Museum, Hilliard T. Goldfarb and Anne Hawley; at the Library of Congress, Linda Ayres, James H. Billington, Katherine Blood, Tambra Johnson, Stephen Ostrow, and Bernard Reilly; at The Metropolitan Museum of Art, Elliot Davis, Evert Fahy, George Goldner, Peter M. Kenney, Nestor Mantilla, Philippe de Montebello, Trine L. Vanderwall, and Barbara Weinberg; at the Munson-Williams-Proctor Institute, Mary Murray, Paul Schweizer, and Debora Winderl; at the Museum of Fine Arts, Boston, Clifford S. Ackley, Erica E. Hirshler, Kim Pashko, Sue Welsh Reed, Malcolm Rogers, and Theodore E. Stebbins; at the National Gallery of Art, Washington, D.C., Stephanie Belt, Nicolai Cikovsky, Ruth Fine, Earl A. Powell III, and Andrew Robison; at the National Gallery of Canada, Colin Bailey, Mimi Cazort, Carole Lapointe, Douglas Schoenherr, and Shirley L. Thompson;

at the Stanford University Museum of Art, Bernard Barryte, Noreen Ong Choe, Betsy Fryberger, Thomas K. Seligman, and Diana Strazdes; at the Sterling and Francine Clark Art Institute, Martha Asher, Michael Conforti, James Ganz, Steven Kern, and Tom Sels; at the Terra Museum of American Art and the Terra Foundation for the Arts, Helene Ahrweiler, John Neff, Dale Newkirk, Stuart Popowcer, Shelly Roman, and Catherine A. Stevens; at the University of Michigan Museum of Art, Annette Dixon, Carole McNamara, and Lori A. Mott; at the Victoria and Albert Museum, Alan Borg, Susan Lambert, Barbara O'Connor, Janet Skidmore, Timothy Stevens, and David Wright; at the Yale Center for British Art, Yale University, Timothy Goodhue, Patrick McCaughey, Patrick Noon, and Malcolm Warner.

Numerous private collectors, dealers, auction-house experts, and scholars have played a major part in the organization of this exhibition either through loans from their own collections or by facilitating the loan of works in private hands. We are very grateful for the participation of the following: The Arie and Ida Crown Memorial; Jean A. Bonna; at Berry-Hill Galleries, Inc., James Hill, Frederick Hill, and Minora Pacheco; Mr. and Mrs. A. Steven Crown; Catherine Gamble Curran; Dorothy Braude Edinburg; at Hildegard Fritz-Denneville Fine Art, Ltd., Hildegard Fritz-Denneville and Aleksandra Todoric; Kenneth A. Lohf; Sally Engelhard Pingree; Mr. and Mrs. Martin Reilly; at Sotheby's, New York, Susan Imbriani and Scott Schaefer; Walter and Nesta Spink; Alan Staley; at Thomas Colville, Inc., Thomas Colville; at Thomas French Fine Arts, Thomas French; Paul F. Walter; and Arthur Wood.

Numerous other individuals have been supportive of the exhibition at various stages of its development. We are grateful for the essential involvement of the following: at Agnew's, Gabriel Naughton; at the Art Gallery of Ontario, Katharine Lochnan; at Augustana College, Catherine Goebel; at the Burrell Collection, Glasgow Museums and Art Galleries, Vivien Hamilton, Stefan van Raay, and Julian Spalding; at Christie's, New York, Paul Provost, Jonathan Rendell, and Anne Spink; and at the Whitney Museum of American Art, David W. Kiehl.

"Songs on Stone: James McNeill Whistler and the Art of Lithography" has been organized at The Art Institute of Chicago, where many members of the staff have participated in bringing the exhibition to fruition. Especially critical were the roles of the following individuals: in the Director's office, James N. Wood, Teri J. Edelstein, and Dorothy Schroeder; in the Department of Conservation, Frank Zuccari, Faye Wrubel, Steven Starling, and Kirk Vuillemot; in the Development department, Edward W. Horner, Jr., Karin Victoria, Gregory Perry, and Jennifer Harris; in the Department of Graphic Design and Communication Services, Lyn DelliQuadri, Virginia Voedisch, Ann Wassmann, Jamie Taradash, and Ellen Wall; in the Department of Imaging, Alan Newman, Gregory Williams, Anne E. Morse, and Iris Wong; in Museum Education, Ronne Hartfield, David Stark, Robert Eskridge, Jane Clarke, Jean Sousa, Celia Marriott, Clare Kunny, Mary Sue Glosser, Katherine Bunker, Margaret Farr, Mary Erbach, Lynn Evans, Daryl Rizzo, Mary Hess, and Elizabeth Safranek; in the Department of Museum Registration, Mary Solt, Mary Mulhern, Reynold Bailey, John Molini, and Ronda Thorne; in the Operations Department, Calvert Audrain and William Heye; in the Department of Prints and Drawings, Douglas W. Druick, Harriet K. Stratis, Margo McFarland, Peter Kort Zegers, Mark Pascale, Christine O'Shea,

Caesar Citraro, Barbara Hinde, Linda Haley, Jennifer Paoletti, and Christine Baker; in Public Affairs, Eileen Harakal, John Hindman, and Kathleen Cardoza; in the Publications Department, Susan F. Rossen, Michael Sittenfeld, Sarah Guernsey, Bryan Miller, Stacey Hendricks, and especially Britt Salvesen, coauthor of this catalogue; in the office of Sustaining Fellows, Barbara Stone; in the Department of Special Events, Theodore Spiegel and Marcia Daniels. We are also indebted to John Vinci and Ward Miller of Vinci/Hamp Architects, Inc., for their beautiful and flexible design for the Chicago installation of "Songs on Stone."

We are extremely pleased once again to be working with the National Gallery of Canada, and we are very grateful to our colleagues there for their important roles in mounting "Songs on Stone" in Ottawa. Particular thanks are due Shirley Thomson, former Director, who made the decision to take the exhibition for the National Gallery, and to Pierre Théberge, C.Q., Director, for overseeing its implementation. Finally, we have been privileged to work with Catherine Jensen, Chief of Exhibition Management, and Richard Hemphill, Assistant Curator of Prints and Drawings, who coordinated the installation in Ottawa.

"Songs on Stone: James McNeill Whistler and the Art of Lithography" has been made possible by a grant from The Arie and Ida Crown Memorial, which, with great vision and generosity, also supported the research and publication of *The Lithographs of James McNeill Whistler,* the two-volume study published this year. We are indebted to the Crown family, and especially to A. Steven Crown, for their commitment to realizing these two landmark projects. Additional funding for the Chicago installation of the exhibition and its related programs has been provided by Mr. and Mrs. Wesley M. Dixon, Jr., and Donors to the Members' Exhibition Endowment, the National Endowment for the Arts, and The Elizabeth Morse Charitable Trust. The exhibition has also been supported by an indemnity from the Federal Council on the Arts and the Humanities.

MARTHA TEDESCHI

Associate Curator of Prints and Drawings,
The Art Institute of Chicago

Art from Industry: James McNeill Whistler and the Revival of Lithography

DOUGLAS W. DRUICK *Prince Trust Curator of Prints and Drawings and Searle Curator of European Painting, The Art Institute of Chicago*

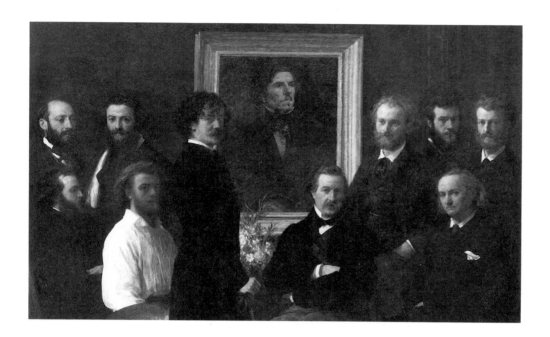

FIGURE 1

Henri Fantin-Latour (French; 1836–1904). *Homage to Eugène Delacroix,* 1863–64. Oil on canvas; 160 x 250 cm. Musée d'Orsay, Paris.

Standing figures, left to right: Louis Cordier, Alphonse Legros, Whistler, Édouard Manet, Félix Braquemond, Albert de Balleroy; seated figures, left to right: Edmond Duranty, Henri Fantin-Latour, Jules Champfleury, Charles Baudelaire.

When James McNeill Whistler referred to the delicate lithographs that he created in the early 1890s as "Songs on Stone," he was making a point: that the aim of his pictorial imagery went beyond its descriptive capacity. Like many Symbolist artists of the fin de siècle, Whistler aspired to create a visual equivalent to music; he had in fact been experimenting with musical titles for paintings, such as "Nocturne" and "Harmony," since 1867. In choosing to describe his lithographs as "Songs on Stone," he displayed his characteristic subtlety: these works are not full-scale symphonies, grand and chromatic, directed toward a large audience—they are intimate, rather quiet compositions, destined for the few.

Whistler thought of lithography in quite different terms when he first became involved with the medium. In 1858 he made a design for a sheet-music cover that was duplicated on a

lithographic stone and published by a large, commercial printing firm. At that time printed imagery was largely produced as it had been for centuries—by the hand of the professional printmaker—and, like Whistler, most artists relied upon these trained craftsmen to translate their paintings and drawings into print so that they could be multiplied and reach a wide public. By the 1890s this task had been largely taken over by new photomechanical imaging technologies. Now the traditional print media (engraving, etching, and lithography) found primary justification in their use not by professionals but by artists—the painters and sculptors whose "original" contributions in these media had hitherto been as numerically insignificant as they were aesthetically important. Whistler was not alone among the leading artists of the second half of the nineteenth century in taking up printmaking at different stages of this industrial development and at different points in his career; in so doing he actively helped to redefine prints and their purposes.

Responsive to the constantly shifting dialogue between industry and art, the history of original printmaking from 1850 to 1900 is dominated by two distinct "revivals" of interest by artists in print media. The Etching Revival was launched in France during the late 1850s, spread to England and the rest of Europe in the 1860s, and continued through the 1890s; and the revival of lithography began—again in France—to gather momentum during the 1880s and became a major artistic force in avant-garde circles in the following decade.[1] Whistler was one of the few major artists to play a formative role in both these histories.

Born in America, Whistler forged his early style in France, but later spent many years in England. Any attempt to associate his work with a particular school is inevitably problematic. But if his mature artistic production and the influences that fed it cannot be tied to a single culture, it does seem to be the case that, in both etching and lithography, Whistler drew upon trends in France, with different results in each medium. His etching practice, grounded in his early French experience, would be both continuous and consistent over the next decades. The story of his work in lithography, which is less frequently examined by art historians, follows a more episodic narrative and thus seems to reveal more clearly the transitional moments in the artist's practice and ambitions. At no point is this more clear than in the late 1880s and 1890s, when Whistler relied upon lithography to realize his aesthetic aims as no other medium could.

The Etching Revival and the Failed Lithography Revival of the 1860s

Whistler's commitment to printmaking first took root and was shaped within the French avant-garde. His early connections there are strikingly represented in the painting *Homage to Eugène Delacroix,* the large group portrait conceived in 1863–64 by his close friend Henri Fantin-Latour (fig. 1). Whistler's links to the nine other young painters and critics in the portrait went beyond shared reverence for the recently deceased French Romantic artist. Just months before Delacroix's death in August 1863, Whistler—like his fellow sitters Fantin, Félix Bracquemond, Édouard Manet, and Alphonse Legros—had exhibited paintings that had been rejected by the official Salon jury in the so-called Salon des Refusés (Salon

of Rejected Works). Whistler's *Symphony in White, No. 1: The White Girl* (1862; National Gallery of Art, Washington, D.C.) was, along with Manet's *Luncheon on the Grass* (1863; Musée d'Orsay, Paris), at the heart of the intense controversy generated by this watershed event. At issue was the aesthetic of Realism, as it would be when Fantin's *Homage* was exhibited at the Salon of 1864. To the majority of critics, Fantin's group portrait represented a gathering of Realists, whom they deemed inappropriate celebrants of the painter who was the very symbol of Romanticism in the visual arts. This essentially reductive view overlooked an important link connecting the Realist sitters to the precepts of Romanticism: the use of black-and-white media such as etching and lithography, and the related belief that drawing—the direct mark of the artist's hand—is expressive of his or her unique personality.

The artists and critics whom Fantin depicted had all been instrumental in the Etching Revival, which had been formalized in 1862 with the founding of the Société des aquafortistes (Society of Etchers). Critics Charles Baudelaire, Jules Champfleury, and Edmond Duranty encouraged painters to adopt the medium of etching, arguing its suitability for the multiplication and dissemination of their compositions. Photography, invented in 1839, was technically not yet capable of duplicating the surfaces and contrasts of paintings, and reproductions made by professional printmakers necessarily interposed a hand other than the artist's. The critics charged the painter-printmaker—the artist—with the task of interpreting his or her own works in print. Etching (as opposed to woodcut or engraving) was seen as the print medium most naturally suited to the painter because it allows for "spontaneity" and "immediacy," draftsmanly virtues associated with Rembrandt, who was revered as the greatest painter-etcher in the history of art.[2]

An artist can use the etching needle with virtually the same freedom as a pen or pencil; thus proponents of the Etching Revival concluded that painters' etchings could be regarded as multiple drawings. Artists, young and old, who responded to the new potential of this time-honored medium began to assume for themselves the responsibility of producing printed translations of their painted compositions, making "direct" contact with a large audience.

By the early 1860s, Whistler had already produced a significant etched oeuvre; yet he alone of the painters grouped in Fantin's *Homage to Eugène Delacroix* was not among the Société's founding members. This, in turn, may account for the fact that Whistler did not join Fantin, Manet, Legros, and Bracquemond in 1862 when, at the behest of the Société's director, Alfred Cadart, they experimented with bringing the Etching Revival's aesthetic of graphic spontaneity—the notion of the print as drawing—to bear on the surface of the lithographic stone. Delacroix, himself a founder of the Société des aquafortistes, had in practice preferred lithography to etching and indeed established the link between Romanticism and lithography. When his lithographs, and those of other painter-lithographers of the first half of the century, were republished in the early 1860s, they played a paramount role in stimulating the Realist nostalgia for the Romantic past, and they directly influenced the practice of the painter-printmakers of the Realist avant-garde whom Fantin's portrait depicts. The lithographs produced by Fantin, Manet, Legros, and Bracquemond for Cadart are notable for the unorthodox boldness of the graphic handling; they were, however, without issue. Despite the precedent provided earlier by Delacroix, at mid-century lithography was compromised by its almost exclusive use for banal imagery and commercial advertisements.

In vain the Etching Revival's leading spokesman, Philippe Burty, called upon painters to do for lithography what they were demonstrably achieving for etching: to revive a dying medium by realizing "delicate improvisations" through its unique properties.[3]

Renewed Interest in Lithography
in the 1870s

While the Etching Revival took hold in both France and England during the 1860s and into the 1870s, artists' attitudes toward lithography also began to change, in part due to dramatic advances in printmaking technology that occurred during the same few years. In 1872 veteran landscape painter and erstwhile etcher Camille Corot published a portfolio of twelve lithographs. Its title—*Douze croquis et dessins originaux* (*Twelve Original Sketches and Drawings*)—advanced lithography as a vehicle for spontaneous drawing, a means rather than an end in itself; the graphic resources specific to the medium were not considered. Among the younger members of the avant-garde, Corot's stature was considerable, and his example was apparently sufficient to pique the interest of the painter-etchers with whom Whistler had posed a decade earlier. Manet, having recently taken up the medium, published three lithographs in 1874, and the following year produced seven more for a renowned illustrated edition of Edgar Allan Poe's *The Raven*, translated into French by the poet Stéphane Mallarmé. Bracquemond and Legros also produced lithographs in the mid-1870s. Then, in 1876, Fantin began to work seriously in lithography; he would henceforth use it as one of the primary vehicles for his imaginative compositions inspired by music, ultimately producing a large and highly significant body of prints. Other avant-garde painters took up the medium, including

the Impressionist Camille Pissarro. Edgar Degas began to explore lithography in the late 1870s, while simultaneously experimenting with various etching techniques in his search for different ways to nuance the textures and moods of his modern-life scenes.

What most of the lithographs by painters such as Corot, Fantin, and Degas had in common was the fact that they were not drawn with crayon directly on stone. Instead they were produced by means of transfer lithography, a technique that, although it had been known since the invention of lithography in 1795, had recently been perfected as a result of developments in the printing industry. Transfer lithographs are made with tusche (a liquid lithographic medium) or crayon on specially coated paper; the resulting image is transferred to the lithographic stone, which is, in turn, prepared and printed following normal procedures. The attractions of transfer lithography over all other traditional print media for artists of the 1870s were twofold: it required no special technical knowledge; and the artist's composition, reversed when transferred to the stone, printed in the same orientation as drawn. This gave rise to the view, advanced in the preface to Corot's *Douze croquis et dessins originaux*, that transfer lithography is the ideal means of multiplying artists' drawings.

London printer Thomas Way, who made notable efforts in the late 1870s to attract leading British artists to lithography, deserves credit for Whistler's decision to take up the medium for the first time in 1878 and for encouraging him to resume it in 1887. But equally important was creative stimulus from France. Degas's practice was particularly compelling, suggesting as it did the benefits of concurrently exploring etching and lithography in order to extract a variety of pictorial possibilities from similar themes. Indeed the parallels and differences between the printmaking activities of Degas

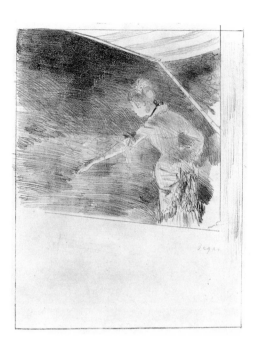

FIGURE 2

Edgar Degas (French;
1834–1917). *Singer at a
Café-Concert*, 1876/77.
Lithograph on
off-white wove paper;
259 x 199 mm (image);
310 x 230 mm (sheet).
The Art Institute
of Chicago, Charles
Deering Collection
(1927.2685).

and Whistler at the end of the 1870s are instructive. At issue is a certain sensitivity to the appropriate usages of each medium—an understanding of what one might call media "protocol." With regard to etching, Whistler was well aware of contemporary French activity but disinclined to follow suit; in lithography, which he had not yet made his own, he was more responsive and open-minded.

Whistler conceived his first lithographs (see cat. nos. 1–2), as did Degas his *Singer at a Café-Concert* (fig. 2), simply as images that thematically echo current drawings and etchings (see cat. nos. 11 and 16). His sole engagement with the unique properties of the medium occurred in his use of a scraper to scratch out highlights on the stone's resistant surface. In subsequent prints, Whistler became more adventurous, exploring with Way's technical aid the resources of wash lithography (lithotint) to achieve increasingly complex and evocative tonal results (see cat. nos. 21–24). Degas's work, beginning around 1877, is similarly marked by an investigation of tonal effects—not, however,

in lithography, but rather in etching, specifically aquatint (see fig. 3).

Whistler's achievement in lithotint in 1878 would indeed have a profound impact on the way he would print his Venice etchings two years later, leaving veils of ink on the copper plate that printed as tone (see cat. nos. 29 and 39). Significantly, however, in his etchings Whistler would never follow Degas's example of actually creating tonal passages *in* the copper printing surface by means of aquatint. To do so was expressly against Whistler's aesthetic of the intaglio technique. As an etcher he dismissed tonal methods such as aquatint as "little tricks," continuing to conceive of etching as an essentially linear medium.[4] While Degas and his other French contemporaries took the expressive potential of etching in new, experimental directions during the 1870s, Whistler remained true to the practices he and other early proponents of the Etching Revival had adopted in France a decade earlier. This was the view of etching that he effectively transplanted to England.

Since lithography lacked a set of artistic conventions, both in the art world in general and in Whistler's own experience, the medium allowed him to experiment in a way that his long practice—and position—as a painter-etcher disallowed. With his artistic identity less invested in lithography than in etching or painting, Whistler in a sense could risk more, pursuing different techniques and possibilities. Having essayed lithography and lithotint on the stone, he proceeded in the fall of 1878 to work on transfer paper. Here he followed the precedent of Corot and Degas, using the medium quite simply to create multiple "drawings"—rendering his imagery in a sketchy, abbreviated graphic handling and completing each subject in a single procedure (see cat. no. 45).

If the lithotints had a notable influence on how Whistler *printed* the etchings that followed, his methods of creating the etched images themselves remained unchanged. Whistler's concentration, at this time, on etching is also evident in the first transfer lithographs of 1879, which can be seen merely to reiterate the etchings that had preceded them; both appear crisp and graphically restrained.

It is difficult to assess the significance of Whistler's first lithographs in simple, evolutionary terms, in part because his attention to them faltered. Whether this was because he had lost interest in the medium or because he was preoccupied with the printing of his Venice etchings remains unclear. But by 1880 Whistler and most of his French colleagues had abandoned, at least for the moment, their experiments with lithography.

Lithography Renewed in the 1880s and 1890s

Eight years later, when Whistler resumed his work in lithography, he did so in a very different climate, one in which advances in new imaging technologies, emerging forces and structures in the art market, and changes in his own aesthetic priorities encouraged the artist to explore the potential of lithography once again.

The industrial printmaking techniques whose applications were nascent in the 1870s had expanded still further, so that mass-produced visual imagery was a part of everyday life as never before. Artists were discovering that original printmaking provided new creative outlets. One important reason for their shifting attitudes was the recent perfection and proliferation of photomechanical printing techniques. Those who cared about fine art greeted with ambivalence the burgeoning illustrated press that these processes spawned.

In 1882 Vincent van Gogh wrote to his brother Theo that he was thinking of doing some lithographs, because, although he liked the "drawings" reproduced in the illustrated periodicals, a lithograph retained the touch of the artist's hand and had a charm of "originality" that could not be achieved by any mechanical means.[5] Soon a majority of artists and critics came to share this opinion.

At the same time, lithography was beginning to assume an ideological significance in France. The French had long considered lithography, though invented in Germany, to be their own—naturalized, as it were, through the practice of such luminaries as Delacroix. The defeat of the French in the war of 1870–71 resulted in a heightened desire to protect the cultural property and heritage of France against further threats. By the early 1880s, critics feared that French preeminence in the art of lithography was in jeopardy, and in 1884 the Société des artistes lithographes français (Society of French Lithographic Artists) was

FIGURE 3

Edgar Degas. *Dancers in the Wings*, 1879/80. Etching and aquatint on ivory wove China paper; 141 x 104 mm (plate); 246 x 169 mm (sheet). The Art Institute of Chicago, Joseph Brooks Fair Collection (1955.1009).

formed. Its goal—to perpetuate the art of lithography—was hailed as a concrete response to the challenge of preserving one of the "branches" of France's "national art."[6]

The majority of the Société's members were professional lithographers, masters of the various techniques of working on stone and largely involved in reproducing works of art made in other media. While their efforts to improve the official status of their medium produced significant results, it was the minority members—the painter-printmakers in their midst—who played the critical role in gaining popularity and respect for lithography. Fantin was a leader in this effort. Since 1876 he had consistently promoted lithography through the example of his own prints, shown at the Paris Salon as well as in specialized "Black and White" exhibitions held in Britain. But a turning point in the fortunes of lithography came in 1886, when Fantin's transfer lithographs for Adolphe Jullien's book *Richard Wagner* (see fig. 4) were shown at the Salon and hailed there as the most important event in the history of lithography since the publication, over forty years earlier, of Delacroix's portfolio of lithographs inspired by *Hamlet.* Critics now proclaimed that an "unexpected renaissance" of lithography was under way, characterizing the medium as a worthy rival of etching for the attentions of painter and collector.[7] These developments, along with a series of shifts in the ways that art was presented to a growing middle-class public, ensured that now—after two false starts, in the 1860s and 1870s—a revival of lithography could begin in earnest.

Whistler took up lithography again in 1887, the year after Fantin exhibited his *Wagner* illustrations, initiating what would be a decade's worth of serious lithographic production by resuming work with Way and his son, T. R. Way, in London. There Whistler's energetic involvement in the medium paralleled contemporary developments in Paris. In 1889 the French art dealers and publishers Boussod, Valadon et Cie marketed a portfolio of lithographs by George William Thornley after works by Degas; the same year, the firm's London branch offered for sale six of Whistler's early lithographs in a portfolio entitled *Notes* (see cat. nos. 21, 23, and 45). The French enthusiasm for lithography's "revival" was echoed by a reviewer for the British journal *The Academy,* who affirmed the medium's artistic viability by stating that Whistler's lithographs were "as autographic as his etchings."[8]

To bolster lithography by comparing it favorably with etching was not a foolproof strategy. Much of the original vitality of the Etching Revival was on the wane. Moreover the perceived status of the original print had become confused by the marketing of photomechanical reproductions as independent works of art on the one hand, and, on the other, by the promotion of handcrafted "original" reproductive prints made by professionals after Old Master and contemporary paintings. This problem was addressed in 1888 by the Société de l'estampe originale (Society of the Original Print), established by Bracquemond and five colleagues. More important than the album of ten original prints by founding members published that year was its preface by Roger Marx, in which the critic advanced two significant concepts: that the artist's original print had a unique value not shared by the reproductive print, and that methods other than etching—notably, lithography—were suitable artistic vehicles for the painter-printmaker.

Also indicative of the shift in taste away from etching and toward lithography is the invitation extended in 1888 by the poet Stéphane Mallarmé to his artist friends—Degas, Auguste Renoir, Claude Monet, Berthe Morisot, and John Lewis Brown—for prints to illustrate a book of his poetry. Though Brown

was an accomplished etcher, Mallarmé asked him to work in color lithography, which Brown had practiced occasionally since the early 1880s. In the works he produced in this medium, Brown took a selective and restrained approach to color, employing a muted palette and achieving effects not unlike those of delicate watercolors. It is no coincidence that Whistler adopted a similar manner when in 1890–91 he first attempted to make color lithographs (see cat. nos. 71 and 79–80). Mallarmé was now a friend and supporter, his admiration for Whistler's lithographs demonstrated both privately and publicly; in the fall of 1890 a sonnet by the poet and a lithograph by the artist appeared side by side in the English periodical *The Whirlwind.*

The publication of lithographs in periodicals contributed to the promotion of the medium in England and France, and also fulfilled one of the ideological aims of the Lithography Revival: the dissemination of—and popularization of the taste for—"original" art. Over the years, Whistler allowed several periodicals to publish his prints, and his correspondence leaves no doubt that he was aware of the belief that affordable lithographs would stimulate and improve public taste. This hope for the democratization of art through lithography had gained currency in 1889, when the colorful and spirited posters of Jules Chéret were shown at the Paris Exposition Universelle. Critics proclaimed Chéret's posters to be exemplary of what the French printmaking movement should be striving to create—a true art for the masses (see fig. 5). The significance of lithography as a means of educating the expanding middle classes in questions of taste and art became one of the rallying cries of the medium's revival. But Whistler's letters ring with his skeptical view that putting his lithographs "before the people . . . at an absurdly small price" would not

in fact produce meaningful results. Increasingly, and against the advice of his dealers, he insisted on raising the prices for his lithographs to the level he was able to charge for his etchings, thereby ensuring that they were unaffordable to the "crowd."[9]

The elitist stance that Whistler adopted with regard to his lithographs was but another facet of that complex and sometimes contradictory market for artists' prints during the 1890s.[10] In 1889, the same year that Chéret's posters earned high praise for their accessibility, an Exposition de peintres-graveurs (Exhibition of Painter-Printmakers) was held at the gallery of the senior Impressionist dealer, Paul Durand-Ruel. The first in what would become a series of annual events, the exhibition was organized to demonstrate the principles that had informed the short-lived Société de l'estampe originale, displaying printmaking as a natural extension of the painter's art and

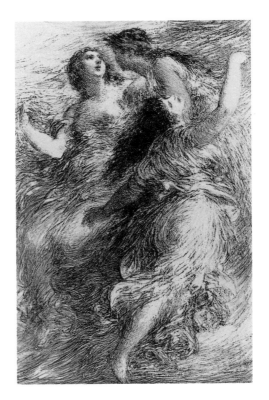

FIGURE 4

Henri Fantin-Latour. *The Rhinegold, Scene I: "The Rhinemaidens,"* 1886. Lithograph on grayish ivory China paper; 227 x 150 mm (image); 227 x 150 mm (sheet). The Art Institute of Chicago, Gift of Mrs. Chauncey McCormick and Mrs. E. Danielson, the Charles Deering Collection (1927.2958).

distinguishing between the "original" print of the artist and the "reproductive" print of the professional translator. Burty, in the catalogue's preface, introduced another necessary distinction when he described the "photographic processes" as no more than a means of "popularizing information." But he also noted that it was because of these mechanical processes that artists no longer had to produce original prints "to make their genius known throughout the world," as had been the case only three decades earlier; now that photomechanical processes were taking over the task of reproduction, artistic printmaking ceased to be primarily defined by the need for multiplicity. Thus an artist might choose to work in lithography—a printmaking medium capable, in principle, of yielding many thousands of prints from a single stone—and, to ensure quality control, deliberately print only a small, or limited, "edition." As Burty explained, the painter-printmakers who participated in the exhibition were committed to the belief "that final states [of a print] can be appreciated only through choice proofs either pulled by the artist . . . or printed under his direct supervision." The intent was "to create an audience of amateurs who seek only the *belle épreuve* for their portfolios, a select public exclusively devoted to original and honest painting [sic]."[11] This notion of the "belle épreuve"—implying as it did a beautiful, special, and therefore necessarily rare and prized impression—was not new, but given the great strides in photomechanical reproduction, the art-buying public was now more sensitive to notions of originality and ready to equate desirability with exclusivity.

Whistler's methods of making and marketing his lithographs were informed by virtually identical beliefs. He maintained that the "difference between a *proof* [printed by hand] —on old Dutch paper—and a print [from a large, mechanically printed edition]" justified charging one hundred times more for the former.[12] Certainly the artist was correct when he later asserted that large, machine-printed editions of his lithographs could not adequately express the true essence of his work. For unlike younger artists in France, such as Henri de Toulouse-Lautrec, Whistler was not interested in adopting the bold design and chromatic effects derived from the popular poster tradition; rather, he sought delicacy.

Instead of "prints for the people," Whistler wanted to create prints that had the appearance of "the most delicate *drawings* out of a Museum."[13] Mallarmé understood and responded to what Whistler intended. In 1890 he praised the artist's lithographs for their refinement, elegance, and charm, complimenting Whistler's achievement by placing the lithographs on a par with both etching and drawing. This was the response of a connoisseur; indeed, by this time, Whistler conceived his lithographs for such a discerning audience. Although democratization was one important aspect of the Lithography Revival, the art-lovers who attended the Exhibitions of Painter-Printmakers was already possessed of sufficient sophistication to understand that they were being invited not to a public spectacle, like the annual Salon, but rather to a private gathering where they could quietly savor intimate works. Whistler himself said of his lithographs that they reveal "the most personal and the very best proof of the qualities of the man who did them."[14] In other words, if paintings (and their reproductions) were for everyone, artists' prints were for the select few.

Mallarmé's friendship, as well as his appreciation for Whistler's lithographs, served, in a sense, to both affirm and define the Symbolist aesthetic they embodied. Indeed the portrait Whistler made of the poet in 1892 (cat. no. 157), which was used as the frontispiece for the

French edition of Mallarmé's *Vers et Prose* in 1893, was among the lithographs that Whistler most frequently selected for exhibition in the following years—and he also consistently priced it higher than most of his other lithographs. That the sitter found the portrait "a marvel, the best thing that has ever been done of me"[15] was high praise, in view of earlier portraits in oil by Manet and in etching by Paul Gauguin. Whistler strove not to produce a physical likeness but rather to express something of the inner life of the poet. The resulting image hovers between resolution and dissolution, as if on the threshold between materiality and intangibility. One can surmise that the reason for Mallarmé's notable enthusiasm was that he saw in Whistler's lithographs the visual realization of qualities akin to those he pursued in his verse. Like Mallarmé's poetry, Whistler's lithographs of the early 1890s are spare and refined, purified of all that is extraneous or that speaks to the labor of their creation. And, importantly, the lithographs seem to embody the Mallarmean aesthetic of suggestion over description. The artist's subjects—notably the series of lightly draped females (see cat. nos. 80, 82, and 86–87)—seem equally remote from naturalist interest and narrative intent. Though formally concise, they appear evanescent and almost dreamlike, as if the forms derive as much from the realm of the artist's imagination as the reality of his studio; they seem to exist as metaphors for—symbols of—the artist's inventive powers.

Lithography offered Whistler the means to perfect this aesthetic as no other medium had. Interestingly, while he referred to his lithographs as "drawings"—and indeed gave them the summary appearance suggestive of private thoughts or sketches committed to paper—Whistler in fact made few actual drawings in this traditional sense.[16] The small number of extant studies related to lithographs

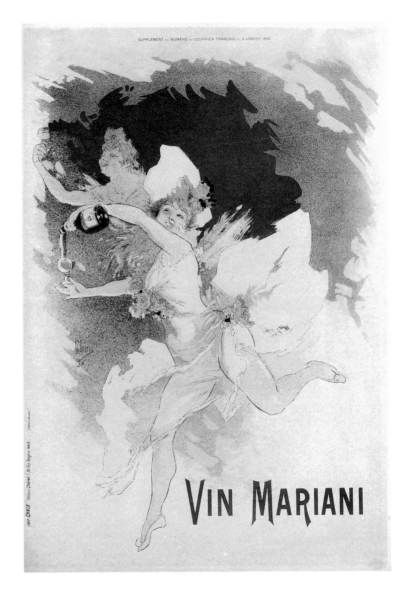

FIGURE 5

Jules Chéret (French; 1836–1932). *Vin Mariani*, 1895. Color lithograph on tan wove poster paper; 573 x 372 mm. The Art Institute of Chicago, Gift of Jim Cuca (1987.374).

FIGURE 6

Eugène Carrière.

(French; 1849–1906).

Portrait of Paul

Verlaine, 1896. Litho-

tint on paper;

519 x 403 mm (image);

631 x 439 mm (sheet).

The Art Institute of

Chicago, anonymous

gift (1938.1259).

suggest the reasons why. These sketches, in recording the disruptive pressure of the artist's hand, as well as the marks of various adjustments and pentimenti, bear witness to his creative exertions. They are working documents produced in the search for an image of exquisite, effortless perfection. Etching—which divorces the act of drawing from the realized image through printing—provides the means to distance, control, and refine the original, spontaneous act of inspiration. However, the intaglio technique is such that etchings literally bear the imprint of the pressure imposed during the printing process. That Whistler removed from his etchings the most obvious sign of this by trimming away the blank paper around the mark left by the plate suggests his dislike of the material evidence of labor.

Lithography provided Whistler with an alternative, especially after he discovered, on a visit to Fantin's Paris studio in 1891, *papier végétal*, a transfer paper without the regular, mechanical-looking surface pattern so evident in the transfer lithographs he had been making on grained *papier viennois*. On the smooth surface of this new paper, Whistler made drawings that, when transferred to the stone, shed the traces of effort. They convey a sense of immanence, in part due to the way the artist worked on the transfer paper: according to T. R. Way, Whistler moved his hand *over* the sheet "again and again . . . until suddenly a firm line appeared" on its surface.[17] When printed by hand, the stone did not disturb the surface of the fine antique and Japanese papers carefully chosen to receive the images, as the etching plate inevitably must. Nor did the artist trim the impressions, instead using sheets of different sizes and types and varying the placement of the images upon them. As a result, the drawn forms appear to float above—rather than sink into—the expansive, creamy surface.

Whistler was an acknowledged originator of the revival of lithography's fortunes in England, where indeed he was one of only a few artists to produce a significant body of work in the medium (another was Alphonse Legros, a former friend from Whistler's youth who had settled in London). France, as English critics freely acknowledged, was the true center of the Lithography Revival, where artists such as Pierre Bonnard, Toulouse-Lautrec, and Édouard Vuillard wrote a new chapter in the history of graphic art and created a lasting testimony to the artistic potential of lithography. In Paris, where Whistler had resettled in 1892, he involved himself in the most significant manifestations of the revival. His works appeared both in a number of major promotional exhibitions and in the albums of the revival's most significant print publications: *The Draped Figure, Seated* (cat. no. 82) was included in André Marty's *L'Estampe originale* in 1893, and Ambroise Vollard included *Afternoon Tea* (cat. no. 199) in his *Album d'estampes originales de la Galerie Vollard* four years later. Moreover Whistler remained attentive to new developments. For example his decision in spring 1896 to create *The Thames* (cat. no. 197) in lithotint, which he had not used since 1878, parallels Eugène Carrière's work on the celebrated lithotint portrait of poet Paul Verlaine (fig. 6), published by Marty in 1896.

Whistler stopped making lithographs in 1897. This decision no doubt had personal motivations, but was nonetheless symptomatic of a larger dynamic. For the Lithography Revival was to be as short-lived as it was brilliant; by the late 1890s, the enthusiasm of both artists and collectors was on the wane. Throughout his career as a printmaker, Whistler had displayed an extraordinary sense of timing, intuitively recognizing the artistic potential of the moment while simultaneously setting the course for future developments. Beginning in the late 1880s, his practice exemplified a new attitude toward printmaking: prized by the artist for its inherent expressive potential. The modernity of Whistler's achievement in lithography lies in the fact that he used it not solely, or even primarily, as a vehicle for the multiplication of his images; instead he discovered that it offered him the means to embody aspects of his individual aesthetic in a way no other medium could.

LENDERS TO THE EXHIBITION

Addison Gallery of American Art, Phillips
 Academy, Andover, Massachusetts
Albright-Knox Gallery, Buffalo
Amon Carter Museum, Fort Worth, Texas
The Arie and Ida Crown Memorial (Mansfield-
 Whittemore-Crown Collection)
The Art Institute of Chicago
British Museum, London
Cecil Higgins Art Gallery, Bedford
Cleveland Museum of Art
Mr. and Mrs. A. Steven Crown
Cummer Museum of Art and Gardens,
 Jacksonville, Florida
Denver Art Museum
Dorothy Braude Edinburg
Fine Arts Museums of San Francisco
Fitzwilliam Museum, Cambridge
Herbert F. Johnson Museum of Art, Cornell
 University, Ithaca, New York
Hildegard Fritz-Denneville Fine Art
Hood Museum of Art, Dartmouth College,
 Hanover, New Hampshire
Hunterian Art Gallery, University of Glasgow
Isabella Stewart Gardner Museum, Boston
Library of Congress, Washington, D.C., Prints
 and Photographs Division

The Metropolitan Museum of Art, New York
Munson-Williams-Proctor Institute Museum of Art,
 Utica, New York
Museum of Fine Arts, Boston
National Gallery of Art, Washington, D.C.
National Gallery of Canada, Ottawa
Estate of Pauline K. Palmer
Sally Engelhard Pingree
Mr. and Mrs. Walter Spink
Stanford University Museum of Art
Sterling and Francine Clark Art Institute,
 Williamstown, Massachusetts
Daniel J. Terra Collection, The Estate of
 Daniel J. Terra
Terra Foundation for the Arts, Daniel J.
 Terra Collection
University of Michigan Museum of Art,
 Ann Arbor
Victoria & Albert Museum, London
Paul F. Walter
Yale Center for British Art, New Haven, Connecticut
Anonymous private collection
Private collection, New England, Courtesy
 of Thomas Colville, Inc.
Private Swiss collection

Songs on Stone

JAMES McNEILL WHISTLER
AND THE ART OF LITHOGRAPHY

MARTHA TEDESCHI
Associate Curator of Prints and Drawings
The Art Institute of Chicago

BRITT SALVESEN
Special Projects Editor of Scholarly Publications
The Art Institute of Chicago

NOTES TO THE READER

The catalogue is organized into thematic sections, each of which is discussed in a short essay. The checklist of works in the exhibition is also divided into sections, which follow the essays.

In the checklist sections, lithographs precede works in other media. All works are arranged in roughly chronological order. Numbers from the appropriate catalogues raisonné are provided for each work; the following abbreviations are used:

C The Art Institute of Chicago, *The Lithographs of James McNeill Whistler*. Vol. 1, *A Catalogue Raisonné*, eds. Harriet K. Stratis and Martha Tedeschi. Chicago, 1998.

K Kennedy, Edward G. *The Etched Work of Whistler*. Rev. ed. San Francisco, 1978.

M MacDonald, Margaret F. *James McNeill Whistler: Drawings, Pastels, and Watercolours. A Catalogue Raisonné*. New Haven, Conn., and London, 1995.

YMSM Young, Andrew McLaren, Margaret F. MacDonald, Robin Spencer, and Hamish Miles. *The Paintings of James McNeill Whistler*. 2 vols. New Haven, Conn., and London, 1980.

W Way, T. R. *Mr. Whistler's Lithographs: The Catalogue*. 2d ed. London and New York, 1905.

The lithographs and etchings were originally printed in black ink unless otherwise noted. Dimensions are given in millimeters, height preceding width.

Unless otherwise noted, all illustrations are works by James McNeill Whistler.

Early Experiments: Images of Maud Franklin

JAMES McNEILL WHISTLER AND THE ART OF LITHOGRAPHY

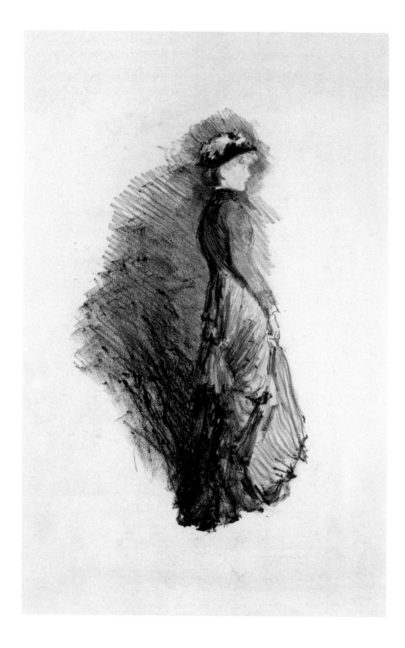

FIGURE 1

Study, 1878 (cat. no. 1).

When James McNeill Whistler made his first images using lithography in 1878, he began with a group of informal figure studies, reiterating poses with which he was already comfortable and familiar. His model was Maud Franklin, a young artist who may have posed for him as early as 1872, and who was certainly his mistress by 1877. She was by then twenty years old, and Whistler was her senior by twenty-three years. Their acquaintances during this period described her as completely devoted to the artist, and there can be no doubt that she was a tireless and stoic model. She appears in his work in every medium, sometimes as herself and sometimes as a stand-in for society ladies who were unavailable to pose for their own portraits. Maud's youth, striking features, and vivid presence clearly inspired Whistler, who interpreted her appearance at will, creating images that range in tone from youthful wistfulness to overt sexuality. Whistler described his portraits of Maud as "artist's" pictures and "impressions of my own,"[1] and the lithographs for which she posed are certainly among the most intensely personal and original of all his portraits.

It was the London printer Thomas Way who first convinced Whistler to try his hand at making lithographs and who supplied him with materials and technical advice. According to Way's son, T. R. Way, who eventually became the first cataloguer of Whistler's work in lithography, the artist's earliest experiment in that medium was a standing portrait of Maud wearing an elaborate hat, entitled simply *Study* (fig. 1). In this work her face is seen in profile, but she is turned in such a way that we see her back and the elaborate flounces at the back of her dress. It is a pose Whistler

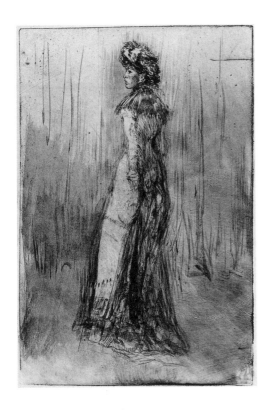

frequently adopted for formal oil portraits of ladies of fashion, as it showed to best advantage the trains of their dresses. It is also the same pose, although seen in reverse, that Whistler had employed in an earlier etching, *Maud, Standing* (fig. 2). The artist had truly labored over this etching, taking it through twelve states and repeatedly altering the background and the model's garments. He worked on at least one impression with gray wash as he struggled to find a way to set the slim figure of his model off against the shadowed background. When Whistler had Maud return to this pose for his first lithograph, he selected the softest grade of crayon in order to create deep, rich shadows around the figure and in the folds of her dress. When the result proved too heavy, he used a roulette and a scraper to bring out highlights on the upper back and shoulder of the figure. As Whistler discovered in this first experiment, the greasy lithographic crayon permitted a greater range of tonal effects than did the etching needle. In etching the only way to suggest an area of shadow is to build up layers of crosshatched lines, a technique that cannot produce a soft, even tone. When he added wash with a brush to the etching of Maud, Whistler was clearly seeking a method for making the print more tonal, for giving it a softer, subtler sense of atmosphere. In 1878 he finally found such a method when he took up lithography under the experienced tutelage of Thomas Way.

Both the etching and the lithograph show Maud as a slender young woman dressed in tightly fitting dresses that were the height of fashion. The few known photographs of Maud (see fig. 3) suggest that she was actually of a more solid build, with a round jaw and, according to the artist John White Alexander,

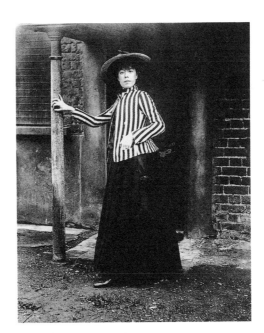

FIGURE 3

Maud Franklin, late 1870s. Library of Congress, Washington, D.C., Pennell Collection.

ABOVE

FIGURE 2

Maud, Standing, 1873 (cat. no. 16).

BELOW

FIGURE 4

The Toilet, 1878
(cat. no. 5).

RIGHT

FIGURE 5

*Study for "Arrange-
ment in Black, No. 2:
Portrait of Mrs. Huth,"*
c. 1872 (cat. no. 15).

"not pretty, with prominent teeth, a real British type."[2] Nevertheless, Whistler again emphasized a lovely profile and the graceful curve of her back and waist in one of the most ambitious of his early lithotints, or wash lithographs, entitled *The Toilet* (fig. 4). In this image his model's posture echoes the dress studies Whistler made in preparation for formal oil portraits such as those of Mrs. Louis Huth and Frances Leyland (figs. 5 and 12), for which

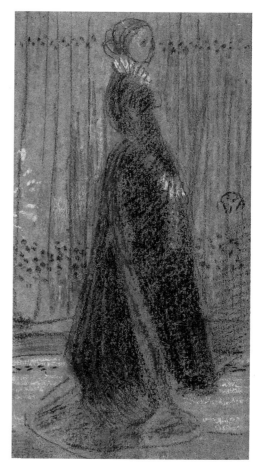

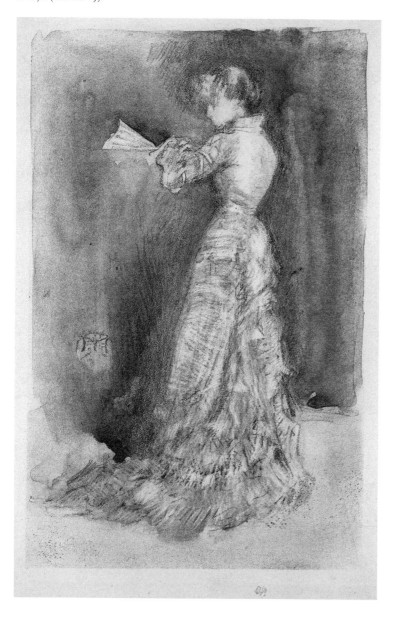

Maud herself probably stood in as model on occasion. It is certainly not a stance invented by Whistler; rather it was a standard studio pose for photographic portraits in this period and also for contemporary fashion plates. The convention no doubt reflects the tendency of the day to situate the most elaborate decorative elements of ladies' gowns on bustles or trains. Whistler maintained a serious interest in women's fashions, even designing the dress depicted in the Leyland portrait himself.

In *The Toilet*, Maud holds a fan before her, a graceful motif that the artist had employed before in chalk drawings on brown paper dating from the early 1870s (see fig. 6), and it is likely he was striving for the same delicate chiaroscuro effects in the lithotint. As was

the case with the majority of his lithotints, Whistler initially misjudged the strength of his tusche washes, and the first proofs of *The Toilet* were too dark and somber for his liking. He eventually took the image through five successive states, scraping and lightening the composition as he went, to give the elaborate flounces of Maud's dress a light, frothy effect. Several proofs heightened with white chalk demonstrate the artist's desire to make the bright figure glow against her shadowed surroundings. Here Maud is at once fashionable, feminine, and ethereal.

Whistler offered a quite different view of Maud Franklin in other early lithographs. Three studies show the young woman in casual repose; clearly these experiments were never intended to be shared with a wider audience, and indeed few impressions of each were printed. The images testify to the notoriously

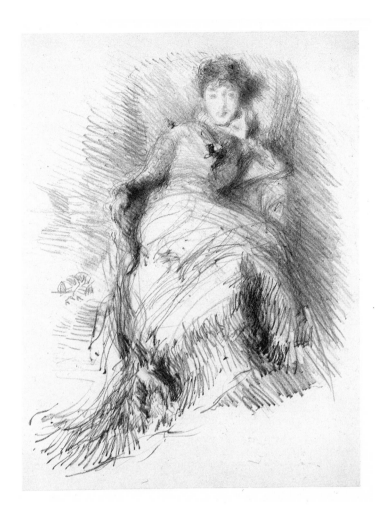

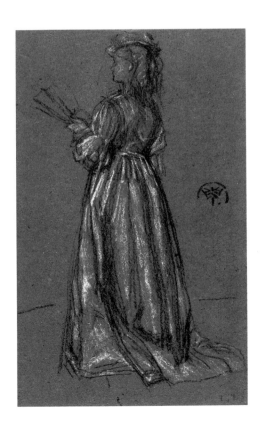

grueling nature of posing for Whistler and at the same time suggest the intimacy of the relationship between artist and model. In Whistler's second lithograph (fig. 7), Maud is seated frontally; although she is dressed fashionably, her open pose—hips angled seductively to the side—and direct gaze distinguish this from a proper society portrait. Whistler's energetic handling of the crayon, particularly where he defined the feathery extravagance of the hemline, also contributes to the vivid, subtly aggressive tenor of the image. This portrayal can be likened to the artist's *Arrangement in White and Black*, a full-length oil portrait of Maud

FIGURE 7

Study, 1878 (cat. no. 2).

FIGURE 6

Lady with a Fan, 1873/75 (cat. no. 17).

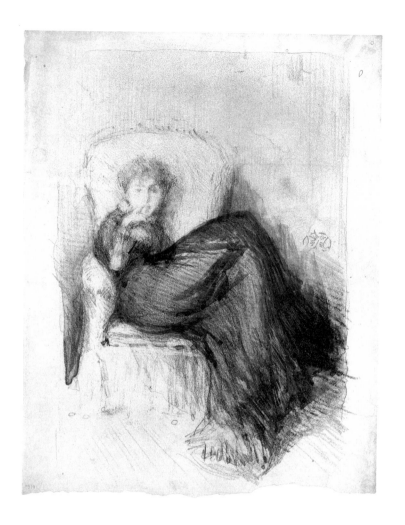

FIGURE 8

Study: Maud Seated,
1878 (cat. no. 3).

armchair, her right hip provocatively thrust toward the viewer, her legs thrown sideways over the arm of the chair. Her lassitude and blank stare spell out her exhaustion, while her pose suggests the ease and intimacy of the partnership between this model and artist. No woman of high society would have allowed an artist to portray her in such a pose. Interestingly, the lithograph comes very close to repeating a composition Whistler first developed in a pencil drawing of the mid-1860s, a study of Maud's predecessor, Joanna Hiffernan (fig. 14). While the figure in the earlier sketch was left rather anonymous, the lithograph is clearly a portrait of Maud, and a rather poignant one at that. It captures a private moment in the life of a mistress and model, much as did Whistler's etching *Weary* (fig. 9), which portrays Jo Hiffernan; or the related chalk and charcoal drawing of 1863 entitled *Sleeping Woman* (fig. 10). In *Weary* the artist used the etched line to suggest the fine, shimmering texture of Jo's hair as she rested, while leaving her body almost entirely to the imagination. In the drawing, too, Jo's face and hair are the focus of attention, while her body merges with the dark field of cross-hatched lines around her. By contrast, in the lithotint Whistler used long, fluid strokes of the brush to emphasize—even exaggerate—the expanse of his model's buttocks, hip, and thigh, while allowing her face to remain pale and distant. Here she is both seductive and frankly human in her fatigue and boredom.

In another wash lithograph (fig. 16), Whistler used a more staccato application of brush strokes to depict Maud reading, again seated sideways in the armchair in what must have been one of her favorite positions of repose. Women are often shown reading in photographic and painted portraits of the day; a model could alleviate the boredom of maintaining a pose over an extended period

from 1876 (Freer Gallery of Art, Washington, D.C.). When the painting was shown at the Grosvenor Gallery in London in May 1878, it was immediately denounced by one art critic as "vulgar," despite the fact that Maud was depicted in a very stylish black-and-white walking costume. To Victorian viewers, her unflinching gaze and pose with hands on her hips quite clearly implied a kind of proletarian directness and suggested that her social standing was not quite that of a respectable lady.[3]

Whistler's first wash lithograph, *Study: Maud Seated* (fig. 8) provides an even more intimate glimpse of Maud's life in the studio with Whistler. Here she is slumped down in an

of time by reading, and Whistler had used the device before in portraits of family members. He had even considered a similar pose for his important portrait of Frances Leyland, making at least one drawing (fig. 17) before rejecting the composition because it failed to do justice to the ornate train of the dress. The lithograph of Maud reading closely resembles, in reverse, a black-and-white chalk drawing of the same subject (1878; Freer Gallery of Art, Washington, D.C.); their similarity in composition and handling shows that one of Whistler's early motivations in taking up lithography was to find a way to reproduce his drawings, and indeed he printed one impression of this wash lithograph in blue ink on the dark brown paper he favored for his drawings. While a photographer or professional engraver could have provided him with meticulous reproductions of his work, Whistler had a hearty disdain for commercial reproductions and seems, at this stage of his career, to have been looking for a way to multiply his images without sacrificing their freshness and originality.

Whistler's first experimental interlude with lithography ended in 1879, when he and Maud left for Venice in the wake of the artist's sensational court action against critic John Ruskin. With his finances in a shambles, Whistler abandoned lithography and concentrated on etching while in Venice, in part because he was far from the London printing offices of Thomas Way and therefore lacked the materials and encouragement to keep working in a medium he was just beginning to understand. It was not until 1887 that he was tempted to resume his work in lithography.

The simple lithographic studies Whistler made of Maud in the late 1870s offer a marked contrast to portraits he made of her in the 1880s, when their relationship gradually began to unravel. In 1879 Maud became pregnant and

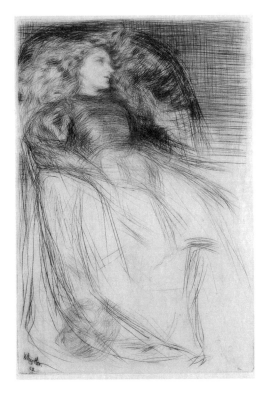

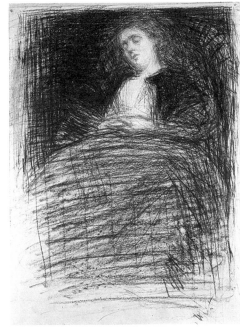

FIGURE 9

Weary, 1863 (cat. no. 9).

FIGURE 10

Sleeping Woman, 1863 (cat. no. 10).

gave birth to a daughter. Whistler neglected her during the pregnancy, leaving her in a London hotel and pretending to go abroad to Paris while actually remaining in London. She bore another daughter, probably in 1881. Both children were sent away to be raised by foster parents, and Maud suffered from poor health; numerous images of her from the early 1880s show her resting or reading in bed. Some of these, like the lithographs of 1878, hint at her position as a *demimondaine*, but with a more overt iconography, by showing her in bed, with a man's evening cloak and hat hanging in the corner. The early lithographs tell the story of Whistler's fruitful partnership with Maud with greater simplicity and abstraction. Through pose, gesture, and the experimental approach to each new image, we can infer that Whistler's first work in a new medium was an adventure he shared with his model and mistress. Later portraits of Maud, such as *Maud Reading in Bed* of 1884/86 (fig. 11), while just as intimate and personal, suggest the growing complexity of their relationship by focusing on her illnesses and on the material details of their increasingly strained domestic life.

In 1888, while Maud was convalescing at the home of friends, she received the news that Whistler had married Beatrix Godwin, an artist and young widow who had been a part of their social circle for some years. Maud's decade-long relationship with Whistler ended in a flash. Still calling herself "Mrs. Whistler," she made her way to Paris, where for a time she supported herself by modeling for other artists. Eventually she married a wealthy New Yorker, with whom she had a son; after the death of her first husband, she was married a second time, again to an American. Unwilling ever to speak about her years with Whistler, she settled in a villa in Cannes, where she lived until her death in about 1941. (MT)

FIGURE 11

Maud Reading in Bed, 1884/86 (cat. no. 20).

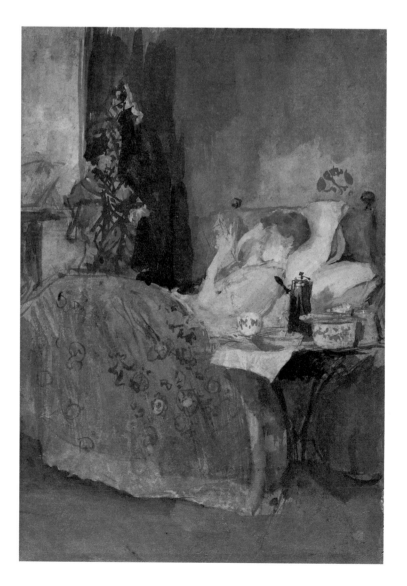

1. *Study*, 1878 (fig. 1)

(C 3; W 1)

Lithograph, printed on ivory
plate paper, first of two states
266 x 149 mm (image);
370 x 237 mm (sheet)
Mansfield-Whittemore-Crown
Collection, The Art Institute
of Chicago, 29.1984

2. *Study*, 1878 (fig. 7)

(C 4; W 3)

Lithograph, printed on cream
chine, mounted on ivory plate
paper, only state
270 x 205 mm (image); 280 x
220 mm (chine); 358 x 262 mm
(plate paper)
Mansfield-Whittemore-Crown
Collection, The Art Institute
of Chicago, 31.1984

**3. *Study: Maud Seated*, 1878
(fig. 8)**

(C 5; W 131)

Lithotint, printed on ivory
wove proofing paper, only state
265 x 186 mm (image);
288 x 224 mm (sheet)
The Art Institute of Chicago,
Bryan Lathrop Collection,
1917.656

4. *Study*, 1878 (fig. 16)

(C 6; W 2)

Lithotint, printed in blue ink
on brown wove paper, second
of two states
265 x 240 mm (image);
288 x 280 mm (sheet)
The Art Institute of Chicago,
Bryan Lathrop Collection,
1934.615

5. *The Toilet*, 1878 (fig. 4)

(C 10; W 6)

Lithotint, printed on cream
wove paper, first of five states;
signed in graphite with butterfly
260 x 164 mm (image);
279 x 177 mm (sheet)
Mansfield-Whittemore-Crown
Collection, The Art Institute
of Chicago, 36.1984

6. *The Fan*, 1879

(C 16; W 14)

Transfer lithograph, printed
on cream chine, mounted on off-
white wove paper, only state
205 x 160 mm (image); 264 x
188 mm (chine); 381 x 275 mm
(plate paper)
Estate of Pauline K. Palmer,
The Art Institute of Chicago,
RX 3056

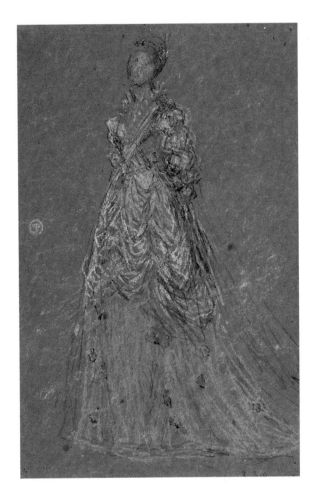

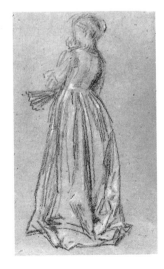

7. *Reading*, 1879 and 1887

(C 17; W 13)

Lithograph, printed on ivory
wove paper, first of four states
155 x 130 mm (image);
285 x 447 mm (sheet)
Mansfield-Whittemore-Crown
Collection, The Art Institute
of Chicago, 44.1984

FIGURE 12

*Study for "Symphony
in Flesh Color
and Pink: Mrs. F. R.
Leyland,"* 1871/74
(cat. no. 14).

FIGURE 13

*Standing Figure of
a Woman with a Fan,*
1873/75 (cat. no. 18).

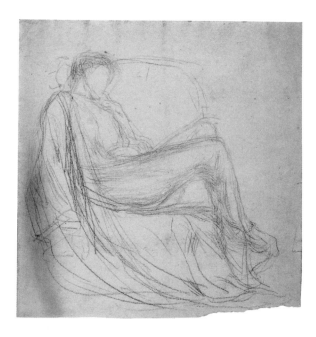

FIGURE 14
*Study of a Draped
Reclining Woman,*
c. 1865 (cat. no. 11).

FIGURE 15
*Draped Figure Seated,
Holding a Fan,* 1865/68
(cat. no. 12).

8. *Reading*, 1879 and 1887
(C 17; W 13)
Lithograph, printed on cream
laid paper, fourth of four states;
signed in graphite with butterfly
253 x 366 mm (image);
310 x 206 mm (sheet)
Mansfield-Whittemore-Crown
Collection, The Art Institute
of Chicago, 45.1984

9. *Weary*, 1863 (fig. 9)
(K 92)
Etching and drypoint, printed
on cream Japanese *gampi*
paper, edge-mounted on card,
second of three states
198 x 132 mm (plate);
267 x 184 mm (sheet)
The Art Institute of Chicago,
Gift of Hilda Young, 1986.481

**10. *Sleeping Woman*, 1863
(fig. 10)**
(M 310)
Black chalk and charcoal on
cream wove paper, laid down
on card
249 x 176 mm
National Gallery of Art,
Washington, D.C., Rosenwald
Collection, 1948.11.306

**11. *Study of a Draped Reclining
Woman*, c. 1865 (fig. 14)**
(M 326)
Crayon and graphite on white
laid paper
228 x 222 mm
Hunterian Art Gallery, University
of Glasgow, Birnie Philip
Bequest, 46013

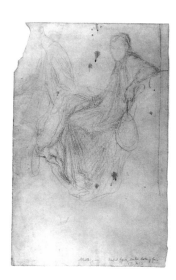

**12. *Draped Figure Seated, Holding
a Fan*, 1865/68 (fig. 15)**
(M 327)
Crayon and graphite on off-
white laid paper
349 x 223 mm
Hunterian Art Gallery,
University of Glasgow, Birnie
Philip Bequest, 46014

**13. *Figure Reading*, 1871/73
(fig. 17)**
(M 428)
Black chalks heightened
with white chalks, on brown
wove paper
232 x 180 mm
Lent by the Syndics of the
Fitzwilliam Museum,
Cambridge, PD.64–1959

**14. *Study for "Symphony in Flesh
Color and Pink: Mrs. F. R. Leyland,"*
1871/74 (fig. 12)**
(M 433)
Pastel and black chalk, over
charcoal, on brown wove paper
288 x 182 mm
Purchased with funds provided
by the Council of the Amon
Carter Museum, Fort Worth,
Texas, 1990.9
Chicago only

**15. *Study for "Arrangement in
Black, No. 2: Portrait of Mrs. Huth,"*
c. 1872 (fig. 5)**
(M 454)
Pastel on brown wove paper
228 x 122 mm
The Art Institute of Chicago,
Walter S. Brewster Collection,
1933.211

16. *Maud, Standing*, 1873 (fig. 2)

(K 114)

Etching and drypoint, with brown and gray washes, printed on cream laid paper

225 x 150 mm

Daniel J. Terra Collection, 12.1990; Photograph courtesy of Terra Museum of American Art, Chicago

Chicago only

17. *Lady with a Fan*, 1873/75 (fig. 6)

(M 533r)

Black crayon, heightened with white chalk, on brown wove paper; signed in chalk with butterfly

210 x 130 mm

University of Michigan Museum of Art, Ann Arbor, Bequest of Margaret Watson Parker, 1954/1.266

18. *Standing Figure of a Woman with a Fan*, 1873/75 (fig. 13)

(M 536)

Black crayon, heightened with white chalk, on brown wove paper

209 x 126 mm

National Gallery of Art, Washington, D.C., Rosenwald Collection, 1943.3.8813

19. *Girl Reading in Bed*, 1882

(M 867)

Pen and brown ink, with traces of graphite, on pink wove paper

113 x 181 mm

The Art Institute of Chicago, Charles Deering Collection, 1927.5877

20. *Maud Reading in Bed*, 1884/86 (fig. 11)

(M 902)

Pen and brown ink, and water-color, with graphite, on tan card

237 x 165 mm

Hood Museum of Art, Dartmouth College, Hanover, New Hampshire; Gift of Mr. and Mrs. Allen, Jr., Class of 1932, W.971.26

Chicago only

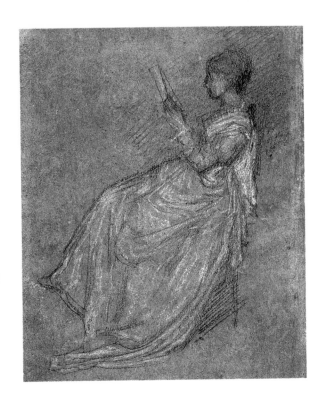

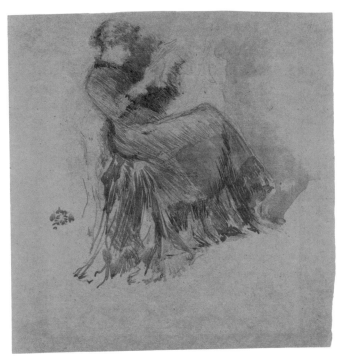

FIGURE 16

Study, 1878 (cat. no. 4).

ABOVE

FIGURE 17

Figure Reading, 1871/73 (cat. no. 13).

JAMES McNEILL WHISTLER AND THE ART OF LITHOGRAPHY

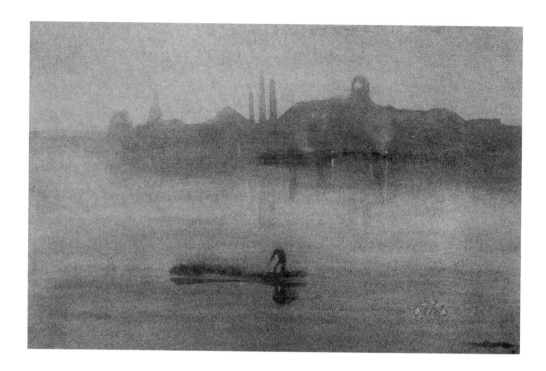

FIGURE 18

Nocturne, 1878
(cat. no. 23).

"And when the evening mist clothes the riverside with poetry,
 as with a veil, and the poor buildings lose themselves in the
dim sky, and the tall chimneys become campanili, and the
 warehouses are palaces in the night. . . . Nature, who, for once,
has sung in tune, sings her exquisite song to the artist alone."

JAMES McNEILL WHISTLER, 1885

London's great waterway, the Thames, is central not only to the city's topography, but also to its economy and overall identity. Running eastward from Gloucestershire into the English Channel, the river was used for barge traffic beginning in the 1600s. By the mid-nineteenth century, it seemed to embody two aspects of the Industrial Revolution—it was thriving with activity but also festering with disease, characteristics that had both moral and physical connotations. With its rich historical and contemporary significance, the Thames in 1859 was a compelling subject for an aspiring Realist artist such as Whistler. Major construction projects were initiated at this time—sewers, embankments, and bridges were built to mitigate pollution, prevent flooding, and facilitate commerce and transportation—raising issues related to

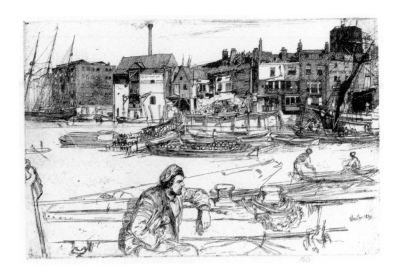

preservation and progress, to the city's past and future.

Whistler concentrated on the present, unsettled state of the Thames and its workers, while not neglecting the tumbledown structures that represented the past, especially given their imminent destruction. He chose the insalubrious, even dangerous stretch of the river at Wapping, Limehouse, and Rotherhithe, between London Bridge and the Thames Tunnel in the East End (see fig. 20). There, from August to October 1859, he produced the etchings (see fig. 19) later included in the "Thames Set," striking images that earned him his initial public recognition. When he returned to this part of the river to experiment with lithotint in 1878, he must have recalled his youthful fascination with what Nathaniel Hawthorne described in 1863 as a "cold and torpid neighborhood, mean, shabby, and unpicturesque, both as to its buildings and inhabitants."[4]

Other parts of the river captured Whistler's attention as well—he lived in a series of residences in Chelsea, west of the city center. Until 1878 his address was on Lindsey Row (later Cheyne Walk), a street boasting formerly aristocratic residences that by the 1860s had become the somewhat shabby quarters of several artists and writers. Whistler held court in Chelsea—invitations to his Sunday pancake breakfasts were much sought after—but he also worked assiduously. From his upstairs window at 7 Lindsey Row, he could see Battersea Bridge extending from Chelsea to the Surrey side of the Thames. Built in 1771, this massive wooden structure was slated for destruction by 1878. In *Brown and Silver: Old Battersea Bridge* (fig. 22), Whistler showed the traffic of pedestrians and carriages, conveying

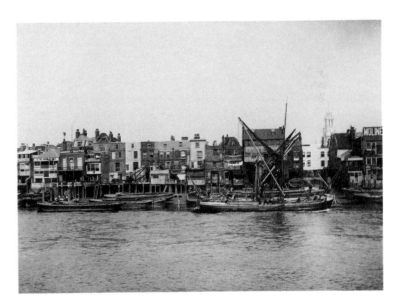

a sense of activity yet controlling it by means of a muted palette and a carefully organized composition of horizontal and diagonal lines.

The "Thames Set," consisting of etchings produced in the late 1850s but not published until 1871, reveals the complex evolution of Whistler's notions about the artist's role in society and his relationship to nature. When producing the early prints, he approached many of the sites with a documentary eye not unlike that of the many photographers who sought to record the appearance of structures that would soon be destroyed; he even etched the scenes in reverse on the plates so that they would print in correct orientation, and chose to

FIGURE 19

Black Lion Wharf, 1859 (cat. no. 29).

FIGURE 20

The Thames and Broadway Wharf, Tower Hamlets, London, c. 1885. Royal Commission on Historical Monuments (England)/Crown Copyright.

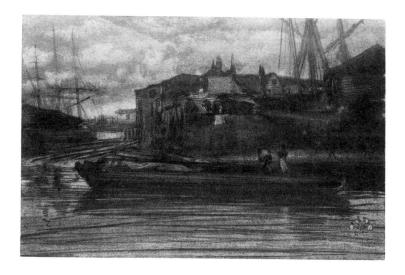

render only old bridges rather than their modern counterparts. The unintentional abstraction of photography, with its exaggerated chiaroscuro and abrupt cropping, offered a compositional model not incompatible with that found in Japanese prints. This conjunction of a quintessentially modern, Western technology with an Eastern representational tradition that was perceived as "primitive" and free of mechanical and artistic conventions was of immense significance for the art of Whistler and of many of his contemporaries. He carried this tendency toward reduction of both form and color, already evident in works such as *Brown and Silver: Old Battersea Bridge* and *Chelsea Wharf: Gray and Silver* (fig. 23), to an extreme in the nocturne paintings of the next decade.

During the 1870s Whistler's paintings of the Thames came increasingly to be arrangements of color and tone intended to communicate mood, time of day, and atmospheric effect. His interest was no longer in delineating the fascinating topography of the riverbank and the picturesque life of its wharves and docklands. As he explained in a letter sent to *The World* in May 1878, "The picture should have its own merit, and not depend upon dramatic, or legendary, or local interest."[5] The topography of the Thames continued to compel Whistler; as we see in preparatory drawings, such as *Sketch for a Nocturne* (fig. 32), he often began his work by depicting the buildings hovering along the shore. The artist remained deeply wedded to the familiar silhouettes of the Battersea side of the river, opposite his home in Chelsea, and reduced them now to iconic simplicity. He used the same approach when, in preparation for a painted screen of 1872 (Hunterian Art Gallery, University of Glasgow), he sketched the familiar span of Battersea Bridge (fig. 33) as a great T looming against the sky.

Whistler's nocturnes were radical pictures in the 1870s, and their challenging nature eventually landed the artist in court, inextricably linking his name and reputation to the imagery of the Thames. In 1877 the art critic John Ruskin took issue with the nocturnal river pictures that Whistler exhibited at the newly opened Grosvenor Gallery, particularly attacking *Nocturne in Black and Gold: Falling Rocket* (1877; Detroit Institute of Arts) and claiming that Whistler was charging exorbitant prices for "flinging a pot of paint in the public's face."[6] Never one to ignore an insult, the artist sued Ruskin for libel. In the course of the sensational trial that followed, Whistler was called on to defend in court his minimal riverscapes, which to Victorian eyes appeared to lack both meaning and effort. Abstraction as an aesthetic concept was still unknown, and a painting in this period was generally priced according to the amount of labor involved and the degree of ambition represented by its scale and subject matter. Although a judgment was eventually rendered in Whistler's favor, he was awarded only a farthing in damages, a clear message that he had not been taken seriously. When it finally

ended, in November 1878, the trial left him bankrupt and bitter.

Given Whistler's tenacious temperament, however, it should come as no surprise that he chose not to back down from Ruskin's attack. In addition to taking the critic to court, he continued to work on his controversial views of the Thames, creating in the spring of 1878 a handful of images even more abstract than his previous work. Furthermore, he did so in a medium—lithography—that Ruskin abhorred and that was generally associated with the world of commerce rather than that of high art. It is likely, in fact, that part of the appeal of lithography for Whistler at this moment lay in its "low" status. He needed a way to popularize his art in the face of negative public opinion, and he may well have been intrigued by the possibilities of a medium generally used for such democratic purposes as the printing of posters, menus, advertisements, and cheap colored reproductions. Yet, as always, he manipulated the medium to serve his own artistic purposes, eventually

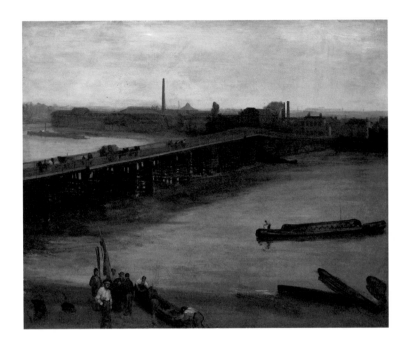

creating images so delicate (and so expensive) that they placed lithography on a par with etching in the fine-arts marketplace.

As we have seen, Whistler's very first experiments in lithography were studies of his mistress at the time, Maud Franklin. Some of these explored the most basic materials of the medium: crayon on stone. However, the artist quickly began to make trials of a much more challenging sort, using diluted tusche washes applied with a brush to stones that had been prepared by the Ways with rectangular areas of half-tint. This technique, called lithotint, can yield extraordinarily subtle effects because of the almost unlimited range of tones that can be created by diluting the washes to alter their intensity and consistency. The difficulty of the process, as Whistler immediately discovered, lies in predicting how dark or light the washes will appear when they are inked and printed. Given this inherent challenge, it is remarkable that three of his earliest lithotints—*Limehouse*, *Nocturne*, and *Early Morning* (figs. 21, 18, and 24)—are works of

FIGURE 22

Brown and Silver: Old Battersea Bridge, 1859/65 (cat. no. 30).

FIGURE 23

Chelsea Wharf: Gray and Silver, 1864/68 (cat. no. 33).

FIGURE 24

FIGURE 24

Early Morning, 1878
(cat. no. 24).

FIGURE 25

*Nocturne: Blue and
Silver—Battersea
Reach*, 1872/78
(cat. no. 37).

such delicacy and effectiveness. They are inarguably among his most haunting and memorable works in any medium.

Despite the ultimate success of these river views, Whistler did not achieve the results he desired on the first try. In each case the first proofs of these images were much heavier and darker than he intended. According to T. R. Way, *Early Morning* at first printed like a nocturnal image, "so dark as to represent a time before dawn," and it was only after the stone was scraped and re-etched twice that "the perfect silvery quality was attained."[7] *Limehouse* and *Nocturne* also had to be re-etched, with selective highlights scraped away, before the artist was satisfied with the contrast between their watery foregrounds and the fog-shrouded structures on the shore.

Nocturne was eventually printed on a gray-blue paper that intentionally brought the image close in effect to Whistler's painted nocturnes of the early 1870s, such as *Nocturne: Blue and Silver—Battersea Reach* or *Nocturne: Blue and Gold—Southampton Water* (figs. 25 and 34). Before beginning to work in lithography, Whistler did not have at his disposal a method for replicating the liquid effects of his painted river views in a printmaking medium. Over the years he had made modest attempts to capture the effects of a specific time of day in such river etchings as *Battersea: Dawn* (fig. 31) of 1875. Lithotint allowed him to paint on stone much as he did on canvas or panel, freeing him from the linear approach dictated by

the etching needle to pursue a wholly tonal concept. Working with diluted tusche, he could construct a riverscape purely by layering washes, as he did when creating the delicate watercolor *Battersea* (fig. 26), which may have served as a kind of preparatory study for the early lithotints.

The ultimate simplicity of the lithotints belies the hard work that went into their creation, the sequence of proofing, re-etching, scraping, and re-proofing that finally yielded these luminous images of the Thames. However, the hardest work of all—and this was also true of the related paintings—was the task of translating the artist's nuanced perceptual experience of the river into a two-dimensional work of art. It was this challenge, as Whistler explained on the witness stand during the Ruskin trial, that required "the knowledge I have gained in the work of a lifetime."[8] Years later, in his famous "Ten O'Clock" lecture of 1885, Whistler described his personal response to the Thames at night and the process by which the artist's perception can transform its everyday topography:

And when the evening mist clothes the riverside with poetry, as with a veil, and the poor buildings lose themselves in the dim sky, and the tall chimneys become campanili, and the warehouses are palaces in the night, and the whole city hangs in the heavens, and fairy-land is before us—then the wayfarer hastens home; the working man and the cultured one, the wise man and the one of pleasure, cease to understand, as they have ceased to see, and Nature, who, for once, has sung in tune, sings her exquisite song to the artist alone, her son and her master—her son in that he loves her, her master in that he knows her.[9]

In the many years he had spent on the banks of the Thames, Whistler had certainly come to know the river in its many guises. In *Limehouse*, *Nocturne*, and *Early Morning* he had radically reduced and distilled his impressions into images of poetic abstraction, as he had in his recent paintings. Yet in two other lithotints produced during the same period, entitled *The Broad Bridge* and *The Tall Bridge* (figs. 36 and 27), he took a more retrospective and documentary approach to the subject. Whistler had been invited to contribute four lithographs to the new weekly magazine *Piccadilly*, where they would be published as "Notes in Black and White." He first created *Early Morning* and *The Toilet* (fig. 4) for this purpose, but set to work on the two bridge subjects when he was asked by the periodical's editor, Theodore Watts-Dunton, and its financial backers to produce "a landscape, more after the manner of the etchings which the public already admired."[10] Clearly, they were referring to Whistler's Realist etchings of the Thames, which had been a critical and popular success. Obligingly, the artist went to work in a boat out on the river, first creating the preparatory drawings (see fig. 28) that would serve as the basis for images he later drew on stones prepared with half-tint. Pulling up quite close to Battersea Bridge—in contrast with the more distant perspective he

FIGURE 26

Battersea, c. 1876/78 (cat. no. 39).

FIGURE 27

The Tall Bridge, 1878
(cat. no. 27).

FIGURE 28

The Tall Bridge, 1878
(cat. no. 40).

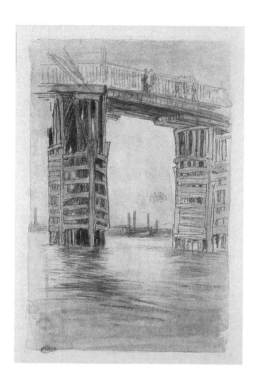

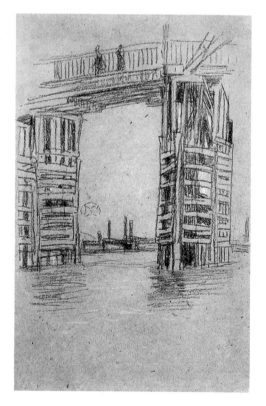

had adopted for *Brown and Silver: Old Battersea Bridge* (fig. 22), painted almost twenty years earlier, or the 1879 etching *Old Battersea Bridge* (fig. 39)—he delineated with strong but careful strokes of the crayon the massive piers of the structure, and indicated with a more delicate touch the cityscape seen beyond it.

These two bridge subjects represent the unique instances in which Whistler relied on finished drawings for his lithographs; for the creation of *Limehouse* (fig. 21), he worked directly on the stone with his brush and washes while sitting in a barge on the water. Also unlike the other river lithotints, Whistler established the majority of the composition in both *The Tall Bridge* and *The Broad Bridge* with crayon work, which, perhaps because he intended them for publication in a periodical, had to be crisp and strong. Once he had drawn on the stone, he used a diluted tusche wash to brush in the watery foregrounds in both images, and to suggest the hazy atmosphere in the distance. Early proofs of both bridge subjects indicate that once again the washes printed more heavily than Whistler intended. After re-etching they achieved the bright, reflective quality he sought to capture initially. Oddly enough, however, the darker early proofs are in themselves more realistic than the artist may have wished, evoking the gritty industrial haze that often hung over many parts of London and the Thames in this period.

In the end, only two of Whistler's lithotints—*The Toilet* and *The Broad Bridge*—appeared in *Piccadilly*, which went out of business only two weeks after the publication of the bridge scene in the July 4, 1878, issue. Whistler seems to have been interested from the first in strategies for the publication and distribution of his lithographs, and in 1878 he and Thomas Way undertook the publication of a set of lithographs, to be entitled *Art Notes*. Not surprisingly, given the low status of both

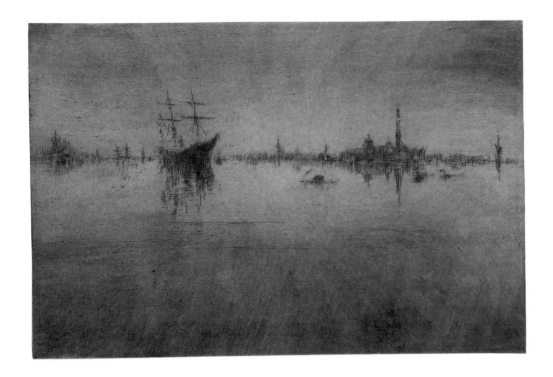

FIGURE 29

Nocturne, 1879/80
(cat. no. 43).

the medium and Whistler's reputation at this moment, the project failed to attract subscribers and had to be abandoned. When it was resurrected successfully in 1887 by the publishers Boussod, Valadon, and Co., it included two of Whistler's most important Thames views, *Limehouse* and *Nocturne*.

Following the verdict of *Whistler* v. *Ruskin*, the artist was forced to auction off his possessions to pay his creditors, and he was declared bankrupt. In September 1879 Whistler and Maud Franklin left London for Venice, where the artist planned to work on etchings commissioned by the Fine Art Society. His experiments in lithography ceased temporarily during this time, but the impact of his Thames lithotints on his subsequent Venice etchings was substantial. Many of the views Whistler scratched into his copper plates in Venice were created with a bare minimum of lines. Upon his return to London in 1880, Whistler began to print his etchings in a new way, leaving a film of ink on the plate and manipulating

it to create atmospheric effects that varied from one impression to another. It can be no coincidence that this highly innovative and personal approach to "painting" on the etching plate followed so closely on the heels of his work in wash lithography. When he created the lithotints *Limehouse*, *Early Morning*, and *Nocturne*, he had for the first time constructed printed images using arrangements of tone rather than line. In many impressions of the Venice etchings, Whistler adapted this principle to the specific requirements of etching. In works such as *Nocturne* or *Nocturne: Palaces* (figs. 29 and 38), he combined line and tone in order to suggest uniquely Venetian interactions of light and water. (BS/MT)

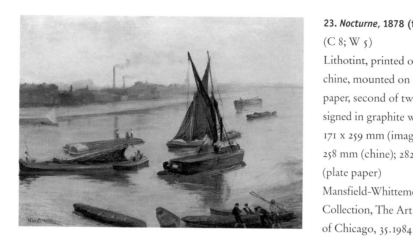

23. *Nocturne*, 1878 (fig. 18)
(C 8; W 5)
Lithotint, printed on blue laid
chine, mounted on ivory plate
paper, second of two states;
signed in graphite with butterfly
171 x 259 mm (image); 172 x
258 mm (chine); 282 x 392 mm
(plate paper)
Mansfield-Whittemore-Crown
Collection, The Art Institute
of Chicago, 35.1984

24. *Early Morning*, 1878 (fig. 24)
(C 9; W 7)
Lithotint, printed on cream
wove proofing paper, first
of four states
165 x 259 mm (image);
256 x 379 mm (sheet)
Mansfield-Whittemore-Crown
Collection, The Art Institute
of Chicago, 37.1984

FIGURE 30
*Gray and Silver: Old
Battersea Reach*, 1863
(cat. no. 32).

FIGURE 31
Battersea: Dawn,
c. 1875 (cat. no. 38).

FIGURE 32
Sketch for a Nocturne,
1872/75 (cat. no. 36).

21. *Limehouse*, 1878 (fig. 21)
(C 7; W 4)
Lithotint, printed on cream
chine, mounted on ivory plate
paper, second of three states;
signed in graphite *Whistler*
172 x 264 mm (image); 192 x
280 mm (chine); 348 x 482 mm
(plate paper)
Mansfield-Whittemore-Crown
Collection, The Art Institute
of Chicago, 33.1984

22. *Nocturne*, 1878
(C 8; W 5)
Lithotint, printed on off-white
wove plate paper, first of
two states; signed in graphite
with butterfly
173 x 265 mm (image);
192 x 277 mm (sheet)
The Art Institute of Chicago,
Clarence Buckingham
Collection, 1938.1908

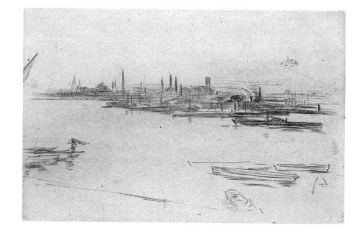

25. *Early Morning* and *The Toilet*, 1878 (fig. 35)
(C 9; W 7/C 10; W 6)
Two lithotints printed on a single
sheet of grayish ivory wove
proofing paper, first of four
states (C 9), first of five states
(C 10)
165 x 259 mm (image [C 9]);
260 x 164 mm (image [C 10]);
323 x 471 mm (sheet)
British Museum, London,
1904.3.11.2 and 1904.3.11.3

26. *The Broad Bridge*, 1878 (fig. 36)
(C 11; W 8)
Lithotint, printed on tan laid
paper, only state
187 x 281 mm (image);
195 x 291 mm (sheet)
Mansfield-Whittemore-Crown
Collection, The Art Institute
of Chicago, 139.1997

27. *The Tall Bridge*, 1878 (fig. 27)
(C 12; W 9)
Lithotint, printed on cream
wove proofing paper, first
of two states
278 x 191 mm (image);
379 x 255 mm (sheet)
Mansfield-Whittemore-Crown
Collection, The Art Institute
of Chicago, 140.1997

28. *Old Battersea Bridge*, 1879 and 1887
(C 18; W 12)
Lithograph, printed on cream
chine, mounted on off-white
plate paper, second of two states;
signed in graphite with butterfly
144 x 332 mm (image); 208 x
344 mm (chine); 380 x 503 mm
(plate paper)
Mansfield-Whittemore-Crown
Collection, The Art Institute
of Chicago, 43.1984

29. *Black Lion Wharf*, 1859 (fig. 19)
(K 42)
Etching, printed on ivory laid
paper, third of three states; signed
in graphite with butterfly
149 x 226 mm (plate); 175 x
252 mm (sheet)
The Art Institute of Chicago,
Bryan Lathrop Collection,
1917.528

30. *Brown and Silver: Old Battersea Bridge*, 1859/65 (fig. 22)
(YMSM 33)
Oil on canvas
63.5 x 76.2 cm
Addison Gallery of American
Art, Phillips Academy,
Andover, Massachusetts
(Gift of Cornelius N. Bliss),
1928.55

FIGURE 33
Battersea Bridge,
c. 1871 (cat. no. 34).

FIGURE 34
*Nocturne: Blue and
Gold—Southampton
Water,* 1872 (cat. no. 35).

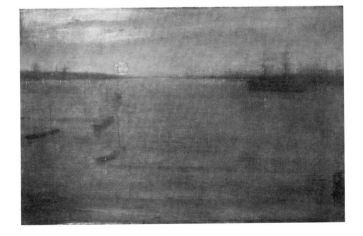

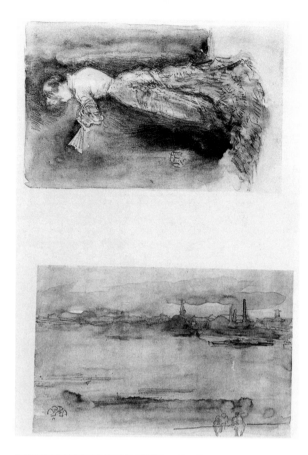

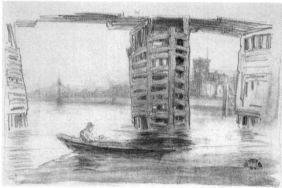

FIGURE 35
Early Morning
and *The Toilet*, 1878
(cat. no. 25).

FIGURE 36
The Broad Bridge,
1878 (cat. no. 26).

31. *Early Morning, Battersea*, 1861
(K 75)
Etching, printed on ivory laid
paper, only state; signed in
graphite with butterfly
113 x 151 mm (plate);
138 x 171 mm (sheet)
The Art Institute of Chicago,
Bryan Lathrop Collection,
1917.537

**32. *Gray and Silver: Old Battersea
Reach*, 1863 (fig. 30)**
(YMSM 46)
Oil on canvas
50.9 x 68.6 cm
The Art Institute of Chicago,
Potter Palmer Collection,
1922.449

**33. *Chelsea Wharf: Gray and Silver*,
1864/68 (fig. 23)**
(YMSM 54)
Oil on canvas
61 x 46.1 cm
National Gallery of Art,
Washington, D.C., Widener
Collection, 1942.9.99
Chicago only

**34. *Battersea Bridge*, c. 1871
(fig. 33)**
(M 483)
Charcoal, with touches of white
chalk and gray wash, on brown
wove paper (pieced)
267 x 355 mm
Albright-Knox Art Gallery,
Buffalo, New York, Gift of
George F. Goodyear, 1958, 58:1.3

**35. *Nocturne: Blue and Gold—
Southampton Water*, 1872**
(fig. 34)
(YMSM 117)
Oil on canvas
50.5 x 76 cm
The Art Institute of Chicago,
Charles Stickney Fund, 1900.52

36. *Sketch for a Nocturne*, 1872/75
(fig. 32)
(M 474r)
Black chalk, heightened
with white chalk, on brown
wove paper
145 x 263 mm
Munson-Williams-Proctor
Institute Museum of Art, Utica,
New York, 69.93

**37. *Nocturne: Blue and Silver—
Battersea Reach*, 1872/78**
(fig. 25)
(YMSM 152)
Oil on canvas
39.4 x 62.9 cm
Isabella Stewart Gardner
Museum, Boston, P1E1
Chicago only

38. *Battersea: Dawn*, c. 1875
(fig. 31)
(K 155)
Etching, printed on cream
laid paper, first of four states
148 x 222 mm (plate);
202 x 322 mm (sheet)
The Art Institute of Chicago,
Clarence Buckingham
Collection, 1938.1858

39. *Battersea*, c. 1876/78 (fig. 26)

(M 588)

Watercolor on off-white wove paper

80 x 122 mm

British Museum, London, 1920.7.28.2

40. *The Tall Bridge*, 1878 (fig. 28)

(M 701)

Black chalk, heightened with touches of white chalk, on brown wove paper

277 x 176 mm

Private collection

41. *Old Battersea Bridge*, 1879 (fig. 39)

(K 177)

Etching, printed in brown ink on cream Japanese paper, second of five states; signed in graphite with butterfly on tab

202 x 296 mm (trimmed to plate mark)

The Art Institute of Chicago, Clarence Buckingham Collection, 1938.1859

42. *Under Old Battersea Bridge*, 1879 (fig. 37)

(K 176)

Etching and drypoint, printed on off-white laid paper, third of three states

209 x 134 mm (plate)

Hunterian Art Gallery, University of Glasgow, 46792

43. *Nocturne*, 1879/80 (fig. 29)

(K 184)

Etching, printed on ivory laid paper, fifth of five states; signed in graphite with butterfly on tab

202 x 291 mm (trimmed to plate mark)

The Art Institute of Chicago, Bryan Lathrop Collection, 1934.562

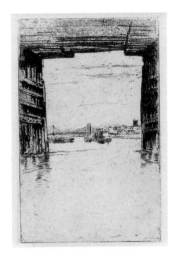

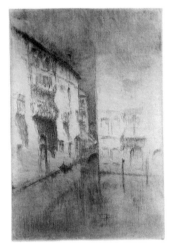

FIGURE 37
Under Old Battersea Bridge, 1879 (cat. no. 42).

FIGURE 38
Nocturne: Palaces, 1879/80 (cat. no. 44).

FIGURE 39
Old Battersea Bridge, 1879 (cat. no. 41).

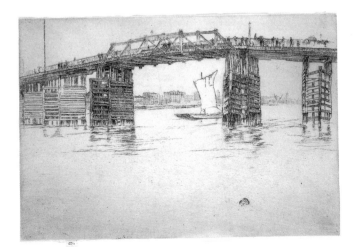

44. *Nocturne: Palaces*, 1879/80 (fig. 38)

(K 202)

Etching, printed on ivory laid paper, eighth of nine states

295 x 201 mm (trimmed to plate mark)

The Art Institute of Chicago, Bryan Lathrop Collection, 1934.593

JAMES McNEILL WHISTLER AND THE ART OF LITHOGRAPHY

"Chelsea [was] practically owned by James McNeill Whistler.
There were his little shops, his rag shops, his green-grocer shops,
and his sweet shops; in fact, so nearly was it all his, that
after a time he sternly forbade other painters to work there at all."

MORTIMER MENPES, 1902

Whistler spent over forty years of his life in London, which (despite being frequently at odds with the British art establishment) he considered "the only city of the world fit to live" in.[11] He passed a great deal of time wandering the streets of London's distinctive neighborhoods, either alone or in the company of fellow artists, always carrying a pencil, brush, etching needle, or lithographic crayon at the ready. Whistler's interest in street scenes was long-standing, fostered by the works of past artists whom he admired, as well as by his own compulsion to record the seemingly insignificant vignettes that caught his attention. He found London to be a city of many moods and milieus, and, for all intents and purposes, he invented a set of representational strategies for depicting its varied aspects. Tradition held that street scenes were either essentially portraits of the human types that populated the city (as in the work of the eighteenth-century graphic artists William Hogarth and George Cruikshank) or topographical studies (seen in portfolios such as those by seventeenth-century printmaker Wenceslaus Hollar and, in the nineteenth century, lithographers like William Shotter Boys). Whistler aimed at neither of these goals, but in some sense he achieved both. He combined documentary and interpretive impulses, infusing the established conventions of genre painting and printmaking with the new perspectives offered by Aestheticism and photography.

Whistler arrived in Paris in 1855, an aspiring young artist open to the influence of Realism, with its goal of revealing inequitable social conditions and the often sordid details of everyday life among the poor. He took this vision to London in 1859, perhaps bearing in

mind Charles Meryon's recent etchings of Paris and Gustave Doré's depictions of London slums. Seeking out the working-class, slightly disreputable East End, Whistler undertook to document this part of the city before it was destroyed in the course of constructing the Thames Embankment (see figs. 19–20).

As Whistler encountered other artists and new places, his adherence to Realism loosened. In Venice from 1879 to 1880, he responded to the exotic, atmospheric locale, devising new ways of depicting urban scenes and becoming interested in compositions based on shapes and the effect of light and water upon them. When Whistler returned to London in the autumn of 1880, he took a new look at his favorite city, perceiving formal patterns rather than hierarchies of class. The streets of London were the raw material for his experiments in testing the possibilities of different media: two etchings of Maunder's Fish Shop in Chelsea (figs. 42 and 55) vary greatly from one another, and from a lithograph of the same shop (fig. 49). Whistler's almost instinctive sensitivity to the idiosyncratic qualities of each medium is especially striking since, for the shopfronts, he almost always adopted the same frontal viewpoint and horizontal format. The goods sold inside the shops were of little interest to him— the establishments of butchers (see fig. 57) and

fishmongers were as appealing as sweetshops and fruit stalls. He was attracted to the facades as patterns, their flat surfaces animated by textured materials, reflective windows, and mysterious interiors.

Figures also play a role in the shopfront compositions—fleetingly suggested with only a few lines, their features blurred by movement, shadow, or the more insistent edges of the architectural backdrop. The effect is not unlike that deliberately achieved by the Impressionists or inadvertently by photographers, in that an attempt has been made to capture an instant. For Whistler this was only part of the challenge. He wanted to observe a motif such

FIGURE 41
Street in Chelsea,
1880/87
(cat. no. 57).

FIGURE 42
The Fish Shop,
Busy Chelsea, 1884/86
(cat. no. 62).

OPPOSITE PAGE
FIGURE 40
Chelsea Rags, 1888
(cat. no. 50).

as a shopfront in numerous subtle variations, portraying the transitory aspects of changing light and passing figures as well as the permanence of its structure and materials. In this effort his own choice of materials was crucial.

In small oil paintings and in watercolors, Whistler made use of the entire panel or sheet, creating adjacent rather than overlapping patches or puddles of color, so that the overall effect—as in *Street in Chelsea* (fig. 41)—is balanced and geometric, the shapes of the windows and doors duplicating the rectangular form of the wood panel on which it is painted.

Whistler composed his etchings slightly differently, often using the negative space of the blank paper as a pictorial element. The

intimacy of Whistler's etchings of London street scenes is partly an effect of their small size—he made them on small copper plates (four to seven inches long) that he could easily carry about in his pocket. The etchings require extremely close scrutiny on the part of the viewer, because representational conventions such as linear perspective, which serve to establish convincing and logical recession into space, are either disrupted or entirely absent. Small hatching lines are used throughout, both for areas of shadows and for figures and details, transforming texture into pure pattern. Although Whistler did not entirely reject traditional chiaroscuro for some elements (he juxtaposed dark interiors against sun-bleached facades and awnings), he treated other areas more arbitrarily. In *The Fish Shop, Busy Chelsea* (fig. 42), for example, selected patches of brickwork are carefully defined while other expanses of wall remain blank. Light-colored figures drawn with fine lines stand beside dark figures surrounded by white space—though logically inconsistent, the composition is nonetheless spatially coherent. As a final touch, Whistler's butterfly signature

FIGURE 43

Study of Rags in a Shop Window, 1887/95 (cat. no. 63).

FIGURE 44

A Chelsea Street, 1883/86 (cat. no. 58).

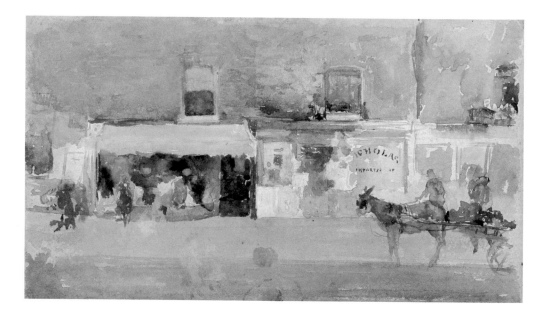

adorns the upper left portion of the composition, fluttering between two windows, its wings delineated with the same hatched lines that represent scattered bricks and shadows.

Whistler's etched scenes of London shopfronts are full of energetic, bustling movement, an animation resulting both from the quality of line and the narrative content. *The Fish Shop, Busy Chelsea* is busy in two senses of the word—full of activity and full of detail. The darkened interior of the fish shop itself is not only a focus of human activity; it is also the fulcrum of a carefully balanced composition, in which figures are illuminated either by the light within or the sun without to create a lively pattern of positive and negative space.

Lithographs of shopfronts (see fig. 40) combine the linearity of etchings or pen-and-ink drawings (see fig. 43) with the patchwork of paintings (see fig. 44). After an eight-year hiatus from lithography, Whistler returned to the medium in 1887, and it was London street scenes that he chose to depict. In these lithographs of the late 1880s and early 1890s, he applied the lessons he had learned from working in other media in London, Paris, and Venice.

Lithographic drawings on transfer paper could represent a first visual response to a scene, selective and animated (see fig. 45). As T. R. Way recalled, the artist "found he could quite conveniently take a little packet of transfer paper about with him, and draw on the spot from nature, just as he was in the habit of making his drawings upon the copperplate."[12]

These lithographs are among Whistler's most experimental and radically cropped compositions. *Chelsea Shops* (fig. 46), for example, displays something of the minimalism of his paintings of similar scenes while retaining a level of detail typically found in his etchings.

FIGURE 45

Gaiety Stage Door,
1879 and 1887
(cat. no. 45).

FIGURE 46

Chelsea Shops, 1888
(cat. no. 47).

FIGURE 47

St. Anne's, Soho, 1896 (cat. no. 54).

FIGURE 48

St. Anne's, Soho, c. 1890. Royal Commission on Historical Monuments (England)/Crown Copyright.

Interestingly, he did not aim for symmetry and balance in the lithograph, choosing to elaborate the ground floor much more carefully than the upper storey, and placing the most complex facade elements not in the center but on the right.

In many ways Whistler's lithographs of London street scenes seem to reject the descriptive tenets of topographical printmaking and also of documentary photography. Yet the preservationist element in Whistler's practice should not be ignored. His attention was caught by small details of crumbling architecture or of daily routine that might easily be overlooked and not missed until they had disappeared. In the lithograph *Churchyard* (fig. 51) and a closely related sketch (fig. 52), he juxtaposed the old, listing headstones in front of St. Bartholomew's Church with the doorways and windows of the seventeenth-century buildings.

Although there is little evidence that Whistler used documentary photographs as literal models for his lithographs, he was attuned to their expressive capacities, which often resulted from heightened contrasts between light and dark and from exaggerated perspectival recession. A photograph, commissioned by the Society for the Protection of Old London, of the Church of St. Anne in Soho (fig. 48) and Whistler's roughly contemporary lithograph of the same subject (fig. 47) both feature an expanse of unmodulated white sky, traced over with patterns of leafless tree branches; in each image the church is seen from an angle that gives a sense of the edifice's bulky mass and unusual tower. Yet Whistler disposed his seated figures directly in front of the church so as to leave the courtyard in front of it entirely empty save for his butterfly signature. Figures, trees, and tower are compressed into a single picture plane in the middle ground, a strategy that empha-

sizes the organic, layered nature of these old structures and the growth of historic neighborhoods over time.

Whistler's instinct was also preservationist in the sense that he sought to capture the essence of his own perceptual activity. As records of an individual's view of London—sometimes elusively fragmentary, sometimes elaborately detailed—these images tell us much about the late nineteenth-century experience of the city. They convey a certain sense of nostalgia for the slightly ramshackle architecture of an earlier era and for the professions that were disappearing with the progress of industrialization. Nonetheless, Whistler's methods of depiction were modern. The artist's evident interest in showing the contrast between inside and outside was tied to the more ambitious aim of grappling with the representation of time, understood both as a series of moments and as a duration.

Indeed Whistler provided a new way of seeing the city, and he was imitated by the artists whom he referred to as his "followers," among them Mortimer Menpes, Theodore Roussel, and Walter Sickert. Menpes even declared: "Nowhere in England could you find better material for pictures than in Chelsea [see figs. 46 and 50], . . . [which was] practically owned by James McNeill Whistler. There were his little shops, his rag shops, his green-grocer shops, and his sweet shops; in fact, so nearly was it all his, that after a time he sternly forbade other painters to work there at all."[13] (BS)

FIGURE 49

Maunder's Fish Shop, Chelsea, 1890 (cat. no. 52).

FIGURE 50

Chelsea Shop, 1897/1900 (cat. no. 64).

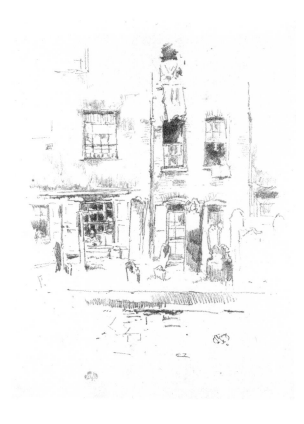

FIGURE 51
Churchyard, 1887
(cat. no. 46).

FIGURE 52
St. Bartholomew's,
1887 (cat. no. 61).

**45. *Gaiety Stage Door*, 1879 and
1887 (fig. 45)**
(C 14; W 10)
Transfer lithograph, printed
on cream chine, mounted on
off-white plate paper, only
state; signed in graphite with
butterfly
123 x 195 mm (image); 182 x
226 mm (chine); 374 x 478 mm
(plate paper)
Mansfield-Whittemore-Crown
Collection, The Art Institute
of Chicago, 40.1984

46. *Churchyard*, 1887 (fig. 51)
(C 21; W 17)
Transfer lithograph, printed on
cream laid paper, only state;
signed in graphite with butterfly
210 x 173 mm (image);
309 x 200 mm (sheet)
The Art Institute of Chicago,
Bryan Lathrop Collection,
1917.550

47. *Chelsea Shops*, 1888 (fig. 46)
(C 24; W 20)
Transfer lithograph, printed
on ivory laid paper, second of
two states; signed in graphite
with butterfly
95 x 195 mm (image);
203 x 310 mm (sheet)
The Art Institute of Chicago,
Bryan Lathrop Collection,
1917.553

48. *Drury Lane Rags*, 1888
(C 25; W 21)
Transfer lithograph, printed
on ivory laid paper, only state
147 x 160 mm (image);
323 x 207 mm (sheet)
The Art Institute of Chicago,
Bryan Lathrop Collection,
1917.554

**49. *Drury Lane Rags*, 1888
(fig. 56)**
(C 25; W. 21)
Transfer lithograph, printed
on cream laid paper, mounted
on off-white plate paper, only
state; signed in graphite with
butterfly, and hand colored
with blue, yellow, bright yellow-
green, orange, light brown,
and gray pencils
147 x 160 mm (image); 308 x
205 mm (sheet); 387 x 261 mm
(plate paper)
National Gallery of Art,
Washington, D.C., Rosenwald
Collection, 1943.3.8681

54. *St. Anne's, Soho*, **1896 (fig. 47)**
(C 162; W 126)
Transfer lithograph, printed
on ivory laid paper, only state;
signed in graphite with butterfly
192 x 134 mm (image);
302 x 189 mm (sheet)
Mansfield-Whittemore-Crown
Collection, The Art Institute
of Chicago, 135.1984

50. *Chelsea Rags*, **1888 (fig. 40)**
(C 26; W 22)
Transfer lithograph, printed on
tan laid paper, only state; signed
in graphite with butterfly
180 x 159 mm (image);
310 x 238 mm (sheet)
The Art Institute of Chicago,
Bryan Lathrop Collection,
1917.555

51. *The Tyresmith*, **1890**
(C 36; W 27)
Transfer lithograph, printed
on cream laid paper, only state
170 x 175 mm (image);
307 x 206 mm (sheet)
Mansfield-Whittemore-Crown
Collection, The Art Institute
of Chicago, 59.1984

52. *Maunder's Fish Shop, Chelsea*,
1890 (fig. 49)
(C 37; W 28)
Transfer lithograph, printed
on cream laid paper, second of
two states; signed in graphite
with butterfly
190 x 170 mm (image); 329 x
233 mm (sheet)
Mansfield-Whittemore-Crown
Collection, The Art Institute
of Chicago, 60.1984

53. *Gatti's*, **1890 (fig. 54)**
(C 38; W 34)
Transfer lithograph, printed
on ivory laid paper, only state;
signed in graphite with
butterfly
173 x 133 mm (image);
367 x 240 mm (sheet)
The Art Institute of Chicago,
Bryan Lathrop Collection,
1917.564

FIGURE 53

Beefsteak Club, c. 1887
(cat. no. 60).

FIGURE 54

Gatti's, 1890
(cat. no. 53).

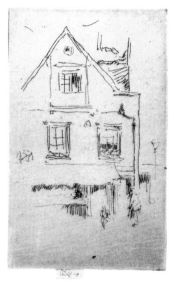

**55. *The Butcher's Dog*, 1896
(fig. 57)**
(C 166; W 128)
Transfer lithograph, printed
on ivory laid paper, fourth
of four states; signed in graphite
with butterfly
183 x 131 mm (image);
298 x 211 mm (sheet)
The Art Institute of Chicago,
Bryan Lathrop Collection,
1917.653

56. *St. Giles-in-the-Fields*, 1896
(C 167; W 129)
Transfer lithograph, printed on
cream laid paper, only state;
signed in graphite with butterfly
217 x 142 mm (image);
278 x 193 mm (sheet)
The Art Institute of Chicago,
Bryan Lathrop Collection,
1917.654

FIGURE 55
Little Maunder's,
1886/87 (cat. no. 59).

FIGURE 56
Drury Lane Rags, 1888
(cat. no. 49).

**57. *Street in Chelsea*, 1880/87
(fig. 41)**
(YMSM 290)
Oil on panel
13.3 x 23.5 cm
Stanford University Museum
of Art, Committee for Art
Acquisitions Fund, 1976.271

**58. *A Chelsea Street*, 1883/86
(fig. 44)**
(M 953)
Watercolor, with touches of
gouache, over traces of graphite,
on white wove paper
126 x 217 mm
Yale Center for British Art,
New Haven, Conn., Paul
Mellon Collection, B1993.30.125
Chicago only

**59. *Little Maunder's*, 1886/87
(fig. 55)**
(K 279)
Etching, printed on blued laid
paper, only state; signed in
graphite with butterfly on tab
83 x 51 mm (trimmed to
plate mark)
National Gallery of Art,
Washington, D.C., Rosenwald
Collection, 1949.5.273

60. *Beefsteak Club*, c. 1887
(fig. 53)
(M 1158)
Pen and brown ink on tan laid
paper
97 x 150 mm
Hunterian Art Gallery,
University of Glasgow, 46127

61. *St. Bartholomew's*, 1887
(fig. 52)
(M 1144)
Graphite on cream wove paper,
page 57 from sketchbook
75 x 119 mm
Hunterian Art Gallery,
University of Glasgow, Birnie
Philip Bequest, 46116

62. *The Fish Shop, Busy Chelsea*,
1884/86 (fig. 42)
(K 264)
Etching, printed on ivory laid
paper, first of two states; signed
in graphite with butterfly
on tab
141 x 216 mm (trimmed to plate
mark)
The Art Institute of Chicago,
Clarence Buckingham
Collection, 1938.1883

63. *Study of Rags in a Shop
Window*, **1887/95 (fig. 43)**
(M 1586)
Pen and black ink, over traces of
graphite, on cream wove paper
225 x 298 mm
Stanford University Museum
of Art, Committee for Art
Acquisitions Fund, 1975.1

FIGURE 57
The Butcher's Dog,
1896 (cat. no. 55).

64. *Chelsea Shop*, **1897/1900**
(fig. 50)
(M 1510)
Watercolor on cream
wove paper
126 x 212 mm
The Art Institute of Chicago,
Walter S. Brewster Collection,
1933.210

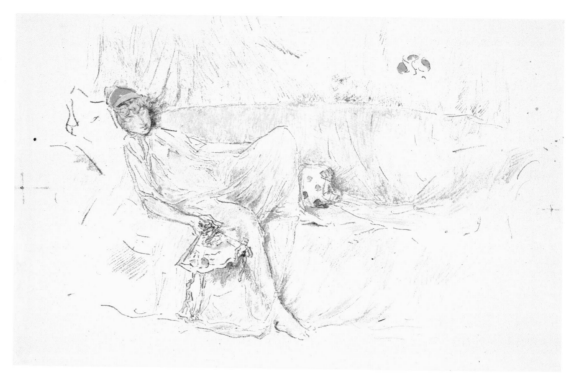

FIGURE 58

Draped Figure, Reclining, 1892 (cat. no. 80).

"Almost any position a model took seemed to him a picture. . . .

He allowed the sitter to do what she liked, more or less, and arrested her whenever her pose formed a picture.

He was generous to his sitters, and made them feel that they were doing half the work."

MORTIMER MENPES, 1904

Whistler found transfer lithography ideal for the spontaneous vignettes he wished to capture as he prowled the streets of London and Paris in search of humble shopfronts, picturesque alleyways, or sun-dappled public gardens. As a result, a large portion of his lithographic oeuvre is made up of such *plein-air* subjects. Yet Whistler also found his crayons and transfer paper to be extraordinarily useful tools in a more circumscribed setting: his studio. As an artist who earned a significant portion of his income by filling portrait commissions, it was necessary throughout most of his career for Whistler to maintain an elegant studio where his sitters could pose for their portraits (see fig. 59). It was also in the studio that Whistler explored, decade after decade, his obsession with the theme of the female form clad in diaphanous drapery. During the 1890s, working in studios

in London and Paris, he used lithography to distill as never before the elusive concepts of grace, transparency, and movement.

A perfectionist in all things, Whistler was notoriously demanding of his sitters and models. A full oil portrait might require months of long, arduous sittings in a drafty studio. One can well imagine why, after countless grueling sessions with Whistler, young Cicely Alexander has a rather bad-tempered pout in her finished portrait of 1872/73 (Tate Gallery, London). Etchings and drawings of Joanna Hiffernan and lithographs of Maud Franklin (see figs. 7–10, and 14) show both women collapsed with sheer exhaustion at the end of modeling sessions with Whistler. The professional models who posed for the artist were required to have more than just strength and endurance among their qualifications, however. A certain amount of athleticism, grace, and acting ability was also necessary, as a model might be told to dance around the studio until Whistler found the pose he wished her to hold indefinitely. Or she might be asked to pose as a young mother with a baby on her lap, or musing into a teacup (see fig. 87), or bending to arrange a vase of flowers (see figs. 60 and 88–89). Whistler's models usually wore garments he kept in his studio; these might be transparent classical gowns with high waists and crossed bodices (see figs. 61–62 and 90–91) or boldly patterned Japanese robes. He generally wanted their hair tied up in brightly colored kerchiefs, a device that can make it difficult to distinguish the various young women who posed for him. Whistler tended to be inspired by certain favorite models, particularly those whose vivacious temperaments matched his own. In addition to those who became his

mistresses, like Jo and Maud, there were the beautiful and witty Pettigrew sisters in London and the young Neapolitan Carmen Rossi, who posed for him in Paris. Conversely, a poor model sometimes resulted in awkward, unsatisfactory drawing on the artist's part.

Whistler's images of studio models tend to be the most closely related of all his lithographs to his studies in other media, particularly to his work in colored media such as oil,

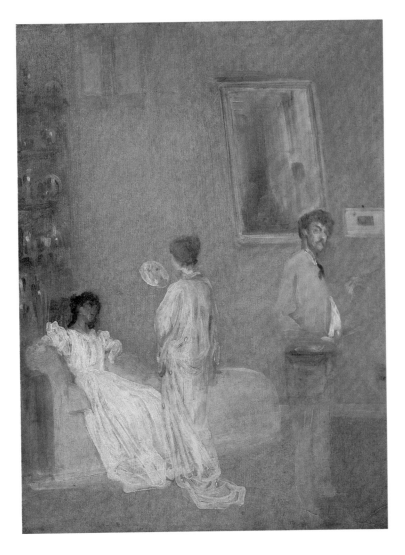

FIGURE 59

The Artist in His Studio, 1865/66 (cat. no. 89).

pastel, and watercolor. In the studio, it was fairly easy for him to shift from one medium to another when working with a particular model or when exploring a given theme. In some cases an image sketched spontaneously in lithography was elaborated later in a colored version. This appears to have been the case with Whistler's first lithograph of a model in classical drapery, *Study* (fig. 61) of 1879, and a pastel entitled *The Greek Slave (Variations in Violet and Rose)* (fig. 62), probably drawn in 1885/86. Since the pastel is nearly identical in size to the print but reversed in orientation, it seems likely that Whistler traced the lithograph and then transferred the tracing to the brown paper he habitually used for his pastels before developing the image in color. In fact it is possible that he had pastel in mind when he first created the lithograph; he may have elected to draw the image on a rectangular area of half-tint, usually reserved for use with lithographic washes, in order to

approximate the effect of the dark pastel paper. Later, in the few experiments he made using color lithography in the early 1890s, the artist seems to have attempted to imitate the soft, delicate effects he achieved in pastel. For example, in *Draped Figure, Reclining* (fig. 58) of 1892, he selectively wiped his color stones with touches of the subtle inks he mixed himself. The result approximates his use of pastel, which he also applied in small localized areas to highlight a composition established primarily in black. In addition, Whistler employed a pastel-like technique in several of the lithographs he realized in black and white, most notably in two fully finished studies of unclothed models, *The Little Nude Model, Reading* and *Nude Model, Reclining* (figs. 85 and 63). In these works, the artist suggested the weight and three-dimensional presence of the model's body, much as he did when creating a pastel like *Nude Reclining* (fig. 64).

Despite a few compelling examples of direct relationships between lithographs and pastels, it is relatively rare among Whistler's studio images to find identical compositions repeated from one medium to another. More often, the artist seems to have moved among media as he explored a particular type of action or pose, experimenting to see which of his materials would yield the most satisfactory results. Lithography figured importantly in his intensive study of dancers during the late 1880s and early 1890s, and it is in the lithographs that he often achieved his most essential expression of this subject: gentle touches of the crayon suggest, almost magically, the fleeting interaction of light, movement, and gauzy drapery. The lithographs *The Dancing Girl* and *Model Draping* (figs. 65–66) explore the graceful movements of a lithe young model dressed in a transparent studio gown. Whistler worked with the same theme in the finished watercolor entitled *Green and Blue:*

FIGURE 60

The Lily, 1870/72 (cat. no. 90).

FIGURE 61

Study, 1879 (cat. no. 65).

FIGURE 62

The Greek Slave (Variations in Violet and Rose), 1885/86 (cat. no. 92).

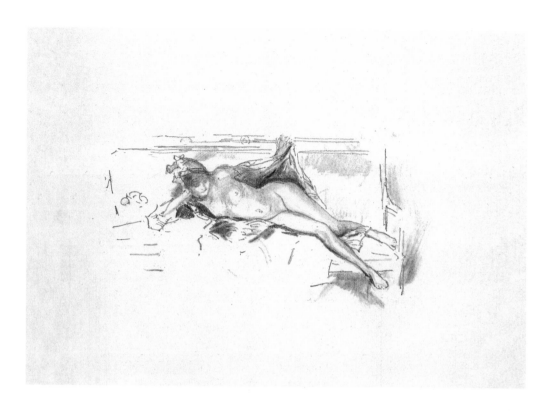

FIGURE 63

Nude Model, Reclining,
1893 (cat. no. 83).

FIGURE 64

Nude Reclining,
1893/1900 (cat. no. 109).

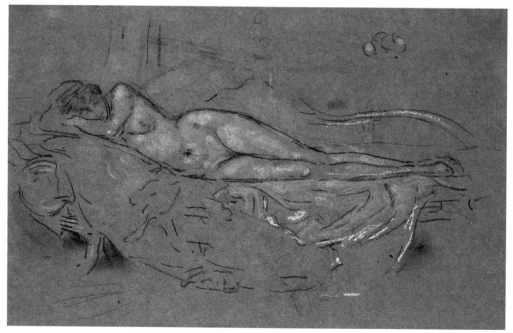

The Dancer (fig. 67), where the thin washes are rendered almost opaque by the dark brown paper on which the image was painted. Delicate and beautiful in effect, this watercolor nevertheless appears more stately and less ethereal than the lithographs, where the white of the paper support is critical in establishing the incredible lightness of the gown's fabric and of the atmosphere as a whole. The presence of color alone is enough to distinctly alter the tenor of a subject. In another watercolor of the late 1880s, *Dancing Girl* (fig. 68), the deep russet tones used to render the model's voluptuous body, as well as her gown and the background, create a darkly sensuous image, emphatically different from the evanescent lithograph of the same title, despite their similar compositions.

Whistler never ceased to be preoccupied with the theme of the dancing girl; he returned to it around 1900, several years after he had given up lithography, for a series of drawings made in pen and brown ink.[14] In *The Dancer (No. 1)* (fig. 93) he has once again put the white sheet of paper to work for him in suggesting the filmy transparency of the model's drapery, yet here he used a complex network of crosshatched lines to build the relative values of shadows and highlights. In lithography it had been possible to use far fewer lines, since Whistler could suggest changes in value simply by adjusting the pressure of his crayon on the transfer paper, as we see particularly clearly in a lithograph like *The Dancing Girl* (fig. 65).

Closely linked to Whistler's many studies of dancing girls are the even more numerous images of stationary models posing in transparent fabric, sometimes in the act of draping or undraping themselves. In addition to such lithographs as *Model Draping* or *Study* (figs. 66

FIGURE 65

The Dancing Girl, 1889 (cat. no. 66).

FIGURE 66

Model Draping, probably 1889 (cat. no. 68).

FIGURE 67

Green and Blue:
The Dancer, c. 1893
(cat. no. 108).

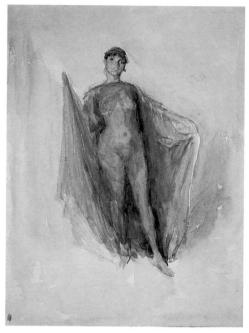

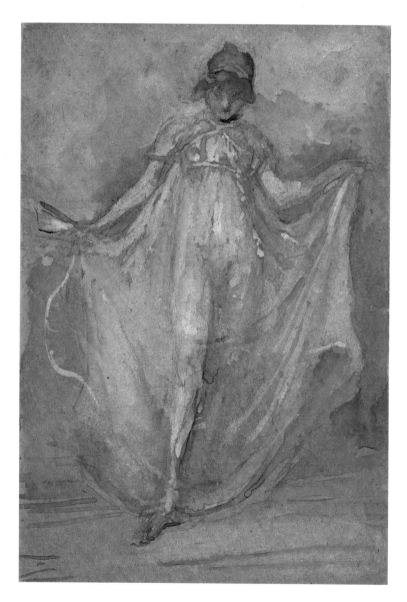

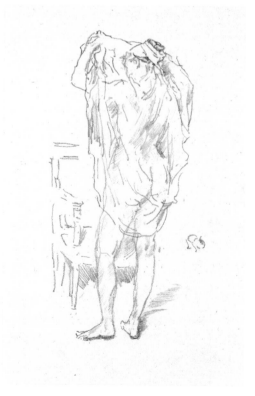

and 69), he treated the theme in two lithographic drawings (figs. 94–95) that were never transferred and printed, but which he later reinforced in pen and black ink. The addition of ink gave the figures firm contours quite different from the soft, suggestive lines of Whistler's lithographic crayon. His oil *La Sylphide* (fig. 70) also takes on the theme of the draped model, juxtaposing the flesh of the woman's body with the ghostly paleness of her clothing; again the effect is distinct from the apparent weightlessness of many of the lithographs, where there is little or no suggestion of background to anchor the model.

Whistler was by no means the only artist interested in this kind of subject matter. Beautiful women posed languidly in classical gowns were a staple of British Aestheticism, and achieved considerable visibility and popularity in the work of such painters as Albert Moore and Frederic Leighton. *The Draped Figure, Seated* (fig. 71), the lithograph Whistler published in the fourth volume of *L'Estampe originale* in 1893, fits squarely into this context of classical revival. By the 1890s, however, he was involved with members of the Symbolist movement in Paris and was especially influenced by the poetry of his friend Stéphane Mallarmé. Capturing the essence of such abstract, intangible qualities as movement and transparency had become more important than ever to Whistler. His repeated work with the moving, draped nude has an experimental—even scientific—quality that can be likened to the celebrated photographic work of Eadweard Muybridge. When Muybridge first published his pioneering *Animal Locomotion* in 1887, he caused a sensation with his long sequences documenting, instant by instant, the movement of animals and humans. Not surprisingly, given his interest in motion and transient effects, Whistler was one of many artists who signed on as subscribers of the publication.[15] Among

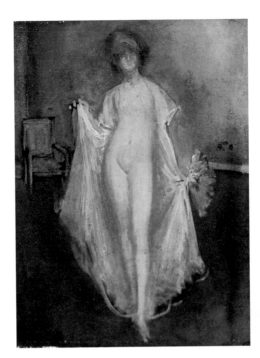

FIGURE 70

La Sylphide, 1896/1900 (cat. no. 112).

FIGURE 71

The Draped Figure, Seated, 1893 (cat. no. 82).

OPPOSITE PAGE RIGHT
FIGURE 68
Dancing Girl, 1885/90 (cat. no. 95).

FIGURE 69
Study, 1894 (cat. no. 87).

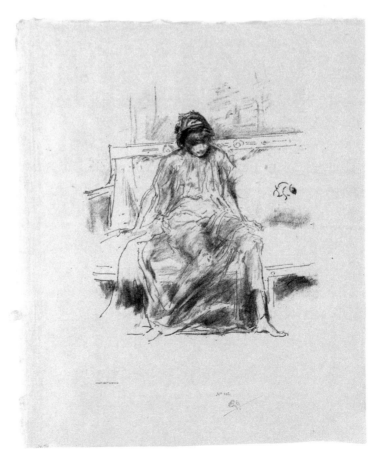

FIGURE 72

Eadweard Muybridge
(American; 1830–1904).
Animal Locomotion
(Philadelphia, 1887),
pl. 177 (detail).

FIGURE 73

Henri de Toulouse-
Lautrec (French;
1864–1901). *Miss Loïe
Fuller,* 1893. Lithograph,
printed in three colors,
with gold powder
applied to stone, on
cream wove paper;
368 x 260 mm. The Art
Institute of Chicago,
Joseph Brooks Fair
Collection (1931.451).

the numerous plates in Muybridge's work are
detailed studies of a female model dancing in
transparent drapery (see fig. 72), raising a gown
over her head, stooping with a large urn in her
arms, or bending to interact with a young child,
all themes that dominate Whistler's litho-
graphs created in the studio in the late 1880s
and early 1890s. In many of Muybridge's
sequences, there are individual frames that
find very close parallels in Whistler's litho-
graphs of the early and mid-1890s (see fig. 65).
One cannot help but wonder whether the artist
might on occasion have asked his models to
approximate the gestures and poses caught in
some of Muybridge's photographs. It seems
quite likely, in fact, that Whistler saw transfer
lithography as a near equivalent to photography
in the freedom it gave him to work quickly
and spontaneously, capturing pose after pose,
effect after effect, in simple black-and-white

terms. Working in oil, watercolor, or pen and ink, the element of time always interfered with this freedom; these media have to dry to prevent smearing, puddling, or muddying of the image, thereby necessarily lending a more studied appearance to works intended to capture the most transitory sensations. Whistler was not alone in trying to harness lithography to such a purpose. Henri de Toulouse-Lautrec, too, turned to lithography when he wanted to capture the shimmering effects of the American dancer Loïe Fuller's famous "butterfly dance" (fig. 73).

Whistler's work on the theme of the classically draped model is also related to his admiration for the ancient Greek terracotta statuettes that were beginning to make their appearance in European galleries and museums in the second half of the nineteenth century. Because a large number of these figurines were discovered at Tanagra, Greek terracottas came to be generically identified as "Tanagras." Whistler's friend Marcus Huish, who was so instrumental in helping to market the artist's lithographs at the Fine Art Society, himself began to collect these figurines around 1890, and by 1900 he was informed and passionate enough about the subject to write a book.[16] Whistler owned an album of photographs of the Tanagra collection belonging to his friend and patron Alexander Ionides, and many of his model studies from the 1890s—such as *The Little Blue Cap*, *The Rose Drapery*, and the color lithograph *Draped Figure, Standing* (figs. 74, 76, and 75)—echo the poses and simplicity of these terracotta statuettes (see fig. 77). They may even have inspired his exploration in etching, lithography, watercolor, and pastel (see figs. 78–81) of the theme of a woman and child sitting or reclining together on a sofa (see fig. 83). Whistler had always admired ancient Greece as a culture in which art enjoyed a golden age. In his "Ten

FIGURE 74

The Little Blue Cap, 1893/95 (cat. no. 111).

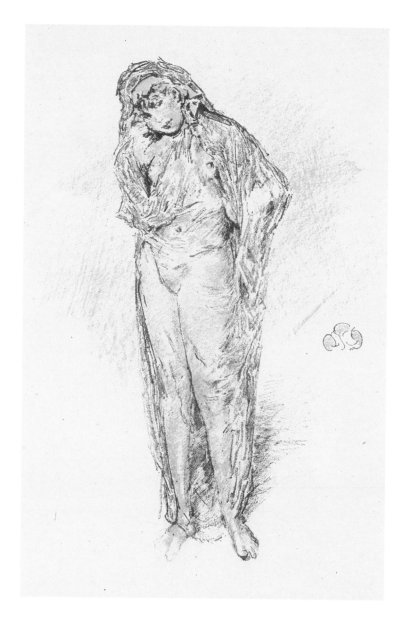

FIGURE 75

FIGURE 75

Draped Figure,
Standing, 1891
(cat. no. 73).

FIGURE 76

The Rose Drapery,
1890/1900 (cat. no. 97).

O'Clock" lecture, he had proclaimed that "the Greeks were, as a people, worshippers of the beautiful" and contrasted the "Arcadian purity" of Greek art with the "ungainly" productions of the present day.[17] The Tanagras, in their small scale, abstraction, and emphasis on the most basic rhythms of the draped female form, helped him to further his own evolving minimalism.

Most of Whistler's lithographs, created both in and out of the studio, were realized in black and white. While a vogue for color lithography raged through the Paris of the 1890s, Whistler made a modest seven experiments in the medium, although he did produce several images of a young model with a child that were very likely drawn with the idea of color in mind; they relate closely to works that were executed in pastel (see fig. 81) and watercolor (see figs. 80 and 82). It may also be that his interest in working up this particular subject

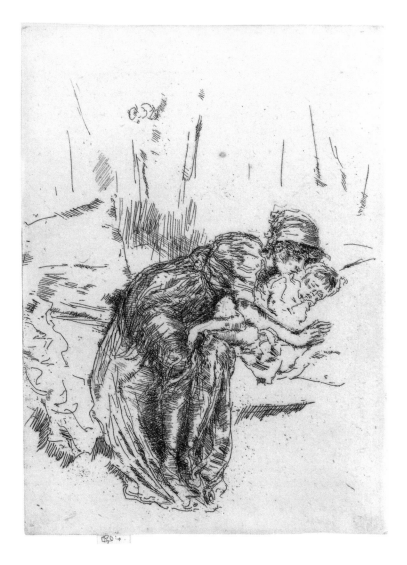

matter in color was ignited by a visit he paid to Durand-Ruel's gallery in Paris in the late summer or early fall of 1891, when Mary Cassatt's color intaglio prints of mother-and-child themes (see fig. 84) were first exhibited and offered for sale.[18] While Whistler abandoned three transfer drawings of the subject (see figs. 98–99), he did realize one transfer lithograph, *Lady and Child* (fig. 101), in color, and he returned again to the mother-and-child drawings in 1895, this time thinking them of sufficient interest to have them transferred and printed as black-and-white images (see fig. 79). In these lithographs, the young child is thought to be the little niece of the model, who is probably one of the three Pettigrew sisters, Whistler's frequent models in London. If they are the same models who appear in several related etchings (see fig. 78), then the etchings were probably executed later than 1885/88, when they have been traditionally dated by scholars.

FIGURE 77

Standing Figure, from Whistler's *Album of Photographs of Tanagra Figurines in the Ionides Collection*, p. 15. Hunterian Art Gallery, University of Glasgow.

FIGURE 78

Cameo, No. 2, c. 1890 (cat. no. 94).

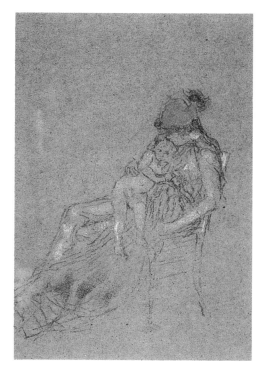

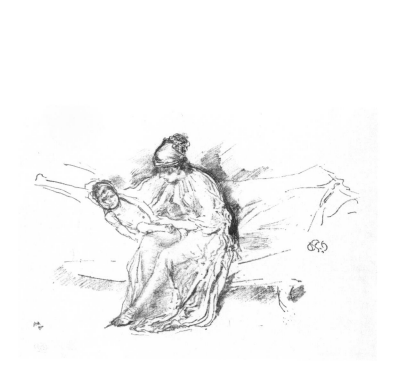

FIGURE 79

*Mother and Child,
No. 4,* 1891 and 1895
(cat. no. 78).

FIGURE 80

*Mother and Child
Reclining on a Couch,*
c. 1890 (cat. no. 99).

ABOVE RIGHT

FIGURE 81

Mother and Child,
c. 1890 (cat. no. 98).

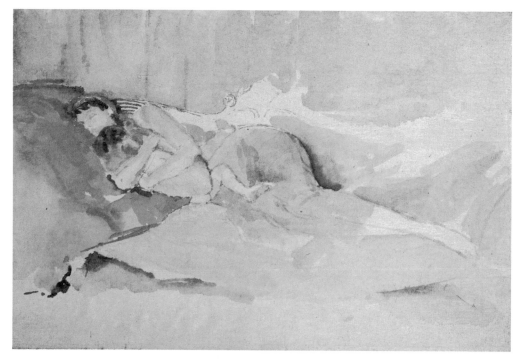

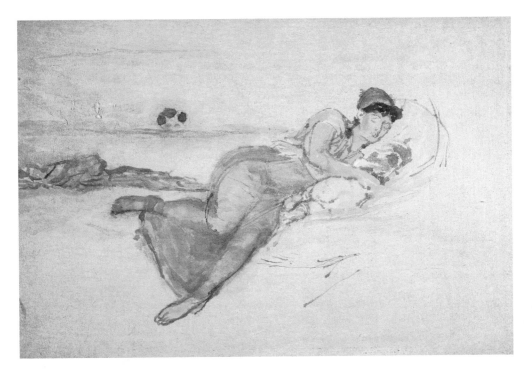

FIGURE 82

*Rose and Pink—
The Mother's Sleep*,
c. 1891 (cat. no. 101).

FIGURE 83

An Interesting Group,
from Whistler's
*Album of Photographs
of Tanagra Figurines in
the Ionides Collection*,
p. 1. Hunterian Art
Gallery, University
of Glasgow.

FIGURE 84

Mary Cassatt
(American; 1844–1926).
The Mother's Kiss,
1890–91. Etching and
aquatint, with dry-
point, printed on
cream laid paper;
220 x 335 mm (plate),
290 x 420 mm (sheet).
The Art Institute
of Chicago, Martin A.
Ryerson Collection
(1932.1286).

FIGURE 85

The Little Nude Model, Reading, 1889/90 (cat. no. 69).

FIGURE 86

Little London Model, 1896 (cat. no. 88).

Like many of Cassatt's images, Whistler's group of etchings and lithographs are not actually portraits of mothers with their children but rather professional models acting a role. The models themselves were very likely teenagers. Nevertheless, the "Mother and Child" titles given to this group of lithographs may have been intended to add to their marketability, capitalizing on the Victorian nostalgia for images of motherhood and domestic happiness.

Whistler tended to prefer teenage girls as his models, particularly in his lithographs of the 1890s, in which his Symbolist interests called for sylphlike grace and slenderness. His last lithograph drawn in the studio takes the subject of the youthful model to the extreme. Entitled *Little London Model* (fig. 86), this image portrays a girl of no more than eleven or twelve years, still slightly plump around the middle and clearly shy about posing nude. Her obvious inexperience distinguishes her from the relaxed young women who posed for earlier lithographs, such as *The Little Nude Model, Reading* and *Nude Model, Reclining* (figs. 85 and 63). There is an awkwardness to her stiff, frontal stance; by delineating her adolescent body in considerable detail, Whistler created an image at once poignant and slightly embarrassing. Drawn in the spring of 1896, when his wife, Beatrix, lay dying of cancer, this final lithograph of a studio subject shows the artist's facility for modeling with the lithographic crayon. At the same time, it represents a departure from the graceful dancers and nudes that had hitherto occupied him. With his own emotions as raw as they had ever been, he observed and captured the discomfiture of his young model with extraordinary acumen. (MT)

65. *Study*, 1879 (fig. 61)

(C 19; W 15)

Lithograph, printed on ivory
plate paper, only state

260 x 165 mm (image);

322 x 210 mm (sheet)

The Art Institute of Chicago,
Bryan Lathrop Collection,
1934.521

**66. *The Dancing Girl*, 1889
(fig. 65)**

(C 29; W 30)

Transfer lithograph, printed on
ivory laid paper, only state;
signed in graphite with butterfly

182 x 148 mm (image);

314 x 201 mm (sheet)

Mr. and Mrs. A. Steven Crown,
The Art Institute of Chicago,
192.1984

**67. *The Horoscope*,
probably 1889 (fig. 87)**

(C 30; W 32)

Transfer lithograph, printed on
cream Japanese paper, only state;
signed in graphite with butterfly

160 x 157 mm (image);

311 x 210 mm (sheet)

The Art Institute of Chicago,
Bryan Lathrop Collection,
1934.515

**68. *Model Draping*,
probably 1889 (fig. 66)**

(C 31; W 31)

Transfer lithograph, printed on
cream laid paper, only state;
signed in graphite with butterfly

196 x 112 mm (image);

332 x 206 mm (sheet)

Mr. and Mrs. A. Steven Crown,
The Art Institute of Chicago,
193.1984

**69. *The Little Nude Model, Reading*,
1889/90 (fig. 85)**

(C 33; W 29)

Transfer lithograph, printed on
ivory laid paper, only state;
signed in graphite with butterfly

167 x 179 mm (image);

320 x 205 mm (sheet)

Mansfield-Whittemore-Crown
Collection, The Art Institute
of Chicago, 61.1984

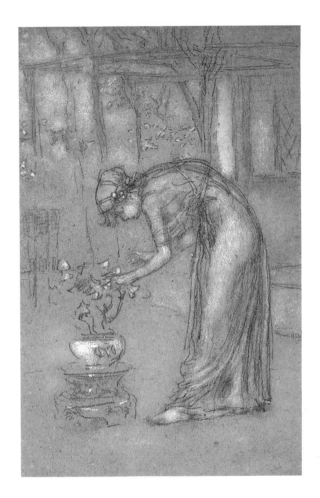

ABOVE

FIGURE 89

Spring, 1893/94
(cat. no. 110).

FAR LEFT

FIGURE 87

The Horoscope,
probably 1889
(cat. no. 67).

LEFT

FIGURE 88

*Nude Girl with
a Bowl*, c. 1892
(cat. no. 107).

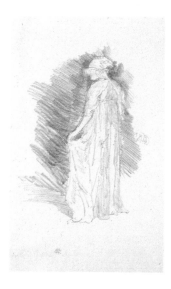

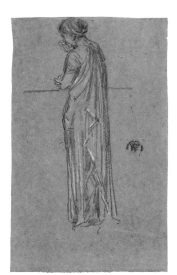

FIGURE 90

The Draped Figure,
Back View, 1893
(cat. no. 86).

FIGURE 91

Draped Model,
1870/73 (cat. no. 91).

70. *Figure Study in Colors*, 1890
(C 39; W 99)
Transfer lithograph, printed on
ivory wove paper, second of
three states
169 x 140 mm (image); 259 x
140 mm (image with registration
marks); 319 x 219 mm (sheet)
Mansfield-Whittemore-Crown
Collection, The Art Institute
of Chicago, 104.1984

71. *Figure Study in Colors*, 1890
(fig. 97)
(C 39; W 99)
Transfer lithograph, printed
in three colors on ivory wove
paper, third of three states;
signed in graphite with butterfly
204 x 150 mm (image); 259 x
140 mm (image with registration
marks); 313 x 262 mm (sheet)
Mansfield-Whittemore-Crown
Collection, The Art Institute
of Chicago, 105.1984

72. *Nude Model, Back View*, 1891
(C 45; W 165)
Transfer lithograph, printed in
nine colors on cream Japanese
gampi paper, laid down on
cream wove paper, only state
183 x 162 mm (image);
269 x 162 mm (image with
registration marks); 255 x
170 mm (sheet)
Mansfield-Whittemore-Crown
Collection, The Art Institute
of Chicago, 172.1984

73. *Draped Figure, Standing*, 1891
(fig. 75)
(C 46; W 155)
Transfer lithograph, printed
in seven colors on ivory plate
paper, fourth of four states
235 x 170 mm (image);
270 x 172 mm (image with three
pinhole registration marks);
366 x 276 mm (sheet)
Mansfield-Whittemore-Crown
Collection, The Art Institute
of Chicago, 164.1984

74. *Draped Model, Dancing,*
probably 1891
(C 50; W 161)
Transfer lithograph, printed
on grayish ivory China paper,
only state
176 x 129 mm (image);
316 x 232 mm (sheet)
Mansfield-Whittemore-Crown
Collection, The Art Institute
of Chicago, 169.1984

75. *Mother and Child, No. 1*, 1891
and 1895
(C 51; W 80)
Transfer lithograph, printed
on cream laid paper, second
of two states; signed in graphite
with butterfly
185 x 191 mm (image);
284 x 228 mm (sheet)
The Art Institute of Chicago,
Bryan Lathrop Collection,
1934.601

76. *Mother and Child, No. 3,*
1891 and 1895
(C 52; W 134)
Transfer lithograph, printed on
cream Japanese paper, only state;
signed in graphite with butterfly
145 x 214 mm (image);
222 x 288 mm (sheet)
Mansfield-Whittemore-Crown
Collection, The Art Institute
of Chicago, 143.1984

77. *Mother and Child, No. 2*, 1891
and 1895

(C 53; W 102)

Transfer lithograph, printed on
cream laid paper, only state;
signed in graphite with butterfly

170 x 204 mm (image);

212 x 330 mm (sheet)

Mansfield-Whittemore-Crown
Collection, The Art Institute
of Chicago, 109.1984

78. *Mother and Child, No. 4*, 1891
and 1895 (fig. 79)

(C 54; W 135)

Transfer lithograph, printed on
ivory Japanese paper, only state;
signed in graphite with butterfly

143 x 232 mm (image);

222 x 290 mm (sheet)

The Art Institute of Chicago,
Bryan Lathrop Collection,
1917.660

79. *Lady and Child*, 1892
(fig. 101)

(C 55; W 157)

Transfer lithograph, printed in
eight colors on cream Japanese
gampi paper, only state

160 x 257 mm (image);

222 x 272 mm (sheet)

Mansfield-Whittemore-Crown
Collection, The Art Institute
of Chicago, 166.1984

80. *Draped Figure, Reclining*, 1892
(fig. 58)

(C 56; W 156)

Transfer lithograph, printed
in nine colors on cream laid
paper, second of two states

180 x 285 mm (image);

187 x 288 mm (sheet)

Mansfield-Whittemore-Crown
Collection, The Art Institute
of Chicago, 165.1984

81. *A Nude Model Arranging
Flowers*, probably 1892
(only printed posthumously)

(C 57)

Transfer lithograph, printed
on ivory laid paper, only state

157 x 113 mm (image);

204 x 151 mm (sheet)

Mr. and Mrs. A. Steven Crown,
The Art Institute of Chicago,
283.1984

82. *The Draped Figure, Seated*,
1893 (fig. 71)

(C 72; W 46)

Transfer lithograph, printed
on tan laid Japanese vellum,
only state; signed in graphite
with butterfly

186 x 162 mm (image);

291 x 240 mm (sheet)

Mr. and Mrs. A. Steven Crown,
The Art Institute of Chicago,
207.1984

83. *Nude Model, Reclining*, 1893
(fig. 63)

(C 73; W 47)

Transfer lithograph, printed
on ivory laid paper, second
of three states; signed in graphite
with butterfly

115 x 214 mm (image);

245 x 366 mm (sheet)

Mansfield-Whittemore-Crown
Collection, The Art Institute
of Chicago, 79.1984

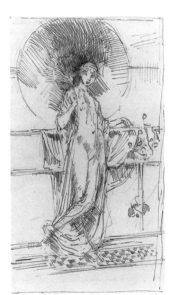

FIGURE 92

Woman with a Parasol,
1886 (cat. no. 96).

FIGURE 93

The Dancer (No. 1),
c. 1900 (cat. no. 113).

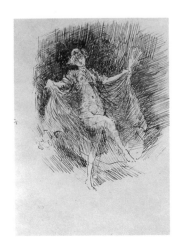

FIGURE 94

Draped Model Leaning on a Rail, 1891 (cat. no. 105).

FIGURE 95

Nude Model Pulling Drapery over Her Head, 1891 (cat. no. 104).

BELOW

FIGURE 96

The Pink Cap, 1890/94 (cat. no. 106).

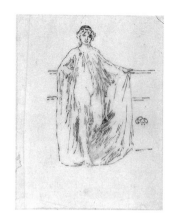

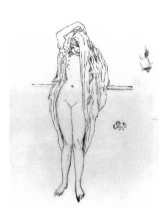

84. *Draped Model, Standing by a Sofa,* 1893 (only printed posthumously)
(C 75)
Lithograph, printed on ivory laid paper, only state
204 x 212 mm (image);
378 x 229 mm (sheet)
Mr. and Mrs. A. Steven Crown, The Art Institute of Chicago, 284.1984

85. *Little Draped Figure, Leaning,* 1893
(C 76; W 51)
Transfer lithograph, printed on cream laid Japanese vellum, only state; signed in graphite with butterfly
179 x 146 mm (image);
316 x 221 mm (sheet)
Mansfield-Whittemore-Crown Collection, The Art Institute of Chicago, 83.1984

86. *The Draped Figure, Back View,* 1893 (fig. 90)
(C 77; W 67)
Lithograph, printed on ivory laid paper, only state; signed in graphite with butterfly
206 x 150 mm (image);
330 x 203 mm (sheet)
The Art Institute of Chicago, Bryan Lathrop Collection, 1917.594

87. *Study,* 1894 (fig. 69)
(C 114; W 77)
Transfer lithograph, printed on ivory laid paper, only state
183 x 94 mm (image);
324 x 205 mm (sheet)
The Art Institute of Chicago, Bryan Lathrop Collection, 1917.606

88. *Little London Model,* 1896 (fig. 86)
(C 168; W 130)
Transfer lithograph, printed on ivory laid paper, only state; signed in graphite with butterfly
172 x 127 mm (image);
296 x 207 mm (sheet)
The Art Institute of Chicago, Bryan Lathrop Collection, 1917.655

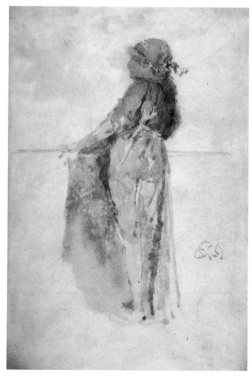

**89. *The Artist in His Studio*,
1865/66 (fig. 59)**
(YMSM 63)
Oil on paper, mounted on panel
62.9 x 46.4 cm
The Art Institute of Chicago,
Friends of American Art
Collection, 1912.141
Chicago only

90. *The Lily*, 1870/72 (fig. 60)
(M 364)
Pastel on brown wove paper;
signed with butterfly
258 x 178 mm
Fine Arts Museums of San
Francisco, Achenbach
Foundation for Graphic Arts,
Bequest of Whitney Warren, Jr.,
in memory of Mrs. Adolph B.
Spreckels, 1988.10.31

**91. *Draped Model*, 1870/73
(fig. 91)**
(M 388r)
Black chalk, heightened
with white chalk, on brown
wove paper
286 x 179 mm
Lent by the Syndics of the
Fitzwilliam Museum,
Cambridge, PD.66–1959

**92. *The Greek Slave Girl (Variations
in Violet and Rose)*, 1885/86
(fig. 62)**
(M 1079)
Pastel on brown wove paper,
laid down on card; signed
with butterfly
258 x 173 mm
Private Swiss collection

93. *Cameo, No. 1*, c. 1890
(K 347)
Etching, printed on ivory laid
paper, only state; signed
in graphite with butterfly
175 x 128 mm (plate);
202 x 157 mm (sheet)
The Art Institute of Chicago,
Bryan Lathrop Collection,
1934.555

**94. *Cameo, No. 2*, c. 1890
(fig. 78)**
(K 348)
Etching, printed on ivory laid
paper, only state; signed in
graphite with butterfly on tab
176 x 126 mm (trimmed to
plate mark)
The Art Institute of Chicago,
Bryan Lathrop Collection,
1934.554

**95. *Dancing Girl*, 1885/90
(fig. 68)**
(M 1068)
Watercolor, over graphite,
on off-white wove paper
297 x 224 mm
Trustees of the Cecil Higgins
Art Gallery, Bedford, P.432

**96. *Woman with a Parasol*, 1886
(fig. 92)**
(M 1095)
Pen and brown ink, with
touches of white gouache, over
graphite, on white laid paper,
laid down on card
157 x 78 mm
Sterling and Francine Clark
Art Institute, Williamstown,
Massachusetts, 1955.1752

**97. *The Rose Drapery*, 1890/1900
(fig. 76)**
(M 1213)
Watercolor, over black chalk,
on brown wove paper, laid
down on card
277 x 184 mm
Hunterian Art Gallery,
University of Glasgow, Birnie
Philip Bequest, 46135

**98. *Mother and Child*, c. 1890
(fig. 81)**
(M 1282)
Pastel on brown wove paper,
laid down on card
177 x 215 mm
Sally Engelhard Pingree

FIGURE 97
Figure Study in Colors,
1890 (cat. no. 71).

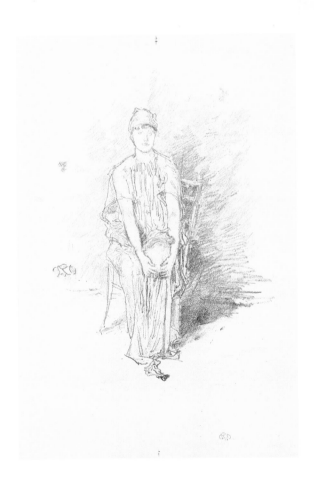

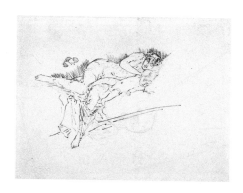

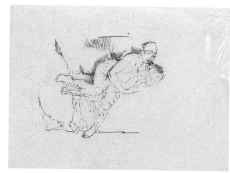

FIGURE 98

Mother and Child Asleep on a Sofa, 1891 (cat. no. 102).

FIGURE 99

Mother and Child Reclining, 1891 (cat. no. 100).

99. *Mother and Child Reclining on a Couch*, c. 1890 (fig. 80)
(M 1297)
Watercolor on buff Japanese paper, laid down on card
181 x 267 mm
The Board of Trustees of the Victoria & Albert Museum, London, P7–1943

100. *Mother and Child Reclining*, 1891 (fig. 99)
(M 1305)
Pen and purple ink (recto) and lithographic crayon (verso), on thin, transparent cream transfer paper, edge-mounted on cream card
140 x 200 mm (image);
233 x 299 mm (sheet)
Hunterian Art Gallery, University of Glasgow, Birnie Philip Bequest, 46162

101. *Rose and Pink—The Mother's Sleep*, c. 1891 (fig. 82)
(M 1300)
Watercolor, over graphite, on cream Japanese paper, laid down on card
171 x 264 mm
National Gallery of Canada, Ottawa, 325

102. *Mother and Child Asleep on a Sofa*, 1891 (fig. 98)
(M 1304)
Lithographic crayon and pen and purple ink (recto) and lithographic crayon (verso), on thin, transparent cream transfer paper, edge-mounted on ivory card; signed in pen and purple ink with butterfly
133 x 196 mm (image);
230 x 295 mm (sheet)
Hunterian Art Gallery, University of Glasgow, Birnie Philip Bequest, 46161

103. *Study of Two Figures*, 1892 (fig. 100)
Graphite and pen and brown ink, with red, blue, and yellow pencils, on off-white wove paper
125 x 202 mm
Munson-Williams-Proctor Institute Museum of Art, Utica, New York, 69.87

104. *Nude Model Pulling Drapery over Her Head*, 1891 (fig. 95)
(M 1306)
Pen and black ink (recto) and lithographic crayon (verso), on thin, transparent cream transfer paper, edge-mounted on ivory card; signed in pen and black ink with butterfly
236 x 135 mm (image); 291 x 204 mm (image with registration marks and crayon trials); 294 x 231 mm (sheet)
Hunterian Art Gallery, University of Glasgow, Birnie Philip Bequest, 46163

105. *Draped Model Leaning on a Rail*, 1891 (fig. 94)
(M 1307)
Pen and black ink (recto) and lithographic crayon (verso), on thin, transparent cream transfer paper, edge-mounted on ivory card; signed in pen and black ink with butterfly (recto), and in lithographic crayon with butterfly (verso)
208 x 228 mm (image); 296 x 228 mm (sheet)
Hunterian Art Gallery, University of Glasgow, Birnie Philip Bequest, 46164

106. *The Pink Cap*, 1890/94
(fig. 96)
(M 1308)
Watercolor on cream
Japanese paper
264 x 177 mm
Denver Art Museum, The
Edward and Tullah Hanley
Memorial Gift to the People of
Denver and the Area, 1974.429

107. *Nude Girl with a Bowl*,
c. 1892 (fig. 88)
(YMSM 400)
Oil on panel
51.4 x 32.2 cm
Hunterian Art Gallery,
University of Glasgow, Birnie
Philip Bequest, 46367

108. *Green and Blue: The Dancer*,
c. 1893 (fig. 67)
(M 1376)
Watercolor and gouache, over
traces of black chalk, on brown
wove paper, laid down on card
275 x 182 mm
The Art Institute of Chicago,
Restricted Gift of Dr. William
D. Shorey; through prior
bequest of the Charles Deering
Collection; through prior
bequest of Mrs. Gordon Palmer,
1988.219

109. *Nude Reclining*, 1893/1900
(fig. 64)
(M 1385)
Pastel and black chalk on brown
wove paper, laid down on card
180 x 278 mm
Terra Foundation for the Arts,
Daniel J. Terra Collection,
1989.7; Photograph courtesy
Terra Museum of American
Art, Chicago
Chicago only

110. *Spring*, 1893/94 **(fig. 89)**
(M 1397)
Pastel and black chalk on brown
wove paper
272 x 175 mm
Terra Foundation for the Arts,
Daniel J. Terra Collection,
1996.91; Photograph courtesy
Terra Museum of American
Art, Chicago
Chicago only

111. *The Little Blue Cap*, 1893/95
(fig. 74)
(M 1393)
Watercolor and gouache, over
charcoal, on brown wove paper,
laid down on card
278 x 182 mm
Promised gift of Dorothy
Braude Edinburg, The Art
Institute of Chicago, 61.1997
Chicago only

112. *La Sylphide*, 1896/1900
(fig. 70)
(YMSM 494)
Oil on canvas
61.2 x 46.2 cm
Hunterian Art Gallery,
University of Glasgow,
Birnie Philip Bequest, 46357

113. *The Dancer (No. 1)*,
c. 1900 (fig. 93)
(M 1624)
Pen and brown ink on cream
wove paper
150 x 109 mm
The Cleveland Museum of Art,
Gift of Mr. and Mrs. Ralph
King, 1924.90

FIGURE 100
Study of Two Figures,
1892 (cat. no. 103).

FIGURE 101
Lady and Child, 1892
(cat. no. 79).

"I have had enough of the country—beautiful it might all have been perhaps if it had not been for the devilish fine weather!"

JAMES McNEILL WHISTLER, 1893

In the early summer of 1893, Beatrix Whistler began to suffer the early symptoms of an illness that would eventually be diagnosed as cancer. Paris, where the Whistlers had moved in 1892, was unbearably hot that summer, and the Latin Quarter, not far from the Whistlers' house on the rue du Bac, was rocked by a series of student revolutions. Worried about his wife's health and unable to concentrate on his own work, the artist made a spontaneous decision to escape the oppressive atmosphere of the city. He and his wife selected the province of Brittany, located along the northwest coast of France, as their destination. Hoping that fresh air and a change of scenery would invigorate them both, the couple set out from Paris in early July and did not return until mid-September.

Brittany, with its dramatic seacoast, rustic hamlets, authentic costumes, ancient superstitions, and aura of complete isolation from the modern world, had been a magnet to artists internationally since the 1860s. By the late 1880s, the reputation of artists' colonies in the once-remote villages of Pont-Aven and Le Pouldou had been cemented by the presence there of Paul Gauguin, Emile Bernard, and others in their circle. However, in the summer of 1893, neither of these seminal figures was in Brittany, and there is no evidence to suggest that Whistler was specifically drawn by the artistic communities of the region, although his friend Claude Monet had painted there, at Belle Ile, in 1886, and another friend, the actress Sarah Bernhardt, acquired a retreat on the same island the summer of Whistler's visit.

The artist and his wife seem to have been intent on working and relaxing at their own

pace, and they meandered from town to town with no particular agenda; later Whistler would even have trouble recalling the specific locations depicted in some of his sketches. He complained endlessly about the heat in letters written to family and friends from Brittany, suggesting that the unrelenting stretch of clear days might be attractive to tourists but offered "nothing for the painter."[19] Yet Whistler clearly found some measure of relief along the coast, on Belle Ile, and working in a boat out on the water, for he painted his first seascapes in about seven years, producing a number of lively watercolors, as well as seven vivid oils, with which he remained greatly pleased long after the holiday was over.

The sojourn in Brittany was fruitful in other ways as well. As he and his wife explored one Breton town after another, Whistler carried with him his lithographic crayons and a block of fine-grained transfer paper (*papier viennois*), easily portable materials that allowed him to record his impressions as rapidly and freely as he might with the pencil and sketchbook he also carried about. During July they traveled inland, visiting the villages of Vitré and Lannion. The lithographs he produced in these small towns reflect his affection for the rustic authenticity of the architecture he discovered there. While he had little true antiquarian knowledge, Whistler did have an eye for the genuine and the picturesque in provincial architecture, a fascination dating back to 1858, when he recorded such unspoiled sites as *Street at Saverne* (fig. 107) for his first published set of Realist etchings, known as the "French Set." The same natural predilection for quaint buildings can be found whenever Whistler traveled away from London or Paris,

as in the lithograph *The Priest's House, Rouen* (fig. 109), produced in 1894 on a short trip to that city.

In the small Breton town of Vitré, Whistler was especially interested in the gables of the houses clustered along the canals. He adopted a high vantage point when he drew *Vitré: The Canal* (fig. 102) in order to provide a view out across the rooftops, while in another lithograph, *Gabled Roofs* (fig. 108), he offered a simple, direct portrait of one of these old houses with its distinctive steep gable. In these two works, Whistler introduced a technical innovation: he used stump suffused with greasy crayon (also known as *crayon estompe*) to manipulate his drawing on the transfer

FIGURE 103

The Marketplace, Vitré, 1893 (cat. no. 114).

OPPOSITE PAGE

FIGURE 102

Vitré: The Canal, 1893 (cat. no. 115).

FIGURE 104

A Brittany Shop with Shuttered Windows, 1893 (cat. no. 121).

paper. In *Vitré: The Canal,* he employed this technique extensively for atmospheric passages in the sky and in the water, while in *Gabled Roofs* he used it only minimally to suggest wisps of clouds. Without knowing it, Whistler took a considerable risk in using the stump without checking first with his printers and technical advisors, the Ways, back in London. Generally, stumping was reserved for work done directly on a lithographic stone and not recommended for use on transfer paper. In September, when Whistler sent his Breton transfer drawings from Paris to London to be printed, the Ways were surprised that he had attempted to use the stump on paper and they worried that the images would not transfer well to stone. Of *Vitré: The Canal,* T. R. Way recalled:

The drawing was made with chalk and finished with stump, the sky and watery foreground being almost entirely so drawn. Now if this had been drawn upon stone, it would have been a simple matter for the printer, but it was done on transfer paper, and was new to us, and one dared not risk such a charming drawing without learning how to treat it. So I made some little drawings in the same manner, and had them put on stone, and worked out the treatment, and I was rewarded by the successful result when the "Canal" was proved.[20]

Whistler again adopted an elevated viewpoint to capture the bustle of people moving around the stands of a small, provincial market (fig. 103). *The Marketplace, Vitré* is one of very few images outside of Whistler's sketchbook in which he focused on an aspect of Breton village life. Gauguin and artists of the Pont Aven school were fascinated by the traditional costumes and customs of the Breton people, and these feature prominently in the

paintings and prints they produced in Brittany in the 1880s and 1890s. Throughout his summer holiday in Brittany, however, Whistler concentrated largely on the sea and on the architectural features of the small towns he visited, recording details of local life and dress primarily in the pages of his sketchbook.

The Marketplace, Vitré—in a sense like Whistler's Breton seascapes—is highly successful at capturing a moment in time because of its emphasis on light and movement. As subject matter, markets had certainly attracted the artist's attention before, particularly when he traveled. In the 1880s he depicted the bustling marketplace on the Rialto in Venice in a large etching, and produced spontaneous watercolors on visits to Dieppe and Bourges (see fig. 110). Lithography gave Whistler the range of tones to suggest the animated effects of such scenes without actually using color. By contrast, he used touches of red against a predominantly black and gray palette to animate another scene of village life, *A Brittany Shop with Shuttered Windows* (fig. 104), a watercolor that may also have been drawn during the sojourn in Vitré. Here the artist's exclusive focus on the first floor of the shop and on the passing figures offers a distinct contrast to the bird's-eye view he selected for the market scene.

The five black-and-white lithographs produced by Whistler in Brittany during the summer of 1893 demonstrate a new boldness of handling and a richer, heavier effect than his previous lithographs of similar architectural subjects, such as the Chelsea shopfronts he drew in 1888. This is due in part to his use of softer, greasier crayons for the Breton images and to the fact that, when the Ways printed the lithographs in London in mid-September, they dampened the paper, as was usual for the printing of etchings. Whistler himself noticed the new properties of the Breton lithographs when

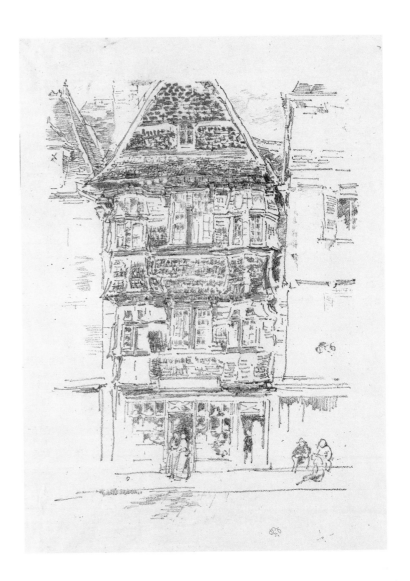

FIGURE 105
Red House, Paimpol,
1893 (cat. no. 117).

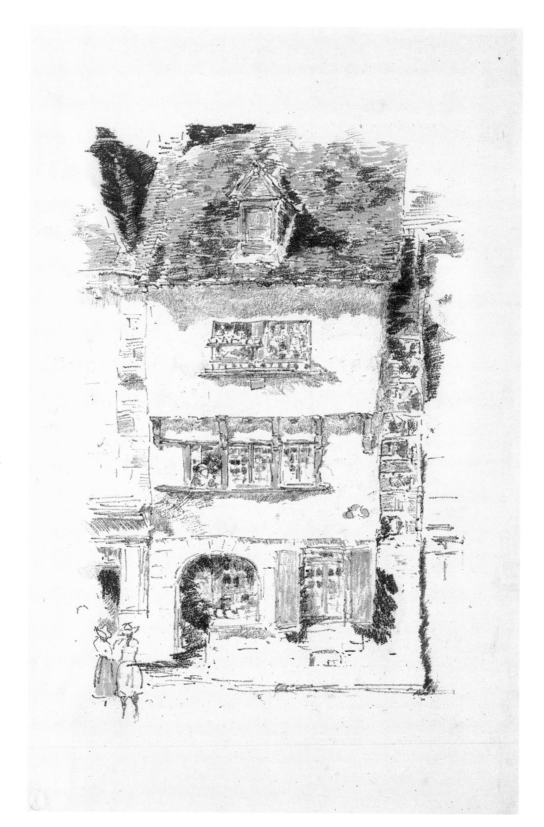

FIGURE 106

Yellow House, Lannion,
1893 (cat. no. 118).

he received the first proofs back from his printers. On September 20 he wrote to T. R. Way: "Just a line in haste to tell you I am *delighted* with the proofs—I don't want *any*thing done to them—They are most delicate and most *beautifully* printed— The stump skies I think quite charming and quite enough. There is a delightful velvety quality about them."[21]

Whistler's tour through Brittany with Beatrix was both relaxing and productive, a combination that seems to have spurred a new confidence, as well as a risk-taking approach to technique, in his lithographic work. In addition to his newly powerful black-and-white images, Whistler laid the groundwork for his last and most sophisticated color lithographs, *Red House, Paimpol* and *Yellow House, Lannion* (figs. 105–06). He had already made a handful of experiments in color lithography in 1891 and 1892, working with the Parisian printer Henry Belfond. These had all been figure subjects, the most complex and successful of which was *Draped Figure, Reclining* (fig. 58). In Paimpol he selected a rather elaborate building, carefully delineating its complex structural elements in a drawing on fine-grained transfer paper. Once back in Paris and working in Belfond's shop, Whistler used this drawing to establish the keystone. He then created the drawings for the color stones on *papier végétal*, a transfer paper that, because it is transparent, allowed him to ensure accurate placement of the color areas by laying them over the keystone image. Whistler added color stones in gray and red to emphasize the pattern of the tiles on the surface of the old house and to highlight its wooden trim. The finished appearance of *Red House, Paimpol* is like a black-and-white drawing with touches of color added, an effect that echoes the way it was created.

Although the facade Whistler depicted in *Yellow House, Lannion* is simpler and more rustic than that of the old house in Paimpol, this lithograph is the more technically sophisticated of the two. Here the artist used color not just for occasional emphasis, as he had in *Red House*, but as a building block of the composition. Whistler and his Parisian printer must have labored long and hard over this image, experimenting with the hues and intensities of their inks, which were mostly in a subtle range of ochers, browns, grays, and greens. In some impressions, as many as eight different ink colors were used; it is possible to see that some stones were selectively wiped with more than one color. Whistler seems to have worked on this image for a full month, and upon its completion *Yellow House, Lannion* was made available for sale at the price of three guineas. Had it not been for a quarrel with Belfond in late 1893, followed by the bankruptcy of the printer's firm, it seems likely that Whistler would have continued his work in color lithography, building on his experience with the two charming images of old Breton houses.

When Gauguin moved to Brittany in 1886, he went in search of an ancient and primitive culture, untainted by the progress of industrialization and urbanization. On holiday with Beatrix in the summer of 1893, Whistler also sought an antidote to his urban existence. Yet his letters dating from that journey indicate that he held no illusions about the purity of Brittany's isolation from the modern world; he recognized that the province had been discovered not only by artists but also by tourists. Nevertheless, the little towns he explored still felt "far away," and he found an appealing genuineness in the province's fresh sea views and humble facades, baking as they always had under the hot summer sun. (MT)

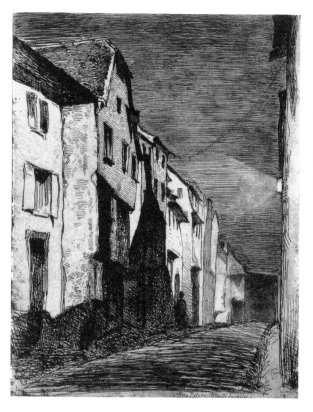

114. *The Marketplace, Vitré*, 1893

(fig. 103)

(C 62; W 40)

Transfer lithograph, printed
on ivory laid paper, only state;
signed in graphite with butterfly
203 x 162 mm (image);
323 x 208 mm (sheet)
The Art Institute of Chicago,
Bryan Lathrop Collection,
1917.570

115. *Vitré: The Canal*, 1893

(fig. 102)

(C 63; W 39)

Transfer lithograph, printed on
cream laid paper, only state;
signed in graphite with butterfly
236 x 153 mm (image);
367 x 243 mm (sheet)
Mansfield-Whittemore-Crown
Collection, The Art Institute
of Chicago, 71.1984

FIGURE 107

Street at Saverne, 1858
(cat. no. 120).

FIGURE 108

Gabled Roofs, 1893
(cat. no. 116).

FIGURE 109

*The Priest's House,
Rouen*, 1894 (cat.
no. 119).

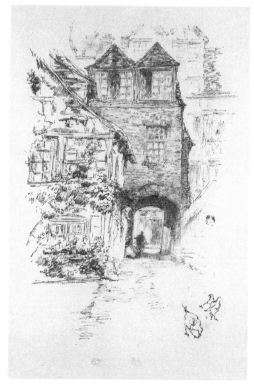

116. *Gabled Roofs*, 1893
(fig. 108)
(C 64; W 41)
Transfer lithograph, printed on cream laid paper, only state; signed in graphite with butterfly
204 x 161 mm (image);
368 x 245 mm (sheet)
Mansfield-Whittemore-Crown Collection, The Art Institute of Chicago, 73.1984

117. *Red House, Paimpol*, 1893
(fig. 105)
(C 66; W 100)
Transfer lithograph, printed in three colors on cream Japanese paper, second of three states; signed in graphite with butterfly
227 x 166 mm (image); 238 x 166 mm (image with registration marks); 317 x 203 mm (sheet)
Mansfield-Whittemore-Crown Collection, The Art Institute of Chicago, 106.1984

118. *Yellow House, Lannion*, 1893 (fig. 106)
(C 67; W 101)
Transfer lithograph, printed in four colors on cream Japanese paper, second of three states
242 x 162 mm (image); 253 x 162 mm (image with registration marks); 319 x 204 mm (sheet)
The Art Institute of Chicago, Charles Deering Collection, 1927.5849

119. *The Priest's House, Rouen*, 1894 (fig. 109)
(C 105; W 74)
Transfer lithograph, printed on cream laid paper, second of two states; signed in graphite with butterfly
241 x 160 mm (image);
327 x 239 mm (sheet)
The Art Institute of Chicago, Charles Deering Collection, 1927.5832

120. *Street at Saverne*, 1858
(fig. 107)
(K 19)
Etching, printed on blue chine, mounted on off-white plate paper, fourth of five states; signed in graphite with butterfly and *Whistler*
208 x 159 mm (plate); 207 x 155 mm (chine); 387 x 304 mm (plate paper)
The Art Institute of Chicago, Bryan Lathrop Collection, 1934.546

121. *A Brittany Shop with Shuttered Windows*, 1893 (fig. 104)
(M 1365)
Watercolor on off-white wove paper, laid down on card
128 x 217 mm
Terra Foundation for the Arts, Daniel J. Terra Collection, 1992.146; Photograph courtesy of Terra Museum of American Art, Chicago

122. *Street in Bourges*, 1897/99 (fig. 110)
(M 1518)
Watercolor, with touches of gouache, on brown wove paper
215 x 130 mm
Courtesy of the Cummer Museum of Art and Gardens, Jacksonville, Florida, Bequest of Ninah M. H. Cummer, C.197.1

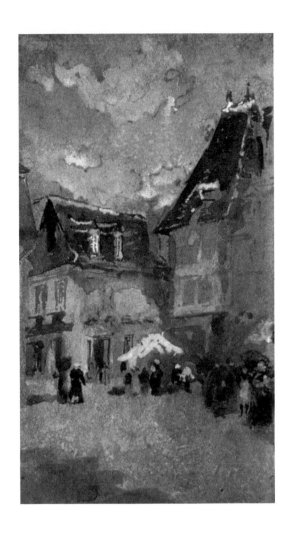

FIGURE 110
Street in Bourges, 1897/99 (cat. no. 122).

At Home in Paris: The Rue du Bac

"Now look at the quality of these new things! . . . Don't they look like the most delicate *drawings* out of a Museum?"

JAMES McNEILL WHISTLER TO T. R. WAY, 1893

When Whistler married, for the first time, on August 11, 1888, he was fifty-five years old. His bride was Beatrix Godwin, an artist and the young widow of architect E. W. Godwin, designer of Whistler's White House in Chelsea. Charming and attractive, with a generous figure, Beatrix (fig. 112) was twenty-three years younger than Whistler. She had been his pupil and a member of his social circle in London for years.[22] Since his student days in Paris, the artist had lived with a succession of mistresses; at the time of his marriage, he was still involved in a long-standing relationship with Maud Franklin. Despite the longevity of his relationships with Joanna Hiffernan and then Maud, it is clear that Whistler had never before enjoyed the kind of domestic happiness and tranquility that marked his married life with Beatrix. He was very much in love with her, and she doted on him and shared many of his passions. Among these was an enthusiasm for lithography, and it can be no coincidence that the years of their marriage witnessed the flowering of his productivity in that medium.

The Whistlers also shared an interest in interior design, a passion in which they fully indulged themselves when, in 1892, they moved from their home on Cheyne Walk in Chelsea to Paris, where they took a house at 110, rue du Bac. Whistler's decision to escape what he called the "dreariness and dullness of London" reflected his increasingly important friendships among the French Symbolists and his bitterness at the failure of the English art establishment to recognize the importance of his art. By contrast, the French government had honored him in 1891 by acquiring

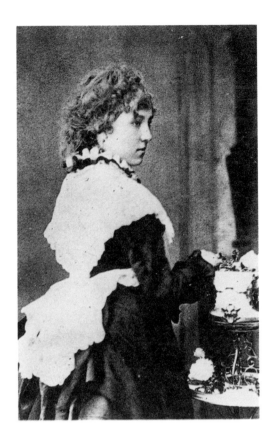

Arrangement in Gray and Black: Portrait of the Artist's Mother (1871; Musée d'Orsay, Paris). Thus he and Beatrix embarked with great optimism on their new life in Paris, living in a succession of neighborhood hotels as they supervised the remodeling and decorating of their elegant garden house. Together they hunted for appropriate furniture and fabrics, sketched furniture designs, and wrote enthusiastically to friends about the progress of their work. When the house was finally complete, they had created their joint masterpiece, an interior so wholly original that it astounded the many visitors who came to call.

The little house at 110, rue du Bac was unusual in many ways; its location, as well as its carefully crafted interior, provided a peaceful haven from the busy thoroughfares of Paris. The Whistlers' distinctive blue-green door was located well off the street in a tiny courtyard. Inside, a series of sparsely yet harmoniously furnished rooms were dispersed on one floor, leading out to a charming garden.

The furniture was Empire in style, mostly painted white. The dining room displayed Whistler's famous collection of blue-and-white porcelain. The drawing room also had a blue-and-white scheme; the white furniture and paneling, light blue ceiling, and dark blue matting on the floor all contributed to an airy and restful effect. The focal point of this room was the garden—its leafy greens and masses of pink flowers could be seen through tall windows and the large doorway that opened onto a shady, latticework portico designed by Beatrix (see fig. 111). Outside, winding gravel paths, lush displays of flowers, dainty latticework furniture, and Beatrix's exotic birds (see fig. 119) were all nestled within the high garden walls, offering a delightful counterpart to the aesthetic interior. The otherworldly sounds of hymns and bells from a nearby seminary frequently added to the serenity of this urban retreat.[23]

The Whistlers enjoyed entertaining at their home on the rue du Bac. They continued the tradition of Sunday breakfasts that Whistler had started in London in the 1870s, and enjoyed the frequent visits of artist friends and family members. Beatrix's family, the Birnie Philips, were always welcome; her sister Ethel was a particular favorite of the artist's, and she appears in a number of lithographs of this period, such as *Confidences in the Garden* (fig. 113), in which she strolls outdoors with Beatrix, or *The Duet* (fig. 118), in which the sisters play the piano together in the half-light of early evening. That Whistler enjoyed the easy intimacy between the two women is clear in such informal lithographs as *The Sisters* (fig. 114). When Ethel married journalist Charles Whibley in July 1894, the wedding party was photographed in the Whistlers' garden (fig. 115).

FIGURE 112

Beatrix Whistler, late 1880s. Library of Congress, Washington, D.C., Pennell Collection.

OPPOSITE PAGE

FIGURE 111

The Garden Porch, 1894 (cat. no. 123).

FIGURE 113

Confidences in the Garden, 1894 (cat. no. 127).

For a brief moment in time, Whistler's world seemed perfect. He enjoyed close friendships, one of the most important and inspiring being his relationship with Symbolist poet Stéphane Mallarmé. As a famous expatriate American living in Paris, he also enjoyed an enhanced social status, frequently receiving wealthy or influential visitors who came to pay their respects, such as Maud Burke (later Lady Cunard), who posed in the drawing room at the rue du Bac for the lithograph entitled *La Jolie New Yorkaise* (fig. 120). Best of all, of course, was the happiness of his marriage to Beatrix and his contentment with his home and nearby studio. The transfer lithographs that he produced in this period, showing his wife and family relaxing in the garden or in the drawing room, suggest the pleasure he took in his domestic life.

These *intimiste* images also indicate his affinity with avant-garde French artists of the Nabis circle, such as Pierre Bonnard and Edouard Vuillard, who themselves took great interest in interior decoration and whose color lithographs of the 1890s situate women in the delicate, patterned interiors they favored. Unlike these artists, however, Whistler created his lithographs of domestic interiors exclusively in black and white. Although he did his most ambitious work in color lithography in 1893, there is no evidence that any of the rue du Bac portraits were intended to be worked up in color, despite the suggestion of color in the title of *La Robe rouge* (fig. 116). Rather, he was intent on perfecting his ability to draw on *papier végétal*, the thin, nearly transparent transfer paper he procured from the Parisian printer Alfred Lemercier. The artist was particularly thrilled with the rich, velvety effects he achieved in *La Robe rouge* and *La Belle Dame endormie* (fig. 121), two portraits of Beatrix drawn during a single evening in late September 1894. Writing to his printers in

London, Whistler described the latter as "certainly, at present, my favorite lithograph."[24]

In lithography, more than in any other medium, Whistler recorded the idyll of his private life in Paris. Beatrix herself encouraged his lithographic work, and he must have found the ease of transfer lithography well suited to the informality of home life. Lithography gave him great flexibility—simply by varying his touch and his choice of crayons, he could effectively capture both the sunstruck serenity of his garden and the long shadows of the drawing room by lamplight. Ironically, these documents of Whistler's happiness also provide the first glimpses of tragedy to come. *La Belle Dame paresseuse*, *La Robe rouge*, *La Belle Dame endormie*, and *The Sisters* all portray Beatrix in a variety of languid poses, reclining in an armchair or fast asleep on the settee. The lassitude implied in these images, while effective in evoking a sense of intimacy and informality, also suggests that she was

The Sisters, 1894
(cat. no. 132).

The Ethel Birnie
Philip-Charles Whibley
wedding party in
the garden of 110, rue
du Bac, Paris, 1894.
Glasgow University
Library, Department
of Special Collections.

FIGURE 116
La Robe rouge, 1894
(cat. no. 130).

FIGURE 117
La Belle Jardinière,
1894 (cat. no. 128).

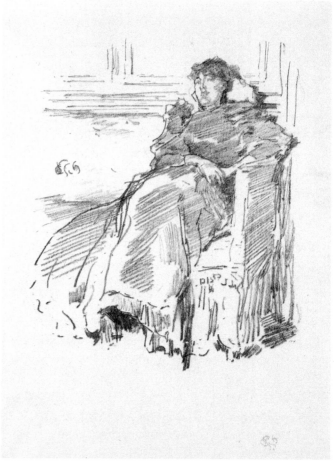

beginning to experience the early symptoms of the illness that would eventually kill her.

Indeed, by late 1894 Beatrix was beginning to feel ill. Panicked and distrustful of their French doctors, Whistler asked his physician brother, William Whistler, to join them in Paris immediately. His diagnosis was the worst possible: Beatrix had a fatal form of cancer. The artist was at first unwilling or unable to accept his brother's opinion, and they argued bitterly. However, desperate to help his wife, he eventually agreed to follow his brother's advice and to return to London with Beatrix for medical treatment. In December they closed up the beloved house on the rue du Bac and thereafter lived a nomadic existence, described in a poignant letter written by Whistler to a friend: "And so we have wandered from home and work—going from town to country, and from doctor to doctor. Living in hotels and leaving behind us the beautiful house you know so well in Paris."[25]

Whistler returned to Paris several times during the course of his wife's illness, but Beatrix remained behind in London in the care of her family. After her death in May 1896, he retained the Paris house and stayed there on his periodic visits to France, sometimes making somber sketches of her family in lithography. He wrote to his American patron Charles Lang Freer: "I have kept her house—in its goodness and rare beauty—as she had made it —and from time to time I go to miss her in it."[26] Although he retained the property until 1901, Whistler never recaptured the sense of well-being so clearly expressed in such lithographs as *La Belle Jardinière* (fig. 117) or *La Belle Dame endormie*. (MT)

FIGURE 118
The Duet, 1894
(cat. no. 129).

123. *The Garden Porch*, 1894
(fig. 111)
(C 88; W 140)
Transfer lithograph, printed
on ivory laid proofing paper,
only state; signed in graphite
with butterfly
215 x 162 mm (image);
281 x 201 mm (sheet)
The Art Institute of Chicago,
Bryan Lathrop Collection,
1917.665

124. *Tête-à-tête in the Garden*, 1894
(C 90; W 54)
Transfer lithograph, printed
on cream laid Japanese vellum,
only state; signed in graphite
with butterfly
198 x 164 mm (image);
340 x 237 mm (sheet)
Mansfield-Whittemore-Crown
Collection, The Art Institute
of Chicago, 86.1984

125. *La Belle Dame paresseuse*, 1894
(C 98; W 62)
Transfer lithograph, printed
on cream wove Japanese vellum,
only state; signed in graphite
with butterfly
236 x 175 mm (image);
311 x 231 mm (sheet)
The Art Institute of Chicago,
Bryan Lathrop Collection,
1917.520

126. *La Jolie New Yorkaise*, 1894 **(fig. 120)**
(C 99; W 61)
Transfer lithograph, printed on
ivory laid paper, only state;
signed in graphite with butterfly
226 x 157 mm (image);
324 x 206 mm (sheet)
The Art Institute of Chicago,
Bryan Lathrop Collection,
1917.519

127. *Confidences in the Garden*, 1894 **(fig. 113)**
(C 100; W 60)
Transfer lithograph, printed on
cream laid paper, only state;
signed in graphite with butterfly
212 x 160 mm (image);
315 x 202 mm (sheet)
Mansfield-Whittemore-Crown
Collection, The Art Institute
of Chicago, 92.1984

128. *La Belle Jardinière*, 1894
(fig. 117)
(C 101; W 63)
Transfer lithograph, printed on
cream laid paper, only state;
signed in graphite with butterfly
223 x 158 mm (image);
314 x 200 mm (sheet)
The Art Institute of Chicago,
Bryan Lathrop Collection,
1917.437

FIGURE 119
Beatrix Whistler Looking at Her Birds, 1894 (cat. no. 133).

FIGURE 120
La Jolie New Yorkaise, 1894 (cat. no. 126).

129. *The Duet*, 1894 (fig. 118)

(C 104; W 64)

Transfer lithograph, printed on cream laid paper, only state; signed in graphite with butterfly

246 x 165 mm (image);

283 x 227 mm (sheet)

The Art Institute of Chicago, Bryan Lathrop Collection, 1917.591

130. *La Robe rouge*, 1894 (fig. 116)

(C 107; W 68)

Transfer lithograph, printed on ivory laid paper, first of two states; signed in graphite with butterfly

188 x 155 mm (image);

324 x 208 mm (sheet)

The Art Institute of Chicago, Charles Deering Collection, 1927.5821

131. *La Belle Dame endormie*, 1894 (fig. 121)

(C 108; W 69)

Transfer lithograph, printed on ivory laid paper, only state; signed in graphite with butterfly

202 x 156 mm (image);

219 x 198 mm (sheet)

Mr. and Mrs. A. Steven Crown, The Art Institute of Chicago, 227.1984

132. *The Sisters*, 1894 (fig. 114)

(C 109; W 71)

Transfer lithograph, printed on cream laid paper, second of two states; signed in graphite with butterfly

150 x 236 mm (image);

210 x 297 mm (sheet)

Mr. and Mrs. A. Steven Crown, The Art Institute of Chicago, 229.1984

133. *Beatrix Whistler Looking at Her Birds*, 1894 (fig. 119)

(M 1398)

Lithographic crayon on thin, transparent cream transfer paper

215 x 145 mm (image);

233 x 154 mm (sheet)

Hunterian Art Gallery, University of Glasgow, Birnie Philip Bequest, 46196

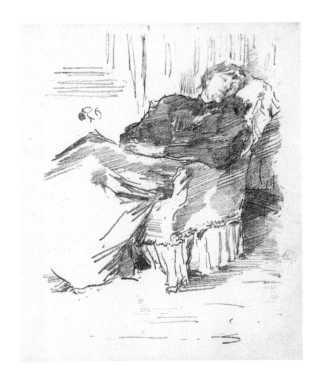

FIGURE 121

La Belle Dame endormie, 1894 (cat. no. 131).

Paris Shops, Streets, and Gardens

JAMES McNEILL WHISTLER AND THE ART OF LITHOGRAPHY

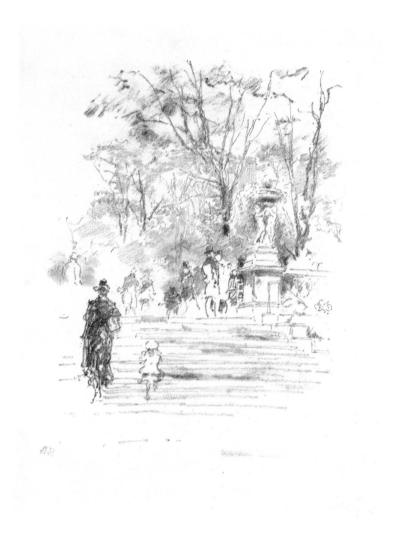

"The lithographs which he made [in Paris] may be fairly
 described as one long series of experiments, so frequently
did he vary his materials and his manner of using them."

T. R. WAY, 1912

When Whistler returned to settle in Paris with Beatrix in 1892, he was welcomed by Mallarmé, Monet, and art critic Théodore Duret. His work was recognized and admired in France—both for its affinities with prevailing French aesthetics and for its unique departures from it.

As a young artist studying in Paris in the 1850s, Whistler had adopted the Realist vision of artists such as Gustave Courbet and Paul Gavarni. Refining his etching technique, Whistler created intimate, incisive images of Parisian working-class types. After producing the twelve "French Set" etchings in 1858, the artist went to London, where his adherence to Realism was challenged by the tenets of Aestheticism, and where he began to test the boundaries of the artistic media in which he worked.

Wandering the streets of Paris as he had in his youth, Whistler was inspired by the arched doorways of picturesque shopfronts (see figs. 123 and 129) and by public parks with their dramatic vistas. From his studio at 186, rue Notre-Dame-des-Champs, a short walk from his rue du Bac residence, he could see the Luxembourg Gardens. As was his custom, he carried prepared copper plates and a delicate etching needle, as well as grained transfer paper and lithographic crayons. Carefully orchestrating architecture and human activity into balanced compositions, he paid particular attention to the patterns found in the doorways and windows of facades or in the foliage and benches in gardens. The Paris images of the 1890s continue the sequence of urban scenes initiated in London and Venice; they are selective yet evocative, containing contrasts of light and dark, interior and exterior, transparency and opacity, vertical and horizontal symmetry.

In etchings such as *Sunflowers, Rue des Beaux-Arts* (fig. 124), dense groups of short lines, distributed more arbitrarily than in Whistler's previous prints, cause the image to shimmer like the copper plate from which it was printed. Yet it was the medium of transfer lithography that seemed to hold the greatest appeal for Whistler at this time. Not only was it convenient for outdoor sketching, but it allowed the artist to combine the almost fussy precision of his etchings with the bold minimalism of his paintings. Fascinated by the complex and sometimes unpredictable relationship between the transfer paper, the lithographic stone, and the printed image, Whistler ignored the contemporary prejudice against lithography as a solely commercial or documentary medium and instead explored its potential to convey mood and individual sensibility.

Whistler was well aware of the increasing interest, especially in France, in artistic lithography, and he was eager to try new transfer papers. Because he continued to have his lithographs printed in London by the Ways, scholars know quite a bit about his experimentation with various materials. The artist and his printers kept up a lively correspondence, with drawings, prints, and accompanying letters crossing the English Channel on an almost daily basis in the summer of 1894.

Encountering difficulties in printing his delicate etchings, and taking an interest in new lithographic materials, Whistler temporarily abandoned etching in favor of lithography for his Paris scenes. Continuing experiments initiated in Brittany, he made use of the stump, with which he could achieve a very soft, blurred tonality, creating effects similar to smudged charcoal lines. He wrote to T. R. Way, enthusiastic about his latest innovation: "Indeed [with] this stump I really believe I am making at last something altogether peculiar—don't you?—I am getting now a richness with it—a certain velvety daintiness—quite unlike anything I have ever seen."[27] The technique was especially effective in the skies and

FIGURE 123

A Shop with a Balcony, c. 1899 (cat. no. 153).

FIGURE 124

Sunflowers, Rue des Beaux-Arts, 1892/93 (cat. no. 150).

OPPOSITE PAGE

FIGURE 122

The Steps, Luxembourg, 1893 (cat. no. 134).

FIGURE 125

Terrace, Luxembourg Gardens, No. 1, 1892/93 (cat. no. 149).

foliage of the scenes he drew in the Luxembourg Gardens. Whereas in etchings such as *Terrace, Luxembourg Gardens, No. 1* (fig. 125) he had established these areas with cross-hatched patches, in a lithograph of a closely related subject, *The Pantheon, from the Terrace of the Luxembourg Gardens* (fig. 126), he used the stump to create wisps of clouds and leaves.

In addition to the stump, Whistler rediscovered the transparent French transfer paper known as *papier végétal*, which is somewhat like a modern tracing paper prepared with gum on one side to facilitate the transfer of a drawing in lithographic crayon to stone for printing. In fact he had already used it for portraits of Mallarmé in 1891, and four years later began a concerted exploration of its properties, which differ significantly from those of the grained transfer paper (*papier viennois*) that he had been using. He was thrilled with its virtually textureless quality and with the way that the

crayon lines could be artfully smudged. Comparing *The Laundress: "La Blanchisseuse de la place Dauphine,"* drawn on *papier viennois,* with *La Fruitière de la rue de Grenelle,* executed on *papier végétal* (figs. 127–28), Whistler noted that the smooth paper allowed him to draw freely and to establish a range of tones, whereas the grained transfer paper had been much more restrictive and did not facilitate halftones. So liberating was this discovery that Whistler delightedly wrote to Thomas Way: "I fancy I am beginning to draw a bit!"[28]

Most challenging of all was the attempt to apply the stump to transparent transfer paper, which is extremely delicate and easily torn. Although the Ways discouraged him from using it, because passages of stumping did not always transfer and print consistently, Whistler was persistent and finally succeeded, using it not only to suggest delicate clouds and foliage but also to establish dark, opaque shadows. Using the motif of a blacksmith

working in his shop for two lithographs, Whistler worked with specially prepared transfer papers and made many adjustments until he arrived at what he wanted. For the first, *The Forge, Passage du Dragon*, Whistler employed the stump on a loose sheet of *papier végétal*, while for the second, *The Smith, Passage du Dragon* (fig. 130), he used a sheet of transfer paper that had been mounted on a heavier backing sheet—a sturdy support that could be carried about the city and could withstand rubbing with the stump. Although Whistler had to work on these images much more than he cared to, he felt it was worth it: "*If* I can only get that paper put *quite* right, then we can do *anything*—and this is something, worth while—for 'Lithography' shall develop into *very* strange matter indeed—and the fun and the mystery will begin in *earnest!*"[29]

So pleased was Whistler with having thus raised lithography to the level of drawing that he decided to raise the prices of his lithographs from an average of two guineas each to three, four, or five—despite protests from his dealers, who knew that the art-buying public was not accustomed to paying so much for lithographs of any sort, let alone ones as minimal as Whistler's. In effect the artist was restricting the availability of his work in lithography to serious collectors who had already developed an appreciation for it.

While he worked on achieving tonality, he also minimized line. He obtained beautiful, lustrous Japanese vellums and fine Dutch papers from old books for the Ways to print the lithographs on, exploiting the surfaces and subtle tones of these papers as part of the images. Whistler's butterfly signatures serve both to anchor and to liberate the drawn images. Describing the Luxembourg Gardens scenes of 1894–95, a reviewer for the *Pall Mall Gazette* stated: "Even the empty ground plays in a fine harmony with the drawing, always

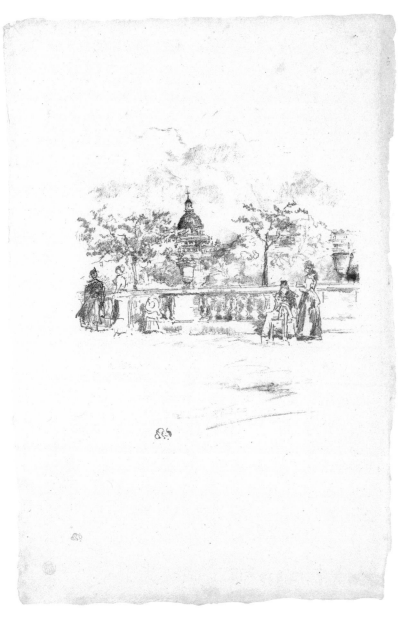

FIGURE 126

The Pantheon, from the Terrace of the Luxembourg Gardens, 1893 (cat. no. 136).

ABOVE

FIGURE 127

*The Laundress:
"La Blanchisseuse de
la place Dauphine,"*
1894 (cat. no. 143).

RIGHT

FIGURE 128

*La Fruitière de
la rue de Grenelle,*
1894 (cat. no. 147).

BELOW

FIGURE 129

The Open Door, c. 1901
(cat. no. 154).

RIGHT

FIGURE 130

*The Smith, Passage du
Dragon,* 1894 (cat.
no. 146).

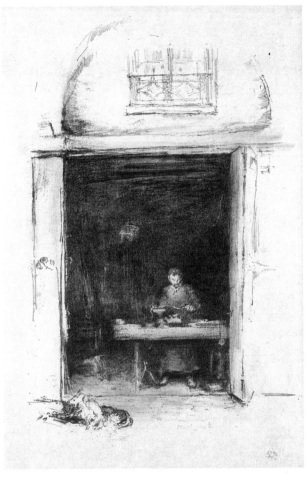

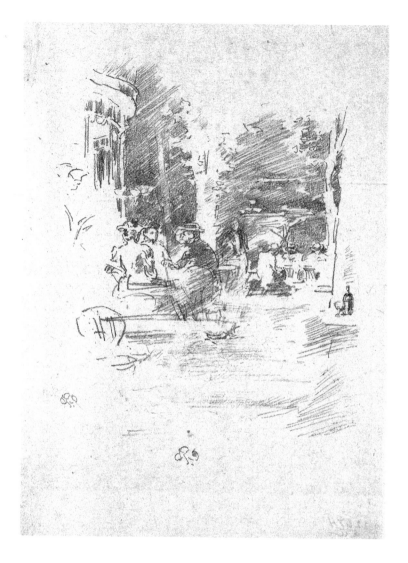

conveys beautiful proportion, and often some meaning signifying space, distance, point of view, distribution of attention."[30]

In *The Little Café au Bois* (fig. 131), the darkness of the background advances to compete with the lamp-lit figures and tree trunks in the foreground, resulting in an overall pattern related to but more stylized than that achieved in photography (see fig. 132). A reviewer for *The Art Journal*, commenting on another lithograph of the period, *Nursemaids: "Les Bonnes du Luxembourg"* (fig. 135), remarked that "as the camera is developed and perfected, the artist, whose medium is black and white, is called upon to produce something more than the sham photograph which at one time delighted and astonished."[31] But Whistler's manner of differentiating his works from photographs was compositional, not coloristic, at least not in the literal sense of some of his French contemporaries. Whistler's images of Parisian shopfronts and gardens, drawn in the streets of the French capital on papers carefully prepared for him by a Parisian printer, and printed in London, are records of technical experimentation, applied in the service of a unique urban vision. Respected as an innovator and rising to new challenges, Whistler used lithography to capture the particular qualities of the Paris scene. (BS)

FIGURE 131

The Little Café au Bois,
1894 (cat. no. 141).

FIGURE 132

Eugène Atget (French;
1857–1927). *Café on the
Champs-Elysées,* 1898.
Bibliothèque Nationale
de France, Paris.

134. *The Steps, Luxembourg*, 1893 (fig. 122)
(C 68; W 43)
Transfer lithograph, printed on cream laid paper, only state; signed in graphite with butterfly
208 x 157 mm (image); 368 x 247 mm (sheet)
Mansfield-Whittemore-Crown Collection, The Art Institute of Chicago, 75.1984

135. *Conversation under the Statue, Luxembourg Gardens*, 1893
(C 69; W 44)
Transfer lithograph, printed on cream laid paper, only state; signed in graphite with butterfly
170 x 154 mm (image); 294 x 200 mm (sheet)
Mansfield-Whittemore-Crown Collection, The Art Institute of Chicago, 76.1984

136. *The Pantheon, from the Terrace of the Luxembourg Gardens*, 1893 (fig. 126)
(C 70; W 45)
Transfer lithograph, printed on cream laid paper, only state; signed in graphite with butterfly
182 x 160 mm (image); 324 x 220 mm (sheet)
Mansfield-Whittemore-Crown Collection, The Art Institute of Chicago, 77.1984

137. *Nursemaids: "Les Bonnes du Luxembourg,"* 1894 (fig. 135)
(C 81; W 48)
Transfer lithograph, printed on cream laid paper, second of two states; signed in graphite with butterfly
202 x 158 mm (image); 310 x 203 mm (sheet)
Mansfield-Whittemore-Crown Collection, The Art Institute of Chicago, 80.1984

138. *The Long Balcony*, 1894
(C 82; W 49)
Transfer lithograph, printed on cream laid Japanese vellum, second of two states; signed in graphite with butterfly
204 x 158 mm (image); 319 x 222 mm (sheet)
Mansfield-Whittemore-Crown Collection, The Art Institute of Chicago, 81.1984

139. *The Little Balcony*, 1894 (fig. 138)
(C 83; W 50)
Transfer lithograph, printed on cream laid Japanese vellum, only state
201 x 157 mm (image); 336 x 235 mm (sheet)
Mr. and Mrs. A. Steven Crown, The Art Institute of Chicago, 211.1984

140. *The Long Gallery, Louvre*, 1894 (fig. 137)
(C 86; W 52)
Transfer lithograph, printed on cream laid paper, only state; signed in graphite with butterfly
216 x 159 mm (image); 323 x 206 mm (sheet)
The Art Institute of Chicago, Charles Deering Collection, 1927.5

FIGURE 133
Fruit Shop, Paris, 1884/86 (cat. no. 148).

FIGURE 134
A Shopfront, 1894 (cat. no. 152).

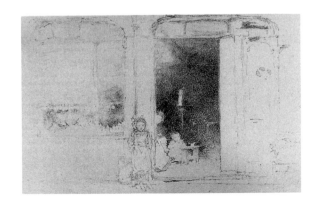

141. *The Little Café au Bois,* 1894 (fig. 131)

(C 91; W 56)

Transfer lithograph, printed on cream laid proofing paper, only state; signed in graphite with butterfly

210 x 156 mm (image);

300 x 196 mm (sheet)

The Art Institute of Chicago, Bryan Lathrop Collection, 1917.514

142. *The Whitesmiths, Impasse des Carmélites,* 1894

(C 92; W 53)

Transfer lithograph, printed on cream laid Japanese vellum, only state; signed in graphite with butterfly

219 x 163 mm (image);

335 x 240 mm (sheet)

Mansfield-Whittemore-Crown Collection, The Art Institute of Chicago, 85.1984

143. *The Laundress: "La Blanchisseuse de la place Dauphine,"* 1894 (fig. 127)

(C 93; W 58)

Transfer lithograph, printed on ivory laid paper, only state; signed in graphite with butterfly

230 x 157 mm (image);

315 x 202 mm (sheet)

Mansfield-Whittemore-Crown Collection, The Art Institute of Chicago, 90.1984

144. *Rue Furstenburg,* 1894

(C 97; W 59)

Transfer lithograph, printed on ivory laid paper, only state; signed in graphite with butterfly

225 x 159 mm (image);

323 x 202 mm (sheet)

Mansfield-Whittemore-Crown Collection, The Art Institute of Chicago, 91.1984

145. *The Forge, Passage du Dragon,* 1894

(C 102; W 72)

Transfer lithograph, printed on ivory laid paper, third of four states; signed in graphite with butterfly

223 x 159 mm (image);

320 x 204 mm (sheet)

Mr. and Mrs. A. Steven Crown, The Art Institute of Chicago, 231.1984

146. *The Smith, Passage du Dragon,* 1894 (fig. 130)

(C 103; W 73)

Transfer lithograph, printed on cream wove Japanese vellum, second of three states; signed in graphite with butterfly

275 x 179 mm (image);

309 x 231 mm (sheet)

The Art Institute of Chicago, Bryan Lathrop Collection, 1934.516

147. *La Fruitière de la rue de Grenelle,* 1894 (fig. 128)

(C 106; W 70)

Transfer lithograph; printed on cream laid Japanese vellum, only state; signed in graphite with butterfly

230 x 156 mm (image);

335 x 211 mm (sheet)

The Art Institute of Chicago, Bryan Lathrop Collection, 1917.598

148. *Fruit Shop, Paris*, 1884/86
(fig. 133)
(K 259)
Etching, printed on paper,
second of two states
125 x 213 mm (trimmed to
plate mark)
The Metropolitan Museum of
Art, New York, Harris Brisbane
Dick Fund, 1917, 17.3.136

149. *Terrace, Luxembourg Gardens,
No. 1*, 1892/93 **(fig. 125)**
(K 425)
Etching, printed on cream
Japanese paper, only state; signed
in graphite with butterfly
on tab
125 x 176 mm (trimmed to
plate mark)
The Art Institute of Chicago,
Bryan Lathrop Collection,
1917.523

150. *Sunflowers, Rue des Beaux-
Arts*, 1892/93 **(fig. 124)**
(K 422)
Etching, printed on ivory
Japanese paper, first of two
states; signed in graphite with
butterfly on tab
220 x 277 mm (trimmed to
plate mark)
The Art Institute of Chicago,
Bryan Lathrop Collection,
1934.643

151. *B b s, Luxembourg Gardens*,
1892/93 **(fig. 136)**
(K 428)
Etching, printed on cream laid
paper, only state; signed in
graphite with butterfly on tab
175 x 125 mm (trimmed to
plate mark)
Mr. and Mrs. Walter Spink

152. *A Shopfront*, 1894 **(fig. 134)**
(M 1458)
Lithographic crayon on thin,
transparent off-white transfer
paper, mounted on white wove
paper; signed in lithographic
crayon with butterfly
153 x 244 mm (image);
165 x 255 mm (sheet)
Hildegard Fritz-Denneville
Fine Art, London

153. *A Shop with a Balcony*,
c. 1899 **(fig. 123)**
(YMSM 526)
Oil on panel
22.3 x 13.7 cm
Hunterian Art Gallery,
University of Glasgow, Birnie
Philip Bequest, 46389

154. *The Open Door*, c. 1901
(fig. 129)
(M 1696)
Watercolor, with pen and
brown ink, over black crayon,
on brown wove paper
216 x 129 mm
Herbert F. Johnson Museum
of Art, Cornell University, Gift
of Louis V. Keeler, Class of
1911, and Mrs. Keeler, 60.088
Chicago only

FIGURE 137
*The Long Gallery,
Louvre*, 1894 (cat. no.
140).

FIGURE 138
The Little Balcony,
1894 (cat. no. 139).

Portraits and Published Editions

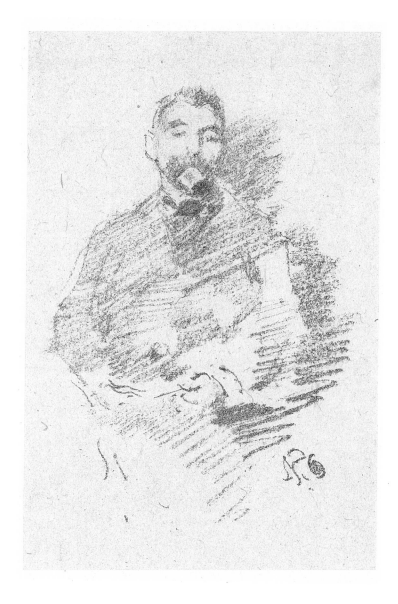

"There is a [lithographic] drawing of Mallarmé . . . which,
to those who knew him, recalls the actual man as no other
portrait does. It is faint, evasive, a mist of lines and
spaces that seem like some result of happy accident."

ARTHUR SYMONS, 1903

The work for which Whistler is best known is a portrait—*Arrangement in Gray and Black: Portrait of the Artist's Mother*—and the genre of portraiture is one that he explored and revised throughout his career, in all media. Some of Whistler's portraits are intimate, private testaments to bonds of love and friendship linking artist and sitter, while others are bravura public statements intended to display the maker's skill and the subject's status. Part of the special fascination of Whistler's lithographic portraits is that they communicate on both of these levels.

Whistler was fond of depicting his sister-in-law Ethel Birnie Philip, a striking, elegant woman whose sense of style and confident demeanor obviously impressed the artist. But she also inspired his affection, as indicated by the nickname he gave her, "Bunnie." Ethel resided with the Whistlers in their Paris home and acted as the artist's secretary during the early 1890s, prior to her marriage to journalist Charles Whibley in 1894. Thus she was an accessible model, and must have enjoyed wearing elaborate, fashionable gowns for paintings such as *Mother of Pearl and Silver: The Andalusian* (1888/1900; National Gallery of Art, Washington, D.C.)—a work that Whistler later described as "very swagger"[32]—and *Red and Black: The Fan* (1890/95; Hunterian Art Gallery, University of Glasgow).

Yet Ethel Birnie Philip was perhaps most impressive when she appeared less formally—as a thoroughly modern woman and a participant in a sophisticated, international social scene. This is how Whistler depicted her in the lithographs *The Winged Hat* and *Gants de suède (Suede Gloves)* (figs. 147 and 140), which preceded the large-scale painted por-

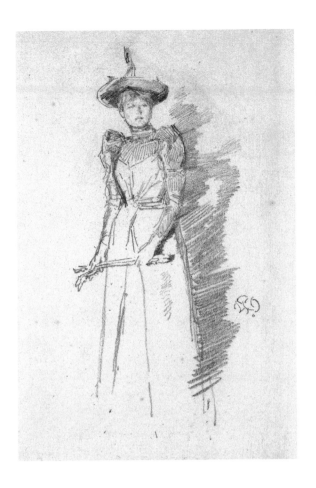

traits and, in many ways, hold their own against them. Compare, for example, the 1891 portrait *Harmony in Brown: The Felt Hat* (fig. 141), so close in pose to *Gants de suède*. In the lithograph an expressively cross-hatched shadow lends animation to Ethel's stance, whereas in the painting an overall dark haze almost overwhelms her. The hands, unresolved in the oil, serve in the print to indicate something about the model's personality, as she assertively clutches a pair of long gloves. Whistler's lithographic portraits of his sister-in-law reveal that he saw her as both a striking model and an intelligent friend. Uniting his own flair for display with an intuitive respect for Ethel's strong character, he captured in a single image her public and her private personas.

Commissioned portraiture was central to Whistler's artistic practice from the 1870s on—but these commissions tended to produce as many controversies as they did masterpieces.

Whistler departed from Victorian conventions by considering the formal aspects of a work of art to be more important than its physical resemblance to a sitter, a priority clearly indicated by his innovative two-part titles. An unfinished portrait of Lady Eden, for example, provoked a lawsuit between Whistler and the subject's husband, Sir William Eden, resulting in the artist's choice to destroy his own canvas rather than part with it before he considered it to be complete. According to Théodore Duret, who posed for Whistler in 1883–84, it took courage to have one's portrait painted by Whistler.[33] These were difficult works for the artist to finish, and although they attracted considerable critical attention, he was almost never truly satisfied with them. Many canvases testify to the extended struggle that went into their making. *Arrangement in Black and Gold: Comte Robert de Montesquiou-Fezensac*

FIGURE 142

Irving as Philip of Spain, No. 1, 1876/77 (cat. no. 170).

BELOW

FIGURE 143

Arrangement in Black and Gold: Comte Robert de Montesquiou-Fezensac, 1891–92 (YMSM 398). Oil on canvas; 208.6 x 91.8 cm. The Frick Collection, New York.

FIGURE 144

Count Robert de Montesquiou, 1894 (cat. no. 159).

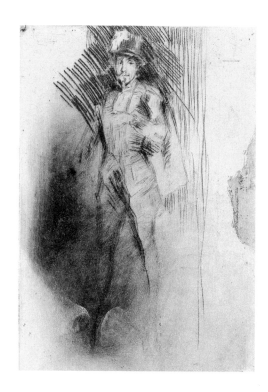

(fig. 143) required over one hundred sittings, and Whistler repeatedly rubbed down the canvas, so that the dramatic qualities of the final work derive not so much from the artist's desire to capture his friend's mercurial personality as from his determination to construct a composition with simple forms and a restricted palette.

In lithography Whistler seemed to know exactly when to stop. In his portrait of Mallarmé (fig. 139), for example, he applied the lithographic crayon with a delicate touch on very thin transfer paper, allowing the line to acquire the texture of the clothbound book he placed it upon. Many admiring viewers perceived an analogy between Whistler's ephemeral rendering and Mallarmé's ineffable genius. In fact this work, like the oil portrait of Montesquiou, required stamina on the part

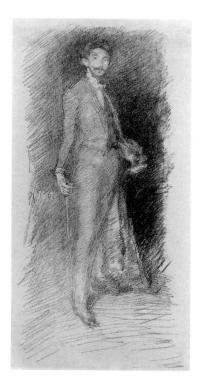

of the sitter; Mallarmé too had to pose repeatedly, and was nearly scorched by the fire that Whistler insisted he sit next to for optimum illumination. Neither Whistler nor Mallarmé would have considered this to be contradictory—they both believed in disguising the hard work of construction that resulted in the effect of beautiful simplicity.

So considered and deliberate was Whistler's portraiture that it could not easily be duplicated. This was a handicap in an era enthralled with mechanical reproducibility. It was common practice for reduced-size reproductions to be made of famous paintings, just as postcards are sold in museum shops today. Typically a professional engraver (or, beginning in the 1850s, a photographer) would be hired to make the reproduction, which would be published and distributed by a gallery or journal. Several editors became interested in issuing reproductions of the painting *Comte Robert de Montesquiou-Fezensac* after its successful

showing at the 1894 Société nationale des beaux-arts exhibition in Paris, but Whistler was uneasy about the intervention of a middleman, and decided that no one but himself should reproduce his work. He had made two attempts to create an etched version of the painting *Arrangement in Black, No. 3: Sir Henry Irving as Philip II of Spain* (1876; The Metropolitan Museum of Art, New York), in 1876/77 (see fig. 142). However, his efforts in 1894 to achieve a lithographic version of the painting of Montesquiou (see fig. 144) failed. Whistler could not blame either of the two printers with whom he worked, nor his materials—he had to conclude that the task of doing the "same masterpiece *twice* over" was an impossible one.[34] In lithography he could not duplicate the mystery of the painting, just as in painting he did not achieve the lightness of his lithographs. It was a mistake he did not make again.

The intimacy of Whistler's lithographic portraits did not preclude their suitability for publication. Both of the 1890 portraits of Ethel Birnie Philip appeared as supplements in an eccentric British journal, *The Whirlwind*, and *Stéphane Mallarmé* served as the frontispiece to the Parisian edition of the poet's volume *Vers et Prose*, published in 1893. Later, one of Whistler's two lithographic portraits of his brother Dr. William Whistler appeared in a short-lived journal of the Aesthetic Movement, *The Pageant*; and an image of his friend and early biographer the American artist Joseph Pennell (fig. 145) was the frontispiece to *Lithography and Lithographers*, written by Pennell and his wife, Elizabeth Robins Pennell. The portraits of Mallarmé and Pennell are two of several studies (see also figs. 150–151 and 154) that Whistler drew by firelight, giving them the drama of flickering light effects and the warmth of intimacy.

Such publications advertised Whistler's activity as a lithographer and provided a source

of income. But the artist also paid a price for presenting his work to the public in this way, because he ran the risk of lowering the market value of his prints; when the lithographs appeared in magazines that cost only a penny, he had difficulty selling the same images through dealers for three and four guineas each. Furthermore Whistler faced a general prejudice in the art world against lithography, which was generally considered to be a commercial medium. His reductive, minimal style was not only at odds with much of his own work in etching, which the public admired, but had no precedents in lithography. Images such as *The Winged Hat* were sometimes mistaken for photomechanical reproductions of

FIGURE 145

Firelight: Joseph Pennell, 1896 (cat. no. 163).

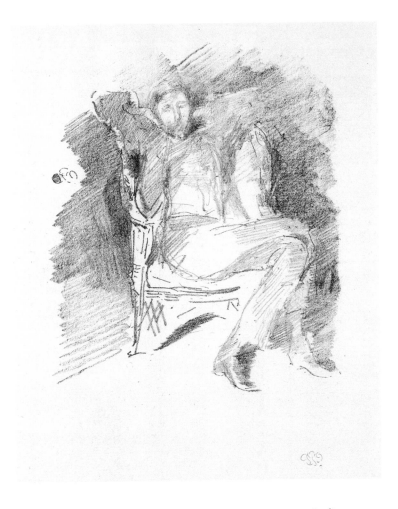

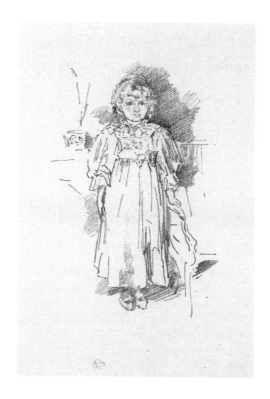

FIGURE 146

Little Evelyn, 1896
(cat. no. 165).

drawings—a curious dilemma for the artist, who wished his prints to resemble unique sketches, but who also wanted to make a distinction between large editions, printed by machine from supplementary stones, and choice hand-printed impressions. In both cases, however, he wished the Ways to do the printing, trusting them to maintain his high standards even for periodical publications. Indeed when *The Art Journal* suggested hiring another printer, Whistler responded irately that he "could not possibly allow my work to be published by anyone else but Mr. Way. . . . It is to him entirely that is due the revival of artistic lithography in England. . . . I certainly owe all the encouragement I may have received in my work to his exquisite interpretation."[35] Whistler paid further tribute to his friend in a handsome lithographic study (fig. 152).

Despite the misunderstandings that Whistler's dual intentions sometimes provoked, his instincts were prescient. By the end of the century, the revival of artistic lithography was well under way in Britain and France, and he had been instrumental in initiating it. Through the example he set, art-buying audiences learned to appreciate the aesthetic value of a few nuanced lines, whereas formerly it had been common to equate skill with elaboration and density of detail.

The increasingly positive reception of Whistler's published portrait lithographs of his friends and family in the 1890s led his dealers to suggest that he seek commissions from other connoisseurs and collectors. A lithographic portrait was likely to be completed in a shorter period of time than a painting, and the client had the opportunity to order an edition of prints to distribute among acquaintances. *Little Evelyn* (fig. 146), a portrait of the four-year-old daughter of Whistler's dealer David Croal Thomson that was published in *The Art Journal* in 1896, seemed to predict the success of this venture. In it Whistler avoided the commonplace sentimentality of Victorian images of children and instead created a character study as direct and unfussy as any of his portraits of adults.

Although the artist declared himself quite pleased with *Little Evelyn* and was amused by the thought of himself as a child portraitist, the scheme to advertise for commissions, proposed in the spring of 1896, was not implemented. Although Whistler needed the income that the venture might have generated, he could not bear to commit himself in this way. His wife, Beatrix, was seriously ill, and he turned to her and her family as the primary subjects of his portraiture. (BS)

155. *The Winged Hat*, 1890
(fig. 147)
(C 34; W 25)
Transfer lithograph, printed
on cream laid paper, second of
two states; signed in graphite
with butterfly and inscribed in
Whistler's hand, "*Songs on Stone*"
179 x 174 mm (image);
260 x 207 mm (sheet)
Mansfield-Whittemore-Crown
Collection, The Art Institute
of Chicago, 57.1984

156. *Gants de suède*
(Suede Gloves), 1890 (fig. 140)
(C 35; W 26)
Transfer lithograph, printed
on cream laid paper, only state
216 x 102 mm (image);
280 x 199 mm (sheet)
The Art Institute of Chicago,
Bryan Lathrop Collection,
1917.559

157. *Stéphane Mallarmé*, 1892
(fig. 139)
(C 60; W 66)
Transfer lithograph, printed
on ivory laid paper, only state
97 x 70 mm (image);
169 x 137 mm (sheet)
The Art Institute of Chicago,
Bryan Lathrop Collection,
1917.593

158. *Count Robert de Montesquiou,*
No. 2, 1894
(C 84; W 138)
Transfer lithograph, printed
on grayish ivory China paper,
only state; signed in graphite
with butterfly
227 x 96 mm (image);
360 x 332 mm (sheet)
The Art Institute of Chicago,
Charles Deering Collection,
1927.5863

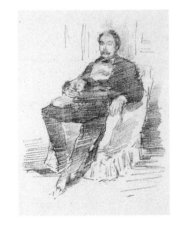

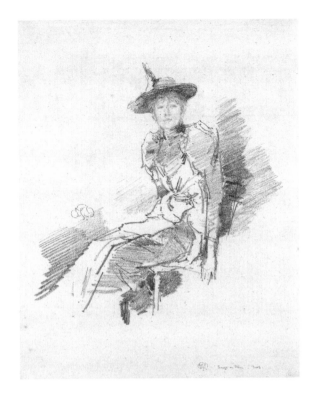

159. *Count Robert de Montesquiou,*
1894 (fig. 144)
(C 85; W 137)
Transfer lithograph, printed
on grayish ivory wove
proofing paper
233 x 112 mm (image)
Collection of Paul F. Walter

160. *Portrait of Dr. Whistler,*
No. 2, 1894 (fig. 149)
(C 111; W 142)
Transfer lithograph, printed
on ivory laid paper, only state
192 x 154 mm (image);
324 x 205 mm (sheet)
Mr. and Mrs. A. Steven Crown,
The Art Institute of Chicago,
275.1984

ABOVE

FIGURE 147

The Winged Hat, 1890
(cat. no. 155).

FAR LEFT

FIGURE 148

*Portrait of the Artist's
Brother Dr. William
McNeill Whistler*,
1871/73 (cat. no. 169).

LEFT

FIGURE 149

*Portrait of Dr.
Whistler, No. 2*, 1894
(cat. no. 160).

FIGURE 150
Firelight, 1896
(cat. no. 164).

FIGURE 151
Walter Sickert, 1895
(cat. no. 161).

BELOW LEFT

FIGURE 152
Study No. 1: Mr.
Thomas Way, 1896
(cat. no. 168).

BELOW RIGHT

FIGURE 153
Study: Portrait of
Thomas Way, 1896
(cat. no. 172).

161. *Walter Sickert*, **1895**
(fig. 151)
(C 115; W 79)
Transfer lithograph, printed
on cream laid Japanese vellum,
only state; signed in graphite
with butterfly
190 x 140 mm (image);
293 x 234 mm (sheet)
Mansfield-Whittemore-Crown
Collection, The Art Institute
of Chicago, RX 20769

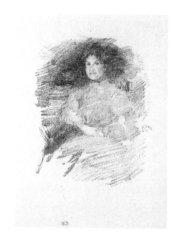

162. *The Russian Schube*, **1896**
(C 142; W 112)
Transfer lithograph, printed
on cream laid paper, second
of two states; signed in graphite
with butterfly
177 x 150 mm (image);
283 x 230 mm (sheet)
The Art Institute of Chicago,
Bryan Lathrop Collection,
1917.641

163. *Firelight: Joseph Pennell*, **1896**
(fig. 145)
(C 144; W 104)
Transfer lithograph, printed
on cream laid paper, only state;
signed in graphite with butterfly
167 x 140 mm (image);
355 x 262 mm (sheet)
Mansfield-Whittemore-Crown
Collection, The Art Institute
of Chicago, 111.1984

164. *Firelight*, **1896 (fig. 150)**
(C 145; W 103)
Transfer lithograph, printed on
ivory laid paper, only state;
signed in graphite with butterfly
191 x 149 mm (image);
332 x 210 mm (sheet)
The Art Institute of Chicago,
Bryan Lathrop Collection,
1917.680

165. *Little Evelyn*, **1896 (fig. 146)**
(C 146; W 110)
Transfer lithograph, printed on
cream Japanese paper, only state;
signed in graphite with butterfly
174 x 115 mm (image);
287 x 219 mm (sheet)
Mr. and Mrs. A. Steven Crown,
The Art Institute of Chicago,
258.1984

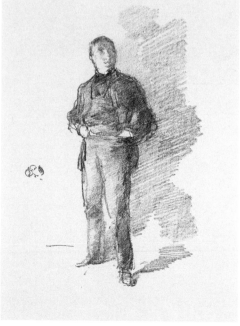

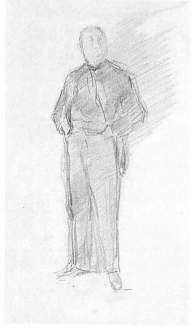

166. *Needlework*, 1896 (fig. 154)

(C 149; W 113)

Transfer lithograph, printed on
cream laid paper, only state;
with black-crayon additions, and
signed in graphite with butterfly

197 x 143 mm (image);

284 x 228 mm (sheet)

Mansfield-Whittemore-Crown
Collection, The Art Institute
of Chicago, 121.1984

**167. *Study No. 2: Mr. Thomas Way*,
1896**

(C 152; W 108)

Transfer lithograph; printed
on grayish ivory chine, mounted
on ivory plate paper, only state

168 x 112 mm (image);

227 x 162 mm (chine);

378 x 284 mm (plate paper)

Mansfield-Whittemore-Crown
Collection, The Art Institute
of Chicago, 115.1984

**168. *Study No. 1: Mr. Thomas Way*,
1896 (fig. 152)**

(C 153; W 107)

Transfer lithograph, printed on
grayish white chine, mounted
on white plate paper, only state

187 x 119 mm (image); 226 x
162 mm (chine); 379 x 283 mm
(plate paper)

Mansfield-Whittemore-Crown
Collection, The Art Institute
of Chicago, 114.1984

**169. *Portrait of the Artist's Brother
Dr. William McNeill Whistler*,
1871/73 (fig. 148)**

(YMSM 123)

Oil on panel

43.8 x 34.9 cm

The Art Institute of Chicago,
Gift of Mary T. Wentworth in
memory of her husband, John,
1977.235

Chicago only

**170. *Irving as Philip of Spain, No. 1*,
1876/77 (fig. 142)**

(K 170)

Etching and drypoint, printed
on off-white laid paper, second
of three states

226 x 150 mm (plate);

333 x 212 mm (sheet)

University of Michigan Museum
of Art, Ann Arbor, Bequest of
Margaret Watson Parker,
1954/1.368

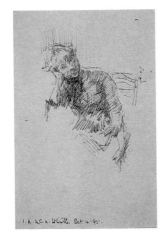

**171. *Miss Ethel Birnie Philip*, 1885
(fig. 155)**

(M 1060)

Pen and brown ink on off-
white laid paper

180 x 118 mm

Hunterian Art Gallery,
University of Glasgow, Birnie
Philip Bequest, 46102

**172. *Study: Portrait of Thomas
Way*, 1896 (fig. 153)**

(M 1453)

Graphite on cream wove paper

201 x 127 mm

Mansfield-Whittemore-Crown
Collection, The Art Institute
of Chicago, 10.1990

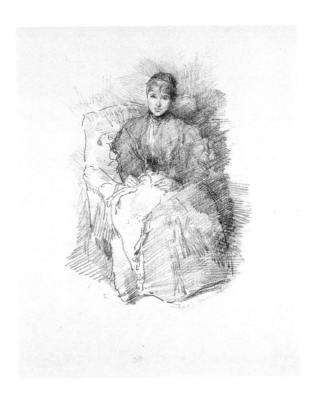

FIGURE 154

Needlework, 1896
(cat. no. 166).

FIGURE 155

*Miss Ethel Birnie
Philip*, 1885 (cat.
no. 171).

JAMES McNEILL WHISTLER AND THE ART OF LITHOGRAPHY

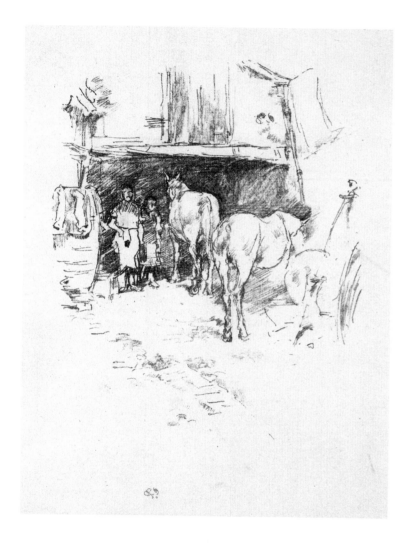

"Here he dealt with figures full of character and suggested action,
 lit by the flickering lights of the forges and rays of sunlight,
in interiors full of all sorts of tools and materials . . . ,
 yet always drawn with such selection that they make perfect
compositions and express just what he intended us to see."

T. R. WAY, 1912

Throughout his career, Whistler was fascinated by the image of the blacksmith at work before a fiery forge. As early as 1861 he made an ambitious etching of the subject, *The Forge* (fig. 157), and in his last years, he returned to the theme in Ajaccio, on the island of Corsica (fig. 164). He was no doubt attracted by the flickering and dramatic light effects, by the camaraderie of the smiths, and perhaps also by the mythological associations with creativity. Hephaestus, the Greek god of fire and fabricator of Achilles's shield, was the representative of both blacksmiths and artisans. Old Masters of the national schools of Spain, France, and England—such as Velázquez, the Le Nain brothers, and Joseph Wright of Derby (see fig. 158)—had established a striking iconography that brought out both the magical and the physical aspects of the smith's work. Whistler was no doubt influenced by his predecessors' use of chiaroscuro to construct monumental forms. But his own contribution to the genre extends its symbolic potential by explicitly drawing attention to the artists' role in creating—almost literally forging—images out of materials like metal or stone.

Despite the fact that the smiths' molding of metal might have suggested parallels with his own manipulation of the copper etching plate, Whistler most frequently treated the blacksmith theme in transfer lithography, a medium that allowed him to balance observation of detail with suggestion of mood. For example, an image of 1895, *The Good Shoe* (fig. 167), is something of a genre scene, showing a man at work shoeing a horse in the forecourt of a smithy. A second horse standing beside the smith and a small crouching cat in

the foreground give the image an anecdotal immediacy. Two Paris lithographs of 1894, *The Smith, Passage du Dragon* (fig. 130) and *The Forge, Passage du Dragon*, concentrate on atmosphere rather than incident—the blacksmiths appear as mysterious figures, only partially visible in the dark interiors of their shops, which the artist strove to render entirely opaque by applying lithographic crayon to a nearly textureless, extremely delicate, French transfer paper.

Perhaps appropriately, given their emblematic associations, blacksmiths' shops turned out to be sites not only for technical experimentation but also for emotional fortification. In 1895 Whistler and his wife, Beatrix, who was recently diagnosed as suffering from cancer, went to the seaside town of Lyme Regis in the county of Dorset in England; Beatrix went on to London in October, but Whistler remained in Lyme Regis through December. There, he sought to quell his anxiety with constant work, producing a series of lithographs and paintings and arranging for a retrospective exhibition of his lithographs at the Fine Art Society in London. His primary subject matter during this time was not the expansive ocean view afforded by the site but rather a local smithy, owned by George Govier and located on Broad Street, not far from the Whistlers' hotel.

It must have given the artist some solace to stroll to the nearby smithy and lose himself in the sights and sounds of this industrious environment. As the Goviers went about their business, fashioning horseshoes and other objects, Whistler was productive as well, rapidly drawing or painting sketches on transfer paper or small wood panels. In these scenes no line seems superfluous, although

Whistler established compositions of varying complexity. The perspective selected for *The Good Shoe* (fig. 167), for instance, was adopted again for *The Smith's Yard* (fig. 156), a more fully elaborated version of a similar scene. These Whistler considered to be "perhaps the most remarkable among all the new lithographs!—The most personal—and the very best proof of the qualities (if there be any at all) of the man who did them!"[36]

Interiors illuminated by a flaming forge show the artist striving to establish in lithography strong, almost painterly, contrasts between light and dark while retaining a

FIGURE 157
The Forge, 1861
(cat. no. 185).

FIGURE 158
Richard Earlom
(British; 1743–1822)
after Joseph Wright
of Derby (British;
1734–1797). *An Iron
Forge*, 1773. Mezzotint
on paper; 480 x 590 mm.
The Art Institute
of Chicago, Purchased
from Zeitlin and Ver
Brugge, Los Angeles,
California (1977.308).

OPPOSITE PAGE

FIGURE 156
The Smith's Yard, 1895
(cat. no. 177).

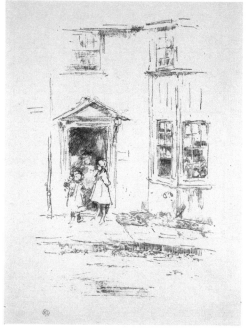

FIGURE 159
The Blacksmith, 1895
(cat. no. 179).

FIGURE 160
*The Little Doorway,
Lyme Regis,* 1895
(cat. no. 173).

FIGURE 161
A Shop, 1894/95
(cat. no. 188).

simplicity of line. In *The Blacksmith* and *The Brothers* (figs. 159 and 169), he seems to have worked from dark to light, establishing a deep, opaque interior before allowing the flames to reveal the figures and objects in the middle- and foregrounds. Early states of several of these lithographs, however, reveal that in fact Whistler drew the figures first and laid in the dark shadows around them. Something of the artist's intent to combine printmaking techniques with those of painting is indicated by his remark that he hoped to get "a lot of colour out of these new drawings."[37]

Perhaps due to the problems he faced in his personal life at this time, Whistler was more willing than usual to engage in the lives of his subjects. The depictions of the Lyme Regis smiths are indeed portraits of the Govier family: the patriarch, George Govier, and his two sons, Samuel and Thomas. Images like *The Smith's Yard* (fig. 156) show that Whistler became thoroughly engaged in the everyday activities of these men. They also appealed to him as subjects for more conventional portraits: the painting *The Master Smith of Lyme Regis* (fig. 162) depicts Samuel Govier, and *The Master Smith* (fig. 166) is an idiosyncratic lithographic portrait of George Govier, one impression of which Whistler had specially mounted and inscribed it with a dedication to "the old Gentleman."[38] Although these works are small in scale, and the proximity between artist and sitter seems to connote intimacy and relaxation, the effect is one of monumentality—the Goviers were men whom Whistler admired.

When not sketching at the Govier smithy, Whistler enjoyed the picturesque architecture and daily life of the seaside town, as he had in Brittany in 1893. He wandered up and down Broad Street, finding many local shopfronts and dwellings to capture his attention (see figs. 160–61 and 170). Even out of doors, however,

FIGURE 162

The Master Smith of Lyme Regis, 1895 (cat. no. 187).

he remained preoccupied with firelight effects. In *The Fair* (fig. 163), which depicts a festive, lantern-lit row of booths, he captured an essential element of the perception of fire—that it is something as much unseen as seen, because of its blinding properties. The white portions in the foreground of the sheet represent this blindness and involve the viewer in the scene.

As much as he relished the process of making the transfer drawings, Whistler felt a restless impatience to bring the work to completion. Maintaining a close correspondence with the Ways, his printers in London, the artist could send them his transfer drawings and receive proofs within days. "It is curious," he wrote to T. R. Way on September 25, 1895, "but I find I have a greater desire than ever to get on with these lithographs—and I fancy I shall be able to do something really

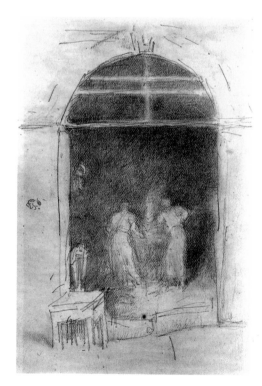

FIGURE 163

The Fair, 1895/96
(cat. no. 184).

FIGURE 164

The Forge,
1901 (cat. no. 190).

good now—So you may imagine how eager I shall be to see the proofs!"[39]

The initial results were not good, however. Whistler, having become very enthusiastic about French transparent transfer paper, had brought a supply with him from Paris and was determined to use it for the Lyme Regis lithographs. It may have been that the damp sea air affected the paper adversely, but the Ways were at first unable to explain the weak, pale impressions they obtained after transferring the drawings to stone.

Having put so much effort into composing the drawings, and trying to bear in mind the lessons he had learned in Paris about simplifying his drawing to accommodate the fragility of the transfer paper, Whistler was bitterly disappointed when so many of them failed to print satisfactorily. He attempted to salvage some of them in the Ways' printing shop upon his return to London in December—even asking T. R. Way to pose as a smith, backlit by a window—but these revisions were not wholly successful, and he was distracted by the opening of a major exhibition of his lithographs at the Fine Art Society and by Beatrix's continuing ill health.

The Lyme Regis lithographs may have been technical disappointments, but the evocative imagery remained in Whistler's memory. Late in his life, when he was on holiday in Ajaccio, he returned to the theme in *The Forge*, a rapidly executed pencil sketch depicting two smiths in the dark, mysterious atmosphere of their working environment (fig. 164). The artist and his subjects seem to have been equally absorbed in their almost ritualistic tasks. *The Forge* is a small but compelling manifesto of Whistler's resilient determination, inspired by the figure of the blacksmith, to create an art that was strong by virtue of its delicacy. (BS)

173. *The Little Doorway, Lyme Regis*, **1895 (fig. 160)**
(C 119; W 83)
Transfer lithograph, printed on cream laid paper, only state; signed in graphite with butterfly
234 x 157 mm (image);
282 x 277 mm (sheet)
The Art Institute of Chicago, Bryan Lathrop Collection, 1917.611

174. *The Master Smith*, **1895 (fig. 166)**
(C 120; W 84)
Transfer lithograph, printed on cream laid paper, second of two states; signed in graphite with butterfly
106 x 72 mm (image);
282 x 227 mm (sheet)
The Art Institute of Chicago, Bryan Lathrop Collection, 1917.612

175. *The Good Shoe*, **1895 (fig. 167)**
(C 122; W 86)
Transfer lithograph, printed on cream laid paper, only state; signed in graphite with butterfly
171 x 120 mm (image);
282 x 227 mm (sheet)
The Art Institute of Chicago, Charles Deering Collection, 1927.5838

176. *Father and Son*, **1895**
(C 123; W 87)
Transfer lithograph, printed on ivory laid paper, only state; signed in graphite with butterfly
211 x 156 mm (image);
319 x 205 mm (sheet)
The Art Institute of Chicago, Bryan Lathrop Collection, 1917.615

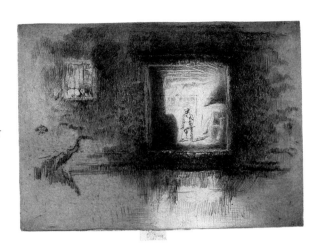

177. *The Smith's Yard*, **1895 (fig. 156)**
(C 124; W 88)
Transfer lithograph, printed on cream laid paper, only state; signed in graphite with butterfly
191 x 158 mm (image);
285 x 227 mm (sheet)
The Art Institute of Chicago, Bryan Lathrop Collection, 1917.616

FIGURE 165
Nocturne: Furnace, 1879/80 (cat. no. 186).

BELOW LEFT
FIGURE 166
The Master Smith, 1895 (cat. no. 174).

BELOW RIGHT
FIGURE 167
The Good Shoe, 1895 (cat. no. 175).

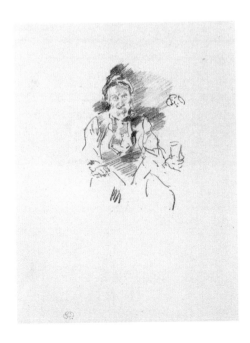

178. *John Grove*, 1895

(C 126; W 93)

Transfer lithograph, printed on ivory laid paper, only state; signed in graphite with butterfly

207 x 154 mm (image);

247 x 192 mm (sheet)

Mansfield-Whittemore-Crown Collection, The Art Institute of Chicago, 98.1984

179. *The Blacksmith*, 1895 (fig. 159)

(C 127; W 90)

Transfer lithograph, printed on cream laid paper, third of three states; signed in graphite with butterfly

220 x 167 mm (image);

282 x 228 mm (sheet)

The Art Institute of Chicago, Bryan Lathrop Collection, 1917.618

180. *The Brothers*, 1895 (fig. 169)

(C 128; W 91)

Transfer lithograph, printed on cream laid paper, second of two states; signed in graphite with butterfly

205 x 153 mm (image);

283 x 230 mm (sheet)

The Art Institute of Chicago, Bryan Lathrop Collection, 1917.620

181. *The Old Smith's Story*, 1895

(C 129; W 98)

Transfer lithograph, printed on cream laid paper, only state; signed in graphite with butterfly

205 x 153 mm (image);

283 x 230 mm (sheet)

The Art Institute of Chicago, Bryan Lathrop Collection, 1917.627

182. *The Little Steps, Lyme Regis*, 1895/96

(C 131; W 94)

Transfer lithograph, printed on cream laid paper, second of two states; signed in graphite with butterfly

211 x 146 mm (image);

285 x 230 mm (sheet)

The Art Institute of Chicago, Bryan Lathrop Collection, 1917.623

183. *Sunday, Lyme Regis*, 1895 (fig. 170)

(C 134; W 96)

Transfer lithograph, printed on cream laid paper, only state; signed in graphite with butterfly

196 x 122 mm (image);

285 x 230 mm (sheet)

The Art Institute of Chicago, Bryan Lathrop Collection, 1917.625

184. *The Fair*, 1895/96 (fig. 163)

(C 135; W 92)

Transfer lithograph, printed on cream laid paper, second of two states; signed in graphite with butterfly

236 x 158 mm (image);

284 x 226 mm (sheet)

The Art Institute of Chicago, Bryan Lathrop Collection, 1917.621

FIGURE 168

The Blacksmith's Howth, 1900 (cat. no. 189).

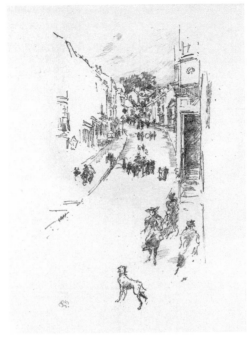

FIGURE 169

The Brothers, 1895
(cat. no. 180).

FIGURE 170

Sunday, Lyme Regis,
1895 (cat. no. 183).

185. *The Forge*, 1861 (fig. 157)
(K 68)
Etching and drypoint, printed
on cream Japanese *gampi* paper,
third of four states
212 x 341 mm (plate);
257 x 371 mm (sheet)
The Art Institute of Chicago,
Bryan Lathrop Collection,
1934.561

**186. *Nocturne: Furnace*, 1879/80
(fig. 165)**
(K 213)
Etching, printed on ivory laid
paper, third of seven states;
signed in graphite with
butterfly on tab
164 x 227 mm (trimmed to
plate mark)
The Art Institute of Chicago,
Gift of H. R. Warner, 1933.955

**187. *The Master Smith of Lyme
Regis*, 1895 (fig. 162)**
(YMSM 450)
Oil on canvas
51.4 x 31.1 cm
Museum of Fine Arts, Boston,
Warren Collection, 96.951

188. *A Shop*, 1894/95 (fig. 161)
(YMSM 448)
Oil on panel
12.5 x 21.6 cm
Terra Foundation for the Arts,
Daniel J. Terra Collection,
1992.148; Photograph courtesy
of Terra Museum of American
Art, Chicago

**189. *The Blacksmith's Howth*, 1900
(fig. 168)**
(M 1619r)
Watercolor on cream Japanese
paper, laid down on card
147 x 249 mm
Hunterian Art Gallery,
University of Glasgow, Birnie
Philip Bequest, 46289

190. *The Forge*, 1901 (fig. 164)
(M 1679r)
Graphite on cream wove paper
150 x 96 mm
Library of Congress,
Washington, D.C., Prints and
Photographs Division

Final Lithographs: The Savoy Hotel and the Birnie Philip Family

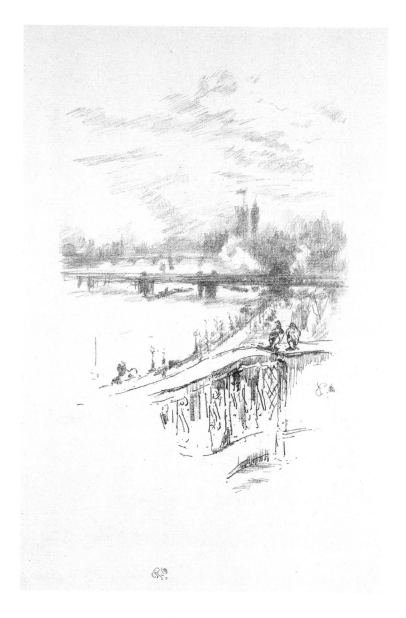

"The gathering tension due to Mrs. Whistler's increasing illness seemed to brace him up to a point of keenness in his lithographic work that enabled him to make a group of drawings, which, I think, form the climax of his black and white work."

T. R. WAY, 1912

Following the artist's return to London from Lyme Regis, the Whistlers lived for a time in De Vere House, overlooking Kensington Gardens. By mid-February 1896 they had relocated to the Savoy Hotel, one of London's newest and most luxurious hotels. There they occupied an upper suite with balconied windows that offered spectacular views of the Victoria Embankment and the Thames (see fig. 172). Although Whistler refused to acknowledge it even to himself, Beatrix was now in the final months of her battle with cancer. She was kept bedridden by the pain of her illness and by the morphine on which she had become dependent. Worried and distracted, Whistler spent long hours by her side. One artist friend wrote: "I will never forget the misery and pathos of his sitting beside his wife's sofa, holding her hand, while she bravely tried to cheer him with banter and gossip."[40]

During this terrible period of Whistler's life, lithography appears to have been the only aspect of his work that did not suffer, perhaps because Beatrix loved the medium, or because the small sheets of transfer paper were convenient to work on as he kept his wife company. The proximity of the hotel to the Ways' printing shop on Wellington Street no doubt also encouraged Whistler to focus on lithography; on many winter afternoons, the artist sought solace in the company of his printers, as he made revisions to his stones. Many years later, T. R. Way recalled: "The gathering tension due to Mrs. Whistler's increasing illness seemed to brace him up to a point of keenness in his lithographic work that enabled him to make a group of drawings, which, I think, form the climax of his black and white work."[41]

Altogether Whistler created eight lithographs in his rooms at the Savoy Hotel. As he attended his wife, he had ample opportunity to contemplate the Thames in all its moods and, not surprisingly, six of his Savoy lithographs are views of the river drawn from his balcony. *Savoy Pigeons* and *Evening, Little Waterloo Bridge* (figs. 171 and 173) were probably the first images he drew on transfer paper after settling in at the hotel. *Savoy Pigeons* takes its title from the two birds perched on the iron railing of the Whistlers' balcony; beyond them is a sweeping view toward Westminster, with Lambeth Palace, the Houses of Parliament, and Westminster Bridge seen in the distance. In his heightened emotional state, the artist seems to have been particularly sensitive to nuances of time and atmosphere on the river. In *Evening, Little Waterloo Bridge*, he suggested a sense of diminishing daylight by emphasizing the long shadows beneath the bridge and the reflections of its piers in the water. Once his printers had transferred this drawing, Whistler worked in their offices with crayon and stump directly on stone to enhance the delicate effects of fog at twilight. In another lithograph drawn from a slightly different vantage point at dawn, the artist contrasted the bustle of awakening life along the Embankment with the stillness of the far side of the Thames, still shrouded in the mists of early morning.

Whistler drew *Charing Cross Railway Bridge* (fig. 180) from approximately the same spot on his balcony as he had *Savoy Pigeons*, but this time he let his eye travel across to the south bank of the Thames rather than along the Embankment on the near side. The Lion Brewery and St. Thomas's Hospital are two

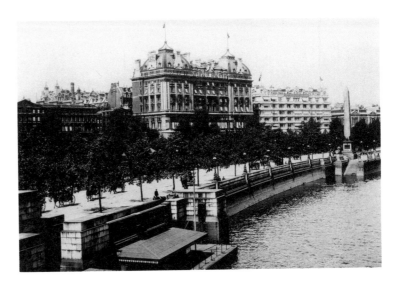

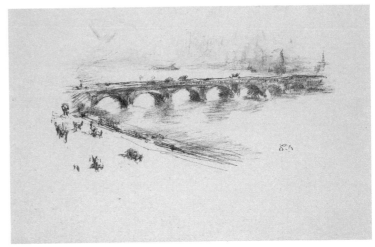

OPPOSITE PAGE

FIGURE 171

Savoy Pigeons, 1896 (cat. no. 191).

FIGURE 172

Victoria Embankment with the Hotel Cecil and the Savoy Hotel, London, 1903. Royal Commission on Historical Monuments (England)/Crown copyright.

FIGURE 173

Evening, Little Waterloo Bridge, 1896 (cat. no. 192).

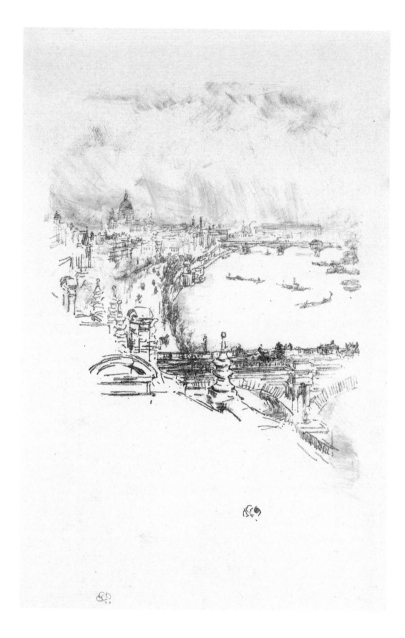

FIGURE 174

Little London, 1896
(cat. no. 194).

this image, the artist was reminded of the risks of stumping directly on transfer paper. When he drew *Little London* (fig. 174), he waited until the image had been safely put on stone before adding subtle touches of stump work throughout the image. This lithograph, probably the last of the river views he drew on transfer paper at the Savoy, is also his most elaborate. A panoramic vista of the north bank of the Thames, the lithograph shows the Victoria Embankment and the City of London as they looked before the devastating bombings of World War II. Looming in the distance are the great dome and towers of St. Paul's Cathedral. In the foreground, just below the artist's vantage point, is a segment of Waterloo Bridge, bustling with traffic. The artist was buoyed up by the delicate results he obtained in his river scenes drawn from the Savoy and, by early April when he had started to distribute the proofs, he wrote to New York dealer Edward G. Kennedy of his belief that they "really mark something 'new' in lithography."[42]

Whistler had fallen in love with the Thames early in his career and had, for decades, contrived to live on its banks in Chelsea. In 1878, when he experimented for the first time with the medium of lithotint, he had explored some of his favorite aspects of the river: in *Limehouse* (fig. 21), the shipping activity of its banks; in *The Tall Bridge* and *The Broad Bridge* (figs. 28 and 36), the rustic yet graceful span of its monuments; in *Nocturne* and *Early Morning* (figs. 18 and 24), the poetic abstraction of the river at the start and end of the day. Now, as he marked time with Beatrix in their rooms atop the Savoy, Whistler returned to lithotint one last time for a masterful portrait of the river, initially entitled *The River from the Savoy* and later, more simply, *The Thames* (fig. 175).

For this image the artist worked directly on a stone that had been prepared for him by

of the identifiable landmarks in the distance. The artist used stumping again in this image to suggest gradations of tone in the sky, water, and in the reflections of the bridge. This delicate work did not transfer well from Whistler's drawing to stone, however, and the result was grittier than he intended. To lighten the heavy areas, he used a fine, sharp tool, scraping extensively in some areas. From his experience with

his printers and delivered to him at the hotel. Over a period of several weeks, Whistler returned to the stone again and again, as he contemplated the atmospheric effects of late winter twilight on the river. In the first proofs, his washes were too heavy; the artist wished to capture the silvery, reflective quality of the river's surface. The stone went back and forth to the Ways' printing offices on Wellington Street several times to be proved. Whistler always insisted on having it brought back to the Savoy for further revisions, explaining that he needed "nature to refer to" as he worked out his changes. According to T. R. Way, Whistler "knew what he wanted to get, and nothing short of it would satisfy him, even if the work had to be done over and over again; no trouble was too great for him to take."[43] As he labored over this lithotint of the Thames, Whistler clearly came to believe in the originality and importance of the image. He had finally succeeded in distilling into a single image the mystery, poetry, and simplicity that had always attracted him to the river at night. When *The Thames* won a medal at the Exposition Universelle in Paris in 1900, Théodore Duret described the lithotint as a "demi-nocturne crafted with a wholly new quality," and exclaimed ecstatically in a letter to his friend Whistler: "It is infused with transparency and incredible lightness, and I was astonished by it."[44]

In late March, toward the end of their stay at the Savoy, Whistler also drew two portraits of his wife on lithographic transfer paper. These images, which show Beatrix about a month and a half before her death, are among the most sensitive and moving portraits of the artist's career. In *The Siesta* (fig. 176), she lies on her couch, gazing back at her husband with pain and exhaustion plainly visible on her face. From under the masses of blankets that cover her, Whistler's

lithograph shows one frail arm hanging lifelessly at her side. The once robust young woman had become hopelessly thin and weak. While he was able to observe the physical effects of her illness as her drew her, Whistler was still unwilling to recognize the inevitable outcome of her suffering. When he sent an early proof of the portrait to Kennedy in New York, he optimistically titled it "la belle dame convalescente"; a few days earlier, he had written a letter to Kennedy in which he reported joyfully that Beatrix was "really better" and added that he would send more lithographs "as we go on getting stronger

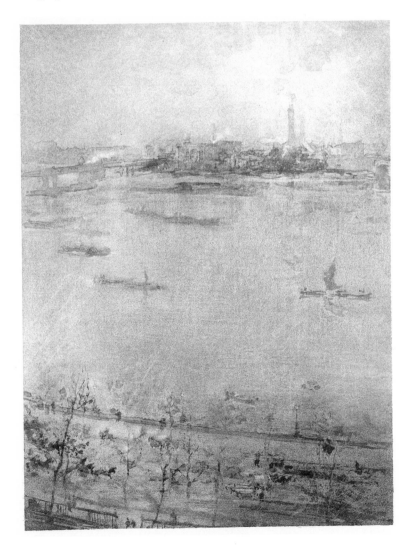

FIGURE 175

The Thames, 1896 (cat. no. 197).

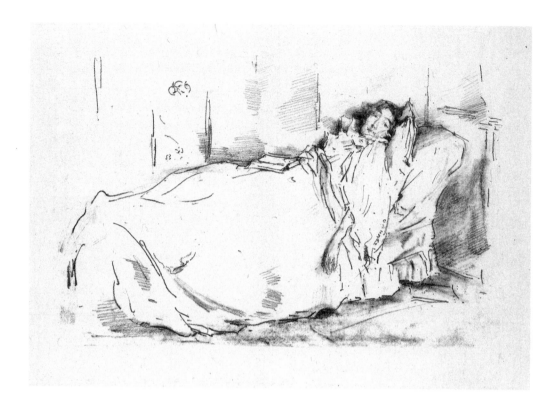

FIGURE 176

The Siesta, 1896
(cat. no. 195).

every day."[45] By early May, however, Whistler could no longer continue to delude himself, and the lithograph was given its present title, *The Siesta*. It was a title he had used before for images of languid young women on their daybeds. There is nothing sexual or luxurious about Beatrix's languor in the lithograph, however; rather, she has the aspect of a prisoner, her wasted body pinned under the weight of her bedclothes.

By the Balcony (fig. 177) is the moving counterpart to *The Siesta*. Here Whistler chose to draw Beatrix resting on a chaise that had been positioned near an open window. She is bundled against the chilly spring air, and she lies with her face turned toward the view. Visible in the distance, beyond the balcony railing, are Waterloo Bridge and the warehouses on the Surrey side of the river. As in *The Siesta*, the artist used stumping here to soften the image, gently smudging the crayon

to suggest the textures of his wife's hair and bedclothes, as well as areas of deep shadow. The poignancy of the image lies not in narrative details, for Whistler carefully avoided obvious references to illness and death. No grieving family members or somber doctors signal the tragedy of the moment, as they do in the well-known sickroom scenes of Norwegian Symbolist Edvard Munch. Instead, the power of this portrait lies in the sensitivity with which Whistler used his lithographic crayon to delineate Beatrix's drowsy profile and in the juxtaposition of her inert form with the distant panorama of London, where the bustle of urban life went on as usual.

The two portraits of Beatrix transferred well to stone. Whistler was especially pleased with *The Siesta* and ordered the Ways to print thirty-one impressions of the image.[46] However, his feelings about the portraits appear to have changed rapidly. By the time *By The*

Balcony was printed, Whistler wanted only six proofs. In contrast to his usual aggressive marketing when new lithographs were ready for sale, he failed to distribute impressions of the two portraits to dealers and collectors. The fact that there were also no impressions remaining in his possession when he died suggests that he found them painful reminders of his wife's suffering and eventually destroyed the impressions he had. As a result, both lithographs are very rare.

Later that spring, Whistler moved with Beatrix to St. Jude's Cottage on Hampstead Heath, where her sisters came to care for her. She died there on May 10, 1896. Whistler's grief was crushing. In a note to his friend Kennedy, he wrote simply: "The end has come . . . !—My dear Lady has left us—and I am without further hope."[47] The artist's work in lithography ceased abruptly with Beatrix's death, the result not only of his despondence but also of his increasingly bitter relationship with the Ways. For more than a year, a series of misunderstandings had strained the once warm friendship between artist and printers.[48] By summer Whistler had broken off all contact with the two men who had done so much to nurture his interest and progress in lithography.

While it is generally believed that Whistler abandoned lithography totally after Beatrix's death, he did in fact return to the medium for a small group of informal portraits of his late wife's family, the Birnie Philips. These were all drawn in Paris in 1897 in the house at 110, rue du Bac that he and Beatrix had decorated together. Beatrix's family rallied around Whistler in his grief. He retained the Paris residence after her death and was often joined there by Beatrix's mother, Mrs. John Birnie Philip (née Frances Black), and her younger sisters, Ethel Whibley and Rosalind Birnie Philip. Rosalind became Whistler's ward after Beatrix's death, keeping house for him and

serving as his secretary. After the artist's death in 1903, the young woman, whom he affectionately dubbed "The Major," became the executor of his estate. He drew a lithographic portrait of her, entitled *The Medici Collar* (fig. 182), in early January 1897, during one of his brief sojourns in Paris, and had it printed at the Parisian firm of Alfred Lemercier. At about the same time he painted a small, related oil painting (fig. 183).

Later that year, in the summer or fall, he drew a group of transfer lithographs of the Birnie Philips in the drawing room of the rue

FIGURE 177

By the Balcony, 1896 (cat. no. 196).

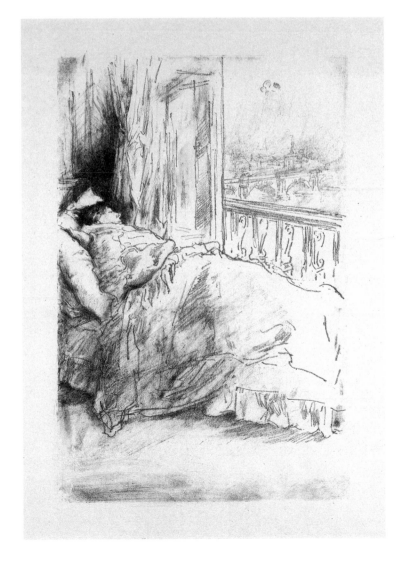

du Bac house, where in happier days he had drawn such portraits as *The Sisters* and *The Duet* (figs. 114 and 118). The tone of these last works is considerably more somber than those he created when Beatrix graced their Paris home: in the later portraits, Whistler's mother-in-law is dressed in the mourning costume that she adopted after Beatrix's death and wore for the rest of her life (see figs. 179 and 184–85). The memory of these last lithographic portraits may have inspired the delicate pen-and-wash drawing of Mrs. Philip (fig. 178) and another of Rosalind Birnie Philip (fig. 186) that Whistler drew in the early 1900s, not long before he sold the Paris house.

Several of Whistler's lithographs of his mother-in-law dating from 1897 appear to have been done simply to pass the time; they

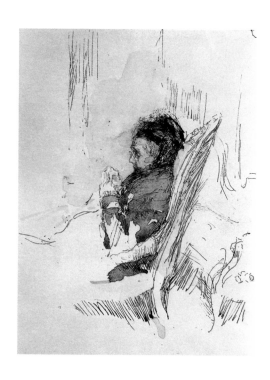

FIGURE 178

The Artist's Mother-in-Law, Mrs. Birnie Philip, c. 1901 (cat. no. 205).

FIGURE 179

Afternoon Tea, 1897 (cat. no. 199).

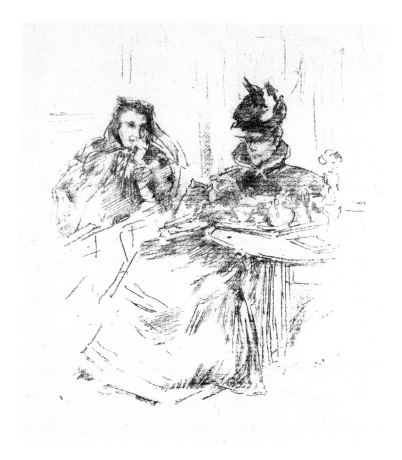

are extremely sketchy and were printed in very few impressions in an off-hand, experimental manner in the shop of Parisian printer Auguste Clot. However, two rather finished subjects in which Ethel attends to her mother, *Afternoon Tea* (fig. 179) and *Mother and Daughter* (fig. 185), were printed by Clot in large editions. *Afternoon Tea* was selected by French dealer and publisher Ambroise Vollard for inclusion in his second album of original prints, *L'Album d'estampes originales de la Galerie Vollard*, released in December 1897. With the publication of this image, Whistler had made his last lithograph. The crayons and blocks of transfer paper that had been his almost constant companions over the last decade were put away for good. (MT)

191. *Savoy Pigeons*, 1896
(fig. 171)

(C 154; W 118)

Transfer lithograph, printed on ivory laid paper, only state; signed in graphite with butterfly

199 x 138 mm (image);

300 x 183 mm (sheet)

Mansfield-Whittemore-Crown Collection, The Art Institute of Chicago, 126.1984

192. *Evening, Little Waterloo Bridge*, 1896 **(fig. 173)**

(C 155; W 119)

Transfer lithograph, printed on ivory laid paper, second of two states

121 x 194 mm (image);

199 x 323 mm (sheet)

Mr. and Mrs. A. Steven Crown, The Art Institute of Chicago, 264.1984

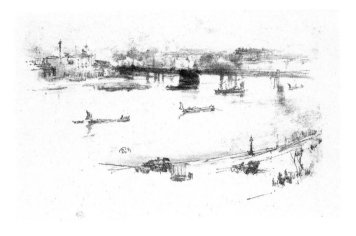

193. *Charing Cross Railway Bridge*, 1896 **(fig. 180)**

(C 157; W 120)

Transfer lithograph, printed on cream laid paper, only state; signed in graphite with butterfly

130 x 216 mm (image);

198 x 270 mm (sheet)

Mansfield-Whittemore-Crown Collection, The Art Institute of Chicago, 128.1984

194. *Little London*, 1896 **(fig. 174)**

(C 158; W 121)

Transfer lithograph, printed on cream laid paper, only state; signed in graphite with butterfly

190 x 140 mm (image);

301 x 173 mm (sheet)

Mansfield-Whittemore-Crown Collection, The Art Institute of Chicago, 129.1984

195. *The Siesta*, 1896 **(fig. 176)**

(C 159; W 122)

Transfer lithograph, printed on cream Japanese paper, only state

139 x 214 mm (image);

219 x 287 mm (sheet)

Mansfield-Whittemore-Crown Collection, The Art Institute of Chicago, 130.1984

196. *By the Balcony*, 1896
(fig. 177)

(C 160; W 124)

Transfer lithograph, printed on cream wove proofing paper, only state

217 x 142 mm (image);

286 x 222 mm (sheet)

Mansfield-Whittemore-Crown Collection, The Art Institute of Chicago, 132.1984

FIGURE 180
Charing Cross Railway Bridge, 1896 (cat. no. 193).

FIGURE 181
Charing Cross Railway Bridge, 1887 (cat. no. 202).

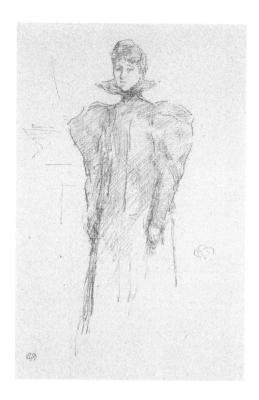

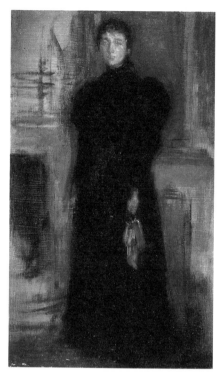

199. *Afternoon Tea*, 1897 (fig. 179)
(C 173; W 147)
Transfer lithograph, printed
on grayish ivory China paper,
only state
185 x 157 mm (image);
242 x 209 mm (sheet)
Mr. and Mrs. A. Steven Crown,
The Art Institute of Chicago,
276.1984

200. *Mother and Daughter* [*"La Mère Malade"*], **1897 (fig. 185)**
(C 174)
Transfer lithograph, printed
on grayish ivory China paper,
only state
187 x 158 mm (image);
307 x 249 mm (sheet)
Mr. and Mrs. A. Steven Crown,
The Art Institute of Chicago,
282.1984

FIGURE 182
The Medici Collar,
1897 (cat. no. 198).

FIGURE 183
Miss Rosalind Birnie
Philip Standing,
c. 1897 (cat. no. 203).

FIGURE 184
Mrs. Birnie Philip and
Her Daughter Ethel,
1893/94 (cat. no. 204).

197. *The Thames*, 1896 (fig. 175)
(C 161; W 125)
Lithotint, printed on cream
Japanese paper, third of three
states; signed in graphite
with butterfly
267 x 196 mm (image);
288 x 222 mm (sheet)
Mansfield-Whittemore-Crown
Collection, The Art Institute
of Chicago, 134.1984

198. *The Medici Collar*, 1897
(fig. 182)
(C 170; W 153)
Transfer lithograph, printed on
buff laid paper, only state;
signed in graphite with butterfly
185 x 112 mm (image);
324 x 245 mm (sheet)
The Art Institute of Chicago,
Bryan Lathrop Collection,
1917.678

201. *Portrait Study: Mrs. Philip,
No. 2*, 1897
(C 179)
Transfer lithograph, printed
on ivory plate paper, only state
191 x 141 mm (image);
191 x 152 mm (sheet)
Mansfield-Whittemore-Crown
Collection, The Art Institute
of Chicago, 53.1995

202. *Charing Cross Railway Bridge*,
1887 (fig. 181)
(K 310)
Etching, printed on ivory laid
paper, only state; signed in
graphite with butterfly on tab
131 x 95 mm (trimmed to
plate mark)
The Art Institute of Chicago,
Bryan Lathrop Collection,
1934.623

203. *Miss Rosalind Birnie Philip
Standing*, c. 1897
(fig. 183)
(YMSM 479)
Oil on panel
23.4 x 13.7 cm
Hunterian Art Gallery,
University of Glasgow, Birnie
Philip Bequest, 46369

204. *Mrs. Birnie Philip and Her
Daughter Ethel*, 1893/94 (fig. 184)
(M 1457)
Pen and black ink on tan wove
paper, laid down on card
150 x 106 mm
Hunterian Art Gallery,
University of Glasgow, Birnie
Philip Bequest, 46244

205. *The Artist's Mother-in-Law,
Mrs. Birnie Philip*, c. 1901 (fig. 178)
(M 1704)
Pen and black ink, and brush
and gray wash, on off-white
wove paper
131 x 91 mm
Museum of Fine Arts, Boston,
Helen and Alice Colburn Fund,
58.738

206. *Rosalind Birnie Philip*, c. 1902
(fig. 186)
(M 1705)
Pen and brown ink, and brush
and brown wash, on white
wove paper
130 x 88 mm
Private collection, New
England; courtesy of Thomas
Colville, Inc.

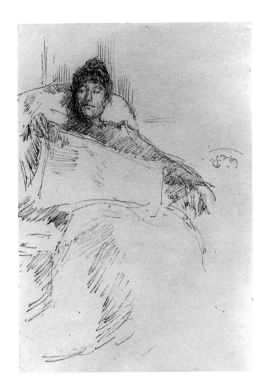

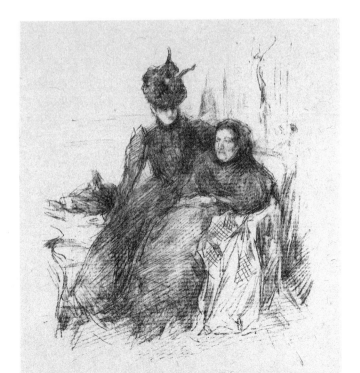

FIGURE 185
Mother and Daughter
["*La Mère malade*"],
1897 (cat. no. 200).

ABOVE

FIGURE 186
Rosalind Birnie Philip,
c. 1902 (cat. no. 206).

Chronology

1834

Whistler is born in Lowell, Massachusetts, on July 11, the son of Major George Washington Whistler and Anna Mathilda McNeill Whistler.

1854

Executes first etchings for the U.S. Coast Survey, Washington, D.C.

1855

Travels to Paris.

1856

Enters the painting studio of Charles Gleyre.

1858

Takes a walking tour of northern France, Luxembourg, and the Rhineland. Produces the "French Set" etchings. Meets the artists Gustave Courbet and Henri Fantin-Latour.

James McNeill Whistler, *Self-Portrait*, 1871 (M 422). Chalk on brown wove paper, laid down on card; 284 x 184 mm. The Art Institute of Chicago (18296/15).

1859

Settles in London. Works with his brother-in-law, Seymour Haden, on etching. Begins the "Thames Set" etchings. Executes first drypoints while visiting Paris from October to December.

1863

Moves to Chelsea. Meets members of the Pre-Raphaelite circle.

1865

Meets the painter Albert Moore; becomes interested in classical sculpture and Tanagra figurines.

1866

Travels to Valparaiso, Chile, where he paints seascapes and first nocturnal scenes.

1867

Breaks with Seymour Haden; rejects the tenets of Realism.

1871

Paints first nocturnes of the Thames.

1872

Arrangement in Gray and Black: Portrait of the Artist's Mother, painted in 1871, is exhibited at the Royal Academy, London.

1873

Maud Franklin becomes his principal model and, later, his mistress.

1874

First one-person exhibition, held at the Flemish Gallery, London, includes paintings, drawings, and a painted screen.

1877

Sues the critic John Ruskin for libel.

1878

Court awards Whistler one farthing in damages in Ruskin trial. Commences work in lithography with the printer Thomas Way, executing lithotints, lithographs, and one transfer lithograph. Four lithotints printed for *Piccadilly*, two of which are issued before the periodical fails.

1879

Declares bankruptcy as a result of the trial. Abandons lithography. Leaves for Venice, commissioned by the Fine Art Society to produce a set of etchings.

1880

Returns to London. Exhibits the "First Venice Set" etchings at the Fine Art Society.

1884

Meets Joseph Pennell and Elizabeth Robins Pennell, American artists who become Whistler's close friends and, later, biographers.

1885

Delivers the "Ten O'Clock" lecture in London.

1886

Publishes the "Second Venice Set" etchings. Elected president of the Society of British Artists.

1887

Resumes work in lithography, working with grained transfer paper (*papier viennois*). Boussod, Valadon et Cie publishes the portfolio *Notes*. Detroit industrialist Charles Lang Freer starts to collect Whistler's work.

1888

Breaks with Maud Franklin. Marries Beatrix Godwin, widow of architect E. W. Godwin. Meets and becomes friends with Stéphane Mallarmé.

1889

Makes etchings in Amsterdam. Made a Chevalier of the French Légion d'honneur.

1890

Executes first color lithograph, printed by Thomas Way in London. Three lithographs published in *The Whirlwind*.

1892

Retrospective exhibition "Nocturnes, Marines, and Chevalet Pieces" held at the Goupil Gallery, London. Settles in Paris with a residence at 110, rue du Bac, and a studio at 186, rue Notre-Dame-des-Champs. Made an Officier of the Légion d'honneur. One lithograph published in *The Albemarle*.

1893

Makes lithographic drawings in Brittany, two of which are developed into color lithographs printed by Henry Belfond in Paris. Makes etchings and lithographs of Paris street scenes and gardens. A lithograph appears as the frontispiece to Mallarmé's *Vers et Prose*; another is included in *L'Estampe originale*.

1894

Temporarily abandons etching to concentrate on lithography in Paris, mastering the use of thin, transparent transfer paper (*papier végétal*). Two lithographs published in *The Studio*; one in *The Art Journal*.

1895

Way selects six Whistler lithographs for the international exhibition commemorating the centenary of lithography, held in Paris; Whistler later reprimands him for choosing early rather than recent works. Works on lithographs in Lyme Regis, Dorset, from September to December. Returns to London in mid-December for the opening of the Fine Art Society exhibition of lithographs. One lithograph appears in *The Studio*, another in *L'Ymagier*.

Cover of *The Studio* 3, 13 (April 1894).

T. R. Way and James McNeill Whistler, *James McNeill Whistler Seen from Behind*, 1895/96. Lithograph on paper, second state; 219 x 141 mm. Hunterian Art Gallery, University of Glasgow, J. W. Revillon Bequest.

1896

Exhibition of lithographs at the Fine Art Society continues through January. Moves with his wife to the Savoy Hotel, London, in mid-February, and in March to St. Jude's Cottage on Hampstead Heath, where Beatrix Whistler dies on May 10. First edition of T. R. Way's catalogue raisonné of Whistler's lithographs is published; Whistler falls out with the Ways soon after, due to a series of misunderstandings related to T. R. Way's catalogue, unpaid bills, and works that Whistler believed remained in the printers' possession. Lithographs appear in *The Pageant*, *The Studio*, and *The Art Journal*.

1897

In April Joseph Pennell brings a libel suit against Walter Sickert, who has published a review of Pennell's lithographs in which he questions their value because they were drawn on transfer paper rather than directly on the stone. Whistler speaks in Pennell's defense at the trial, which Pennell wins. Travels frequently to Paris, staying at 110, rue du Bac with his late wife's family. Draws and prints last lithographs in Paris. An 1895 lithograph appears in *The Studio*, and a recent lithograph in *L'Album d'estampes originales de la Galerie Vollard*. An 1896 lithographic portrait of Joseph Pennell appears as the frontispiece to Joseph Pennell and Elizabeth Robins Pennell's *Lithography and Lithographers*.

1900

Visits Tangiers and Ajaccio, Corscia. Suffers from declining health.

1903

Dies on July 17 in London. Rosalind Birnie Philip, Whistler's sister-in-law and executor, commissions Frederick Goulding to print posthumous editions of ninety-three lithographs, eleven of which had remained unprinted during Whistler's lifetime.

1904

Memorial exhibition held in Boston. Théodore Duret publishes biography of Whistler.

1905

Memorial exhibitions held in London and Paris. Second, expanded edition of T. R. Way's catalogue raisonné of Whistler's lithographs is published.

Glossary

AQUATINT

Technique used to produce tonal effects in etchings, usually in combination with etched and drypoint lines.

DRYPOINT

Intaglio print made by incising lines directly into an uncoated metal plate; often used in combination with etching.

EDITION

Specified number of impressions ordered or printed by an artist once trial proofs have been approved. Whistler's editions of lithographs generally numbered between twelve and twenty-five impressions.

ETCHING

Intaglio print in which lines drawn on a metal plate covered with an acid-resistant coating are bitten or etched with acid.

IMPRESSION

Approved, editioned print, usually signed by the artist.

KEYSTONE

Template block for a color lithograph, containing the complete drawing. Registration marks are used so that subsequent printings from separate stones will be in alignment.

LITHOGRAPH

Planographic print traditionally made from a stone to which greasy lithographic crayon and/or tusche has been applied.

LITHOGRAPHIC CRAYON

Greasy crayon used for drawing on a lithographic stone or transfer paper.

LITHOGRAPHIC STONE

Thick, heavy, flat slab of limestone, ground to a lightly grained surface to prepare it for being drawn on with lithographic crayon or tusche.

LITHOTINT

A type of lithograph in which washes of tusche are applied to the stone with a brush (often over a prepared half-tint ground), either instead of or in addition to lithographic crayon.

ORIGINAL PRINT

Artist-invented composition in a print medium, printed either by the artist or by another person; considered to be the product of the artist's hand.

PAPIER VIENNOIS

Grained lithographic transfer paper, often of German or Austrian manufacture.

PAPIER VÉGÉTAL

Thin, transparent lithographic transfer paper with gum-coated surface intended to receive the lithographic drawing and release it onto the stone.

BELOW LEFT

Detail of transfer lithograph, drawn on *papier viennois* (*Chelsea Rags*, 1888). Hunterian Art Gallery, University of Glasgow.

BELOW RIGHT

Detail of transfer lithograph, drawn on *papier végétal* (*Rue Furstenburg*, 1894). Hunterian Art Gallery, University of Glasgow.

Detail of lithotint
(*Study*, 1878).
Hunterian Art
Gallery, University
of Glasgow.

PROOF

Preliminary or experimental trial print, generally considered to be outside the regular edition. Whistler drew a distinction between "proofs," which were pulled in small quantities by hand, and "prints," which were produced in large editions by machine.

REPRODUCTIVE PRINT

Print (engraving, lithograph, etc.) made by a professional printmaker after a unique painted or drawn composition. In the nineteenth century, reproductive prints had a special status as translations of visual imagery, as do literary translations.

REPRODUCTION

Photomechanically generated version of a work of art.

ROULETTE

Spiked wheel mounted on a handle, used to score an etching plate or occasionally to manipulate lines drawn on stone with a lithographic crayon. The resulting printed line is made up of a series of dots.

SCRAPER

Sharp steel blade used to scrape portions of lithographic crayon or tusche from the surface of the stone; employed primarily for correcting.

STATES

Preliminary stages of a printed image produced as guides for further work to be done on the plate or stone.

STUMP (*CRAYON ESTOMPE*)

Implement made of rolled paper or leather, used to blend lines on the stone. The stump can also be suffused with lithographic tusche and used for drawing.

TRANSFER LITHOGRAPH

Lithograph in which the image was first created on a sheet of transfer paper and then transferred onto a stone.

TUSCHE

Liquid drawing medium containing the same materials as lithographic crayon, applied to stone with brush or pen.

Suggestions for Further Reading

LITHOGRAPHS

The Art Institute of Chicago. *The Lithographs of James McNeill Whistler.* Vol. 1, *A Catalogue Raisonné,* eds. Harriet K. Stratis and Martha Tedeschi. Vol. 2, *Correspondence and Technical Studies,* ed. Martha Tedeschi. Chicago, 1998.

Hobbs, Susan, and Nesta R. Spink. *Lithographs of James McNeill Whistler from the Collection of Steven Louis Block.* Washington, D.C., 1982.

Kennedy, Edward G. *The Lithographs of Whistler.* New York, 1914.

Levy, Mervyn. *Whistler Lithographs: An Illustrated Catalogue Raisonné.* London, 1975.

Lochnan, Katharine A. "Whistler and the Transfer Lithograph: A Lithograph with a Verdict." *Print Collector's Newsletter* 12, 5 (Nov.–Dec. 1981), pp. 133–37.

MacDonald, Margaret F. "Whistler's Lithographs." *Print Quarterly* 5, 1 (Mar. 1988), pp. 20–55.

Smale, Nicholas. "Whistler and Transfer Lithography." *Tamarind Papers* 7, 2 (fall 1984), pp. 72–83.

Tedeschi, Martha. "Whistler and the English Print Market." *Print Quarterly* 14, 1 (1997), pp. 15–41.

Way, T. R. *Mr. Whistler's Lithographs: The Catalogue.* 1st ed. London, 1896.

———. *Mr. Whistler's Lithographs: The Catalogue.* 2d ed. London and New York, 1905.

———. "Whistler's Lithographs." *Print-Collector's Quarterly* 3, 3 (Oct. 1913), pp. 277–309.

ETCHINGS

Kennedy, Edward G. *The Etched Work of Whistler.* Rev. ed. San Francisco, 1978.

Lochnan, Katharine A. *The Etchings of James McNeill Whistler.* New Haven, Conn., and London, 1984.

Wedmore, Frederick. *Whistler's Etchings, a Study and Catalogue.* London, 1886.

DRAWINGS, PASTELS, WATERCOLORS, AND PAINTINGS

Getscher, Robert. *James Abbott McNeill Whistler: Pastels.* New York, 1991.

MacDonald, Margaret F. *James McNeill Whistler: Drawings, Pastels, and Watercolours. A Catalogue Raisonné.* New Haven, Conn., and London, 1995.

Young, Andrew McLaren, Margaret F. MacDonald, Robin Spencer, and Hamish Miles. *The Paintings of James McNeill Whistler.* 2 vols. New Haven, Conn., and London, 1980.

DESIGN AND DECORATION

Bendix, Deanna Marohn. *Diabolical Designs: Paintings, Interiors, and Exhibitions of James McNeill Whistler.* Washington, 1995.

Horowitz, Ira. "Whistler's Frames." *Art Journal* 39, 2 (Apr. 1981), pp. 164–76.

Nakanishi, Branka. "A Symphony Reexamined: An Unpublished Study for Whistler's Portrait of Mrs. Frances Leyland," *The Art Institute of Chicago Museum Studies* 18, 2 (1992): pp. 156–67.

Pennell, Elizabeth. "Whistler as a Decorator," *Century Magazine* 73 (Feb. 1912), pp. 500–13.

WRITINGS AND CORRESPONDENCE

Barbier, Carl Paul, ed. *Correspondance Mallarmé-Whistler.* Paris, 1964.

MacDonald, Margaret F., and Joy Newton. "Correspondance Duret-Whistler." *Gazette des beaux-arts,* 6th pér., 60 (Nov. 1987), pp. 150–64.

Merrill, Linda, ed. *With Kindest Regards: The Correspondence of Charles Lang Freer and James McNeill Whistler, 1890–1903.* Washington, D.C., 1995.

Thorp, Nigel, ed. *Whistler on Art: Selected Letters and Writings, 1849–1903, of James McNeill Whistler.* Manchester, 1994.

Whistler, James McNeill. *The Gentle Art of Making Enemies.* London and New York, 1890.

———. *Mr. Whistler's Ten O'Clock.* London, 1885.

BIOGRAPHICAL SOURCES

Anderson, Ronald, and Anne Koval. *James McNeill Whistler: Beyond the Myth.* London, 1994.

Denker, Eric. *In Pursuit of the Butterfly: Portraits of James McNeill Whistler.* Exh. cat. National Portrait Gallery, Washington, D.C., 1995.

Donnelly, Kate, and Nigel Thorp. *Whistlers and Further Family.* Glasgow, 1980.

Duret, Théodore. *Histoire de J. McN. Whistler et de son oeuvre.* Paris, 1904.

———. *Whistler.* Trans. Frank Rutter. London and Philadelphia, 1917.

Fine, Ruth E., ed. *James McNeill Whistler: A Reexamination.* Studies in the History of Art 19. Washington, D.C., 1987.

Getscher, Robert H., and Paul G. Marks. *James McNeill Whistler and John Singer Sargent: Two Annotated Bibliographies.* New York and London, 1986.

MacDonald, Margaret F. *Beatrice Whistler: Artist and Designer.* Exh. cat. Hunterian Art Gallery, University of Glasgow, 1997.

Merrill, Linda. *A Pot of Paint: Aesthetics on Trial in Whistler v. Ruskin.* Washington, D.C., 1992.

Munhall, Edgar. *Whistler and Montesquiou: The Butterfly and the Bat.* Exh. cat. The Frick Collection, New York, 1995.

Pennell, Elizabeth Robins, and Joseph Pennell. *The Life of James NcNeill Whistler.* 2 vols. London and Philadelphia, 1908.

———. *The Whistler Journal.* Philadelphia, 1921.

Smale, Nicholas. "Thomas R. Way: His Life and Work." *Tamarind Papers* 10, 1 (spring 1987), pp. 16–27.

Sutton, Denys. *Nocturne: The Art of James McNeill Whistler.* London, 1963.

Way, T. R. *Memories of James McNeill Whistler: The Artist.* London and New York, 1912.

SELECTED EXHIBITION CATALOGUES

Curry, David Park. *James McNeill Whistler at the Freer Gallery of Art.* Exh. cat. Freer Gallery of Art, Washington, D.C., 1984.

Dorment, Richard, Margaret F. MacDonald, et al. *James McNeill Whistler.* Exh. cat. Tate Gallery, London, 1994.

Getscher, Robert H. *The Stamp of Whistler.* Exh. cat. Allen Memorial Art Museum, Oberlin, Ohio, 1977.

McNamara, Carole, and John Siewert. *Whistler: Prosaic Views, Poetic Vision.* Exh. cat. University of Michigan Museum of Art, Ann Arbor, 1994.

Staley, Allen, ed. *From Realism to Symbolism: Whistler and His World.* Exh. cat. Columbia University, New York, 1971.

GENERAL REFERENCES ON PRINTMAKING

Antreasian, Garo Z., and Clinton Adams. *The Tamarind Book of Lithography: Art and Techniques.* Los Angeles, 1971.

Cate, Phillip Dennis. *The Color Revolution: Color Lithography in France, 1890–1900.* Exh. cat. Rutgers University Art Gallery, New Brunswick, N.J., 1978.

Druick, Douglas W., and Peter Kort Zegers. *La Pierre parle: Lithography in France, 1848–1900.* Exh. cat. National Gallery of Canada, Ottawa, 1981.

Gascoigne, Bamber. *How to Identify Prints: A Complete Guide to Manual and Mechanical Processes from Woodcut to Ink Jet.* New York, 1986.

Gilmour, Pat, ed. *Lasting Impressions: Lithography as Art.* London, 1988.

Griffiths, Antony. *Prints and Printmaking: An Introduction to the History and Techniques.* London, 1980.

Moore, Kemille S. "The Revival of Artistic Lithography in England, 1890–1913." Ph.D. diss., University of Washington, 1990.

Notes

DRUICK, pp. 8–19.

1. For more on the printmaking revivals, see Douglas W. Druick and Peter Kort Zegers, *La Pierre parle: Lithography in France, 1848–1900,* exh. cat. (Ottawa, 1981); and Kemille S. Moore, "The Revival of Artistic Lithography in England, 1890–1913" (Ph.D. diss., University of Washington, 1990).

2. See Douglas W. Druick and Peter Kort Zegers, "Degas and the Printed Image, 1856–1914," in Sue Welsh Reed and Barbara Stern Shapiro, *Edgar Degas: The Painter as Printmaker,* exh. cat. (Boston, 1984), p. xx.

3. Quoted in Douglas W. Druick and Michael Hoog, *Fantin-Latour,* exh. cat. (Ottawa, 1983), p. 138.

4. Letter from James McNeill Whistler to Joseph Pennell, Nov. 8, 1894, Library of Congress, Washington, D.C., Pennell Collection; quoted in The Art Institute of Chicago, *The Lithographs of James McNeill Whistler,* vol. 2, *Correspondence and Technical Studies,* ed. Martha Tedeschi (Chicago, 1998), p. 258.

5. Druick and Zegers (note 1), p. 91.

6. Ibid.

7. Ibid.

8. F. W., "Mr. Whistler's Lithographs," *Academy,* no. 818 (Jan. 7, 1888), p. 16. For information about lifetime exhibitions of Whistler's lithographs and critical responses to them, see Kevin Sharp, comp., "Marketing the Lithographs: A Selective Chronology of Exhibitions, Publications, and Sales," in *The Lithographs of James McNeill Whistler,* vol. 2 (note 4), pp. 232–77.

9. Letter from James McNeill Whistler to D. C. Thomson, Aug. 30, 1894, Library of Congress, Washington, D.C., Pennell Collection; and letter from James McNeill Whistler to Ernest Brown, Sept. 3, 1894, Glasgow University Library, Department of Special Collections, LB9/25. Both quoted in *The Lithographs of James McNeill Whistler,* vol. 2 (note 4), pp. 253–54.

10. For more on the market for artists' prints, see Martha Tedeschi, "Whistler and the English Print Market," *Print Quarterly* 14, 1 (1997), pp. 15–41.

11. Philippe Burty, preface to *Exposition de peintres-graveurs,* exh. cat. (Paris, 1889).

12. Letter from James McNeill Whistler to Marcus Huish, Nov. 17, 1895, Glasgow University Library, Department of Special Collections, LB3/38; quoted in *The Lithographs of James McNeill Whistler,* vol. 2 (note 4), p. 262.

13. Letter from James McNeill Whistler to Edward G. Kennedy, Sept. 22, 1894, Edward Guthrie Kennedy Papers, The New York Public Library, Manuscripts and Archives Division, Astor, Lenox and Tilden Foundations; quoted in *The Lithographs of James McNeill Whistler,* vol. 2 (note 4), p. 255.

14. Letter from James McNeill Whistler to Edward G. Kennedy, Mar. 14, 1895, Edward Guthrie Kennedy Papers, The New York Public Library, Manuscripts and Archives Division, Astor, Lenox and Tilden Foundations; quoted in *The Lithographs of James McNeill Whistler,* vol. 2 (note 4), p. 266.

15. Letter from Stéphane Mallarmé to James McNeill Whistler, [Nov. 5, 1892], in Carl Paul Barbier, ed., *Correspondance Mallarmé-Whistler* (Paris, 1964), p. 88, no. 107.

16. Whistler seems to have felt, as did Fantin, that "my drawings are my lithographs"; see Druick and Zegers (note 1), p. 92.

17. T. R. Way, *Memories of James McNeill Whistler, the Artist* (London, 1912), p. 125.

TEDESCHI and SALVESEN, pp. 22–124.

1. James McNeill Whistler, quoted in Margaret F. MacDonald, "Maud Franklin," in *James McNeill Whistler: A Reexamination,* Studies in the History of Art, vol. 19, ed. Ruth Fine (Washington, D.C., 1987), p. 25.

2. John White Alexander, quoted in Elizabeth Robins Pennell and Joseph Pennell, *The Whistler Journal* (Philadelphia, 1921), pp. 164–65; see also MacDonald (note 1), p. 16.

3. MacDonald (note 1), pp. 20–21.

4. Nathaniel Hawthorne, quoted in Katharine A. Lochnan, *The Etchings of James McNeill Whistler* (New Haven, Conn., and London, 1984), pp. 79–80.

5. James McNeill Whistler, letter published in the *World,* May 22, 1878.

6. John Ruskin, "Letter 79: Life Guards of New Life," *Fors Clavigera* 7 (July 1877), in *The Works of John Ruskin,* eds. E. T. Cook and Alexander Wedderburn, vol. 29 (London, 1907), p. 160.

7. T. R. Way, *Mr. Whistler's Lithographs: The Catalogue,* 2d ed. (London and New York, 1905), p. 23, no. 7.

8. James McNeill Whistler, under cross-examination in *Whistler v. Ruskin,* quoted in Linda Merrill, *A Pot of Paint: Aesthetics on Trial in Whistler v. Ruskin* (Washington, D.C., and London, 1992), p. 148.

9. James McNeill Whistler, *Mr. Whistler's Ten O'Clock* (London, 1885), pp. 13–14.

10. T. R. Way, *Memories of James McNeill Whistler: The Artist* (London and New York, 1912), p. 19.

11. James McNeill Whistler, quoted in Lochnan (note 4), p. 222.

12. Way (note 10), p. 88.

13. Mortimer Menpes, *World Pictures* (London, 1902), p. 7.

14. Margaret F. MacDonald, *James McNeill Whistler: Drawings, Pastels, and Watercolours. A Catalogue Raisonné* (New Haven, Conn., and London, 1995), pp. 584–86, nos. 1624–27.

15. Eadweard Muybridge, *Animal Locomotion,* 16 vols. (Philadelphia, 1877). These volumes contain 781 plates. Whistler's name and the names of other subscribers were published by Muybridge in the 1891 printing of the *Prospectus and Catalogue of Prints.* For further information on subscribers, see Robert Bartlett Haas, *Muybridge: Man in Motion* (Berkeley, Calif., and Los Angeles, 1976), pp. 157–58.

16. Marcus B. Huish, *Greek Terra-Cotta Statuettes* (London, 1900).

17. Whistler (note 9), p. 6.

18. In a letter to collector George Lucas, Cassatt herself mentioned her amusing encounter with Whistler at the gallery. Letter from Mary Cassatt to George A. Lucas, [July] 1891, George A.

Lucas Collection, Baltimore Museum of Art; quoted in Barbara Stern Shapiro, review of *Cassatt and Her Circle: Selected Letters*, ed. Nancy Mowll Mathews, *Print Collector's Newsletter* 16, 1 (Mar.–Apr. 1985), p. 28.

19. Letter from James McNeill Whistler to D. C. Thomson, probably July 1893, Pennell Collection, Library of Congress, Washington, D.C.; quoted in Richard Dorment, Margaret F. MacDonald et al., *James McNeill Whistler*, exh. cat. (London, 1994), p. 234, no. 152.

20. Way (note 10), p. 92.

21. Letter from James McNeill Whistler to T. R. Way, Sept. 20, 1893, Freer Gallery of Art Archives, Smithsonian Institution, Washington, D.C.; reprinted in The Art Institute of Chicago, *The Lithographs of James McNeill Whistler*, vol. 2, *Correspondence and Technical Studies*, ed. Martha Tedeschi (Chicago, 1998), p. 62, letter 45.

22. On the life and art of Beatrix (christened Beatrice) Whistler, see Margaret F. MacDonald, *Beatrice Whistler: Artist and Designer*, exh. cat. (Glasgow, 1997).

23. For a detailed description of the interior of the Whistlers' home at 110, rue du Bac, see Deanna Marohn Bendix, *Diabolical Designs: Paintings, Interiors, and Exhibitions of James McNeill Whistler* (Washington, D.C., and London, 1995), pp. 185–200.

24. Letter from James McNeill Whistler to T. R. Way, [Oct. 1, 1894], Freer Gallery of Art Archives, Smithsonian Institution, Washington, D.C.; reprinted in *The Lithographs of James McNeill Whistler*, vol. 2 (note 21), p. 124, letter 125.

25. Letter from James McNeill Whistler to J. J. Cowan, Apr. 4, 1896; quoted in Kate Donnelly and Nigel Thorp, *Whistlers and Further Family* (Glasgow, 1980), p. 5.

26. Letter from James McNeill Whistler to Charles Lang Freer, Apr. 2, 1897, Freer Gallery of Art Archives, Smithsonian Institution, Washington, D.C.

27. Letter from James McNeill Whistler to T. R. Way, Nov. 21, [1893], Freer Gallery of Art Archives, Smithsonian Institution, Washington, D.C.; reprinted in *The Lithographs of James McNeill Whistler*, vol. 2 (note 21), p. 72, letter 58.

28. Letter from James McNeill Whistler to Thomas Way, [Aug. 22, 1894], Pennell Collection, Library of Congress, Washington, D.C.; reprinted in *The Lithographs of James McNeill Whistler*, vol. 2 (note 21), p. 114, letter 109.

29. Letter from James McNeill Whistler to Thomas Way, [Sept. 14, 1894], Pennell Collection, Library of Congress, Washington, D.C.; reprinted in *The Lithographs of James McNeill Whistler*, vol. 2 (note 21), p. 119, letter 118.

30. R. A. M. S[tevenson], "Whistler," *Pall Mall Gazette*, Dec. 11, 1895, p. 3.

31. "Art and Mr. Whistler," *Art Journal* 46 (Dec. 1894), p. 358.

32. James McNeill Whistler, quoted in Andrew McLaren Young et al., *The Paintings of James McNeill Whistler* (New Haven, Conn., and London, 1980), vol. 1, p. 170, no. 378.

33. Théodore Duret, *Histoire de J. McN. Whistler et de son oeuvre* (Paris, 1904), p. 94. *Arrangement in Flesh Color and Black: Portrait of Théodore Duret* is now in The Metropolitan Museum of Art, New York.

34. Letter from James McNeill Whistler to T. R. Way, [July 15, 1894], Freer Gallery of Art Archives, Smithsonian Institution, Washington, D.C.; reprinted in *The Lithographs of James McNeill Whistler*, vol. 2 (note 21), p. 103, letter 93.

35. Letter from James McNeill Whistler to D. C. Thomson, July 20, 1894, Library of Congress, Washington, D.C., Pennell Collection; quoted in *The Lithographs of James McNeill Whistler*, vol. 2 (note 21), p. 250.

36. Letter from James McNeill Whistler to Edward G. Kennedy, Mar. 14, 1895, Edward Guthrie Kennedy Papers, Manuscripts and Archives Division, The New York Public Library, Astor, Lenox and Tilden Foundations; quoted in *The Lithographs of James McNeill Whistler*, vol. 2 (note 21), p. 266.

37. Letter from James McNeill Whistler to T. R. Way, [Sept. 27, 1895], Freer Gallery of Art Archives, Smithsonian Institution, Washington, D.C.; reprinted in *The Lithographs of James McNeill Whistler*, vol. 2 (note 21), p. 135, letter 141.

38. This proof, in its original mount, is now in the Freer Gallery of Art, Smithsonian Institution, Washington, D.C.

39. Letter from James McNeill Whistler to T. R. Way, [Sept. 25, 1895], Freer Gallery of Art Archives, Smithsonian Institution, Washington, D.C.; reprinted in *The Lithographs of James McNeill Whistler*, vol. 2 (note 21), p. 134, letter 140.

40. G. P. Jacomb-Hood, *With Brush and Pencil* (London, 1925), p. 46; also quoted in MacDonald (note 22), p. 17.

41. Way (note 10), pp. 125–26.

42. Letter from James McNeill Whistler to Edward G. Kennedy, early Apr. 1896, Edward Guthrie Kennedy Papers, Manuscripts and Archives Division, The New York Public Library, Astor, Lenox and Tilden Foundations; quoted in *The Lithographs of James McNeill Whistler*, vol. 2 (note 21), p. 267.

43. T. R. Way, "Whistler's Lithographs," *Print-Collector's Quarterly* 3, 3 (Oct. 1913), p. 290.

44. Letter from Théodore Duret to James McNeill Whistler, Sept. 29, 1900; quoted in Margaret F. MacDonald and Joy Newton, "Correspondance Duret-Whistler," *Gazette des beaux-arts*, 6th pér., 60 (Nov. 1987), p. 160.

45. Letter from James McNeill Whistler to Edward G. Kennedy, Mar. 25, 1896, Edward Guthrie Kennedy Papers, Manuscripts and Archives Division, The New York Public Library, Astor, Lenox and Tilden Foundations; quoted in *The Lithographs of James McNeill Whistler*, vol. 2 (note 21), p. 267.

46. The Art Institute of Chicago, *The Lithographs of James McNeill Whistler*, vol. 1, *A Catalogue Raisonné*, eds. Harriet K. Stratis and Martha Tedeschi (Chicago, 1998), p. 451, no. 159.

47. Letter from James NcNeill Whistler to Edward G. Kennedy, around May 10, 1896, Edward Guthrie Kennedy Papers, Manuscripts and Archives Division, The New York Public Library, Astor, Lenox and Tilden Foundations; quoted in *The Lithographs of James McNeill Whistler*, vol. 2 (note 21), p. 268.

48. For a full account of the extraordinary relationship between Whistler and the Ways, see Nicholas Smale, "Whistler, Way, and Wellington Street," and the Whistler-Way Correspondence, in *The Lithographs of James McNeill Whistler*, vol. 2 (note 21), pp. 8–27, 32–155.